LONE STARS

A Legacy of Texas Quilts,
1836–1936

LONE STARS

A Legacy of Texas Quilts, 1836–1936

by Karoline Patterson Bresenhan
and Nancy O'Bryant Puentes
Foreword by Jonathan Holstein

UNIVERSITY OF TEXAS PRESS, AUSTIN

Second Printing, 1986

Requests for permission to reproduce material
from this work should be sent to
Permissions, University of Texas Press,
Box 7819, Austin, Texas 78713-7819.

The publication of this book was assisted by a grant
from the Andrew W. Mellon Foundation.

LIBRARY OF CONGRESS
CATALOGING-IN-PUBLICATION DATA

Bresenhan, Karoline Patterson.
 Lone stars.

 Exhibition catalog.
 1. Quilts—Texas—History—19th century—
Exhibitions. 2. Quilts—Texas—History—20th
century—Exhibitions. I. Puentes, Nancy O'Bryant.
II. Title.
NK9112.B68 1986 746.9′7′097640740164 85-31589
ISBN 0-292-74641-5
ISBN 0-292-74649-0 (pbk.)

This book is the official catalog for the Texas Sesquicentennial Quilt Association's traveling exhibition, which is partially supported by a grant from the Texas Commission on the Arts and the National Endowment for the Arts.

To our great-great-grandmother,
WILHELMINA SCHLACK UTTECH,
who journeyed to Texas from Germany in 1868 as a young widow with three children and learned to quilt by lamplight in a tent on the Texas plains;

To our great-grandmother,
KAROLINE ESMUNDE UTTECH GLAESER,
who created a life of order for herself and thirteen children as well as creating quilts for our weddings;

To our grandmother,
ELLA WILHELMINA GLAESER PEARCE,
who taught us to quilt and to value the combined strength of many tiny, individual stitches both in our quilts and in our lives;

To our mothers,
JEWEL ESTELLE PEARCE PATTERSON
AND HELEN LYDIA PEARCE O'BRYANT,
who show us every day the beauty of fine workmanship and the fulfillment of a job well done.

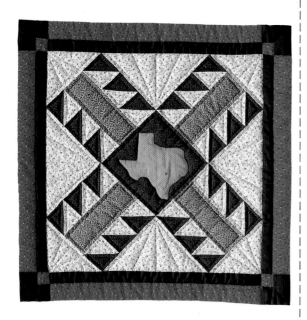

THIS BOOK is part of a statewide effort by its authors and the Texas Sesquicentennial Quilt Association to see that the artistic and cultural contributions made to Texas history by women through their quiltmaking are recognized during the Texas Sesquicentennial, the state's 150th birthday, in 1986, and beyond.

The decision was made to search the state for the very best examples of Texas quiltmaking from 1836 to 1936, from Texas' beginning as a Republic to its Centennial celebration in 1936. This project, the Texas Quilt Search, took a total of three years, two of them spent traveling to twenty-seven Texas cities and towns to seek out the finest quilts still in private hands. The search documented 3,500 quilts; 350 of these were considered; and 62 of them were finally selected for this book. *Lone Stars: A Legacy of Texas Quilts, 1836–1936* is the catalog for an exhibit of these 62, opening in the Rotunda of the State Capitol on San Jacinto weekend, April 19–21, 1986. Thirty-nine of the quilts will tour Texas museums during 1986 and 1987.

CONTENTS

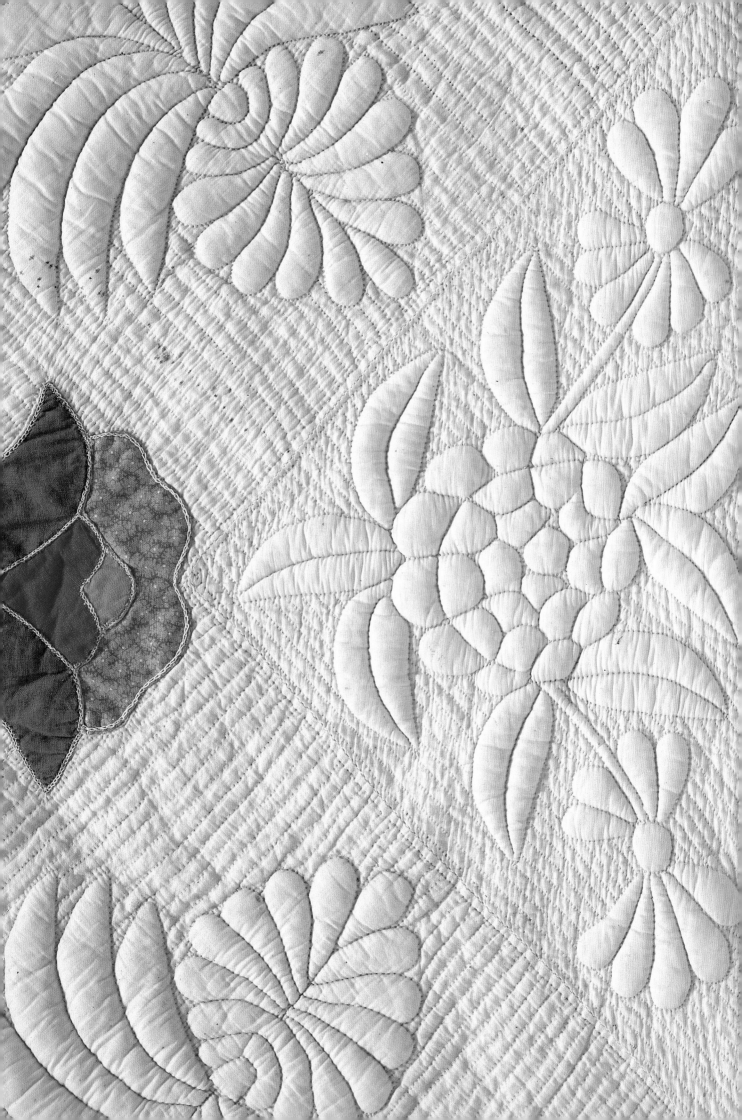

FOREWORD

THE MIGRATION of American quilts from beds to walls seems, in retrospect, to have happened with remarkable speed. Within quite recent memory quilts were celebrated more as artifacts and symbols of a supposed golden past than as art objects. With the exception of a few pioneering museums, such as the Shelburne in Vermont, which showed some quilts stretched flat like paintings, most on public display were used as accessories in period rooms.

Beginning about a decade and a half ago, however, a succession of widely seen and very popular exhibitions in major museums presented quilts as designed objects, concentrating on aesthetics rather than history or the niceties of workmanship. These exhibitions, centered largely on pieced quilts, have continued to the present and have had two important effects: they separated quilts from their mythic past, and they introduced them to scholars, collectors, and a general public both here and abroad as an important American design form. Many noted the strikingly "modern" look of some pieced quilts, and their resemblance to the works of some schools of modern nonobjective painting.

This intense and lasting interest, supported by many exhibitions, books, articles, and lectures, changed our perceptions of what a "good" quilt was. To the traditional judgment, in which workmanship, age, and historical associations were as important as design, was added a judgment based purely on aesthetics—what looked good to us regardless of the other criteria. In addition, quilts were established as a distinct body of American folk art, along with primitive paintings, whirligigs, painted furniture, and the like. Dealers in New York and other metropolitan centers began to specialize in quilts, offering the most visually dazzling examples to increasingly sophisticated collectors. Certain categories of quilts—such as those of the Pennsylvania Amish—found distinct niches within the larger body of American quilts. More specialized exhibitions and books were created, and specialized collections built.

This concentration on the visual aspects of quilts to the exclusion of their other intrinsic qualities caused an inevitable reaction. Some scholars, particularly those interested in both quilts and women's history or in women's art as such, felt that the emphasis on the aesthetics of quilts was causing their importance as cultural objects to be overlooked or forgotten. Consequently, starting in the late 1970s, there began to appear books, articles, films, and exhibitions that examined quilts as women's art and as social objects, that looked at their meaning in the lives of the women who made them and in the society in which they were created. Such explorations of the social aspects of quilts have continued to attract both scholarly and more general interest. Other areas of continuing study include design sources, history, and craft. Thus, a more complete and integrated view of quilts is slowly emerging.

One obvious effect of all this activity has been its encouraging influence on the modern quilt-making boom. For scholars, the most important manifestation of a broadening interest has been, in my opinion, the large-scale surveys that have attempted to document quilt aesthetics, history, and craft in a defined geographic area. These grew initially from the desire to both show and save—to discover and exhibit the greatest quilts of a given area and at the same time preserve vanishing history. It is important to do such surveys while many quilts remain in their makers' families and thus can be linked to their social histories. While other aspects of quilt study are equally interesting, this disappearing information has for me an "endangered species" status, and collecting it is a first priority.

The Kentucky Quilt Project was the first large-scale effort to document a state's quilts. While this was followed elsewhere by several well-conducted though less-ambitious projects, the Texas Quilt Search was the second attempt at a statewide survey, with all the organizational nightmares and prodigies of labor that entails. Each survey has definite parameters. Every quilt that fits within them and turns up on the public working days of such projects must be documented; hundreds may appear. To properly document quilts, they must be examined thoroughly for their technical, or craft, features; their social histories must be accurately noted; their designs must be considered and recorded with photographs.

One goal of the Texas Quilt Search from the beginning was an exhibition of the best quilts that were found and an accompanying book of record, this catalog. At the conclusion of the search, Di-

rectors Karey Bresenhan and Nancy Puentes reviewed all aspects of each documented quilt and made an initial broad selection. To ensure an objective and impartial result, they entrusted the final selection of the exhibition to three jurists uninvolved in the search, an act of great courage. I was fortunate to be one of the jurists (along with Julie Silber, curator of the Esprit Quilt Collection, and Cecilia Steinfeldt, senior curator of the San Antonio Museum Association) and could not have had a more interesting introduction to Texas quilts. We were asked to select an exhibition from 350 quilts considered by the directors the most interesting of the 3,500 documented. It was a wonderful group. Of the several unique things I noted I will mention only the particularly interesting drawing style seen in a number of otherwise typical red-and-green appliqué quilts of the 1850–1870 period. These had a thin and reedy, or nervous, line that gave them a tension and liveliness most unusual for the floral appliqué quilts of the time. I consider this a Texas trait. And I liked many of the strange and moving unique quilts I saw, some of which are in the exhibition, some of which, sadly, are not; an exhibition twice the size, and therefore unmanageable, would have been needed to include all the quilts I thought worthy of exhibition and publication.

Objective judgment informs me that the most important work of the Texas Quilt Search was gathering and preserving information. This will be of continuing interest to scholars concerned with American quilts in general and Texas history in particular. What is most exciting to me, however, is seeing the best of these wonderful textiles in a setting sympathetic to their extraordinary visual qualities.

The exhibition and catalog are the first tangible results of the immense work of the search and will introduce an interested worldwide audience to Texas quilts and their history. Those involved in the work and support of the search and exhibition have given their state a great gift.

JONATHAN HOLSTEIN

PREFACE

QUILTS have endured for centuries to take their rightful place as one of the most universally recognized American art forms, an art of the people, an art that speaks of love with every stitch—love of beauty, love of life, love of work, love of family.

Since the early 1970s, Texas, like all of America, has experienced a renaissance of interest in quilting, a gradual realization among the people that this homey domestic work could produce spectacular results. These results have outlived their makers, have transcended their humble beginnings, and have come off the bed and onto museum and corporate walls. They have even spread to foreign lands where people respect and value them as America's national treasures.

Quilting was almost a lost art in Texas after World War II, as in the rest of the nation. Since America's Bicentennial celebration in 1976, however, more and more women and men have turned to quilting classes to replace learning at the knees of the grandmothers now gone. New generations of quilters are taking their places in the continuing American love affair with quilts. Quilt magazines count their readership in the hundreds of thousands. Quilt guilds provide quilters with a support network to replace the quilting bees that have almost vanished with our mobile society. Quilt shows are held throughout the nation, attended by thousands of people, and the largest one in the United States is held in Texas each year. Museums mount quilt exhibitions and find, sometimes to their astonishment, that these exhibits are the ones that break attendance records. Americans, and Texans, love quilts.

Quilts provide us with a solid bridge to our past, with cultural continuity, with historical documents of the daily lives of people. Each quilt tells its own story in stitches, not in words, but the tale is no less compelling:

– When Polly McCright made her Octagon Star quilt in 1890, she stitched into it the memories of holding off an Indian attack in a one-room cabin sheltering thirty-eight terrified settlers.

– When a West Texas quilter pieced into her Crazy quilt the political ribbon inscribed "Turn Texas Loose!" she was leaving behind a definite message for future generations to heed.

– When the anonymous Confederate quilter in East Texas stitched a warning about the coming war into her white-work quilt in 1861, she was reflecting the divided sentiments that split Texas.

She painstakingly stitched and stuffed the legend "We offer peace, but ready for war" onto her homespun, along with the seal of the Confederate States of America.

– When Lizzie Tidwell made her son's Oil Patch quilt in Bosque County, she had his comfort in mind, for the heavy, thick quilt would provide him protection as he rolled up in it to sleep on the ground near the oil wells. Yet today that quilt is symbolic of the wild, exciting years of the early Texas oil booms.

– Still another quilt carries a story of unrequited love in its Oak Leaf and Acorn design. Made by a Texas girl for the man she hoped to marry, instead it was given to him as a wedding present when he married someone else. The quilt was never used because his wife refused to sleep under it!

– Stories of bravery and defiance abound in Texas quilts that survived the Civil War. Bloodstains from war wounds were left in the quilts, which then were passed down through the generations with the message "These stains are honorable." Others are honored in family memory as "the quilt they buried to keep the Yankees from carrying it off."

– Other quilts carry carefully stitched prayers and hopes for children, like the Album quilt made in Milam County about 1875, which is embellished with lovingly traced feet and hands of a tiny firstborn son, or the Moss Rose quilt made by Harriet J. Durst, wife of a hero of the Texas Revolution, for her granddaughter Cassie Hopkins. Embroidered on it is a prayer: "May the Lord be thy Guardian and Guide, and o'er every thought and step preside."

These stories stitched into the quilts remind us that times in Texas have been very hard indeed. "A heaven for men and dogs, but a hell for women and oxen." That was one woman's assessment of frontier life in Texas as she lived it, later described in Noah Smithwick's *Evolution of a State or Recollections of Old Texas Days*. And nothing in the state's volatile history suggests that she might have been wrong. Life was dangerous and insecure; pioneers were beset on every side with enemies of all kinds, from Indians to rattlesnakes, from yellow fever to wars.

Quilts tell us about their makers with every thread. By their very nature, quilts are linked to the bed, to the most important events of human life, birth and death, joy and sorrow. Quilts are important family links in a time when the concept of an extended family is fast fading. Particularly interesting about this search for Texas quilts and its results is that so many of the quilts remain in family hands, treasured despite their sometimes tattered condition.

The name of the quilter may have been lost, but the relationship, or sense of kin, lives on: "my husband's great-great-grandmother" . . . "a great-aunt of my grandmother" . . . "my mother-in-law's second cousin" . . . "the grandmother who died when my mother was born"—women we have never known but understand all the better for the work of their hands, work left behind as a symbol of the importance of their lives, as a legacy to unborn generations.

Our Great-Grandmother Karoline was such a woman. As little girls we knew her, but only from the enormous distance that separates the very young from the very old. Many years after her death we learned that she had made each of us a quilt top for our weddings, a Star design just like the Star quilts she made for every new Methodist preacher who moved into town. When the first engagement was announced, our grandmother called the women of the family together, including all the great-aunts, for a quilting bee. We learned to quilt that weekend. Our grandmother sat both of us down at the head of the quilt and warned us: "Learn to take pretty little stitches . . . because you're going to have to wake up and look at them every morning!"

For the first quilt, there were eight of us around the frame; we finished the quilt in one weekend by working around the clock. As we were putting in the last stitches, Great-Aunt Minnie looked at the bride-to-be stitching diligently and said to our grandmother, "You know, Ella, that girl's going to make a pretty fair quilter." Nothing more, but that praise has never been forgotten and seldom equaled. The memory of our first quilting bee has never faded, and the two quilts from our great-grandmother are still among our most treasured possessions.

Quilts are at the heart of the memories of many Texas families. The stories of the sixty-two quilts in the Texas Exhibit are told in this book. They trace quilts in the state from 1825 to 1936, more than one hundred years. As we searched Texas, we found out a great deal about quilts in the Lone Star State, but we learned even more about the people who live here. In particular, we found that they have a very keenly developed sense of family—perhaps to be expected in a state influenced by a strong Southern family heritage.

Other conclusions can be drawn from our trek through the state: Very few quiltmakers signed or dated their work. (Unfortunately, few are doing so today, either.) Quilts, even when worn out, are kept safe and handed down if they have any family significance whatsoever. In some instances, the quilt has survived in perfect condition, sometimes passing through as many as five generations without ever being used on a bed. On the other hand, many Texas quilts were "washed to death" in the 1930s. At that time it was not unusual for the bed to be stripped of its linen, including the quilts, and the linens boiled in a washpot over an outdoor fire until the housewife judged they were clean.

Texas quilts cannot be stereotyped. While the state produced many fine classic quilts, it is also home to some unusual quilts rarely seen elsewhere. For example, "Please Pass the Biscuits, Pappy," Ophelia Murray's whole-cloth quilt made of printed flour sacks from the Burrus Mills, featuring Texas Governor Pappy Lee O'Daniel, along with many thirties' images of the state, found in Fort Worth; Cattle Brand quilt, specifically made by Mrs. Guy Willis of Burkburnett for her husband to use as a saddle blanket, embroidered with brands from West Texas ranches, found in El Paso; Sachet quilt, a Lone Star with individual cotton sachets sewn into each diamond, found in Galveston; Feed Bag quilt, a Weathervane design that used burlap feed bags for batting, found in San Angelo; beard protectors, soft muslin casings sewn to the top edge of the quilt to protect it from the friction of a man's beard, found throughout the state; American Flag quilt, an exact rendition of the nation's flag, complete with appliquéd stars, found in Del Rio; Snake's Trail, a quilt top depicting the winding path of a snake, brought by Mary Lou Bollman to Midland (Mrs. Bollman, a West Texas resident,

drove hundreds of miles to attend three Quilt Search Days in Lubbock, Midland, and Amarillo). Some quilts were made entirely "from scratch," like the Log Cabin that Roy Boatman brought to the Austin Quilt Search Day: "My grandmother spun the thread, wove the cloth, and made this quilt." Many Texas quilters working as late as the 1930s can recall picking, ginning, and carding their own cotton to make quilt batting. Home spinning, weaving, and dyeing went on much longer in Texas than in other parts of the nation. Because Texas was basically rural until the recent past, it was difficult for women to obtain manufactured fabrics here, which forced them to make what they could. Also, because many of the early settlers of Texas were Southerners, they brought with them the handicrafts and self-reliant habits characteristic of that area.

We also saw character quilts, such as the pair of painted quilts made by two sisters and found in Wichita Falls. One, made by Martha Estep, portrays mischievous Campbell Soup kids at play; the other, made by Gwen Franks, depicts the child star Shirley Temple in many of her famous movie roles. The Suggan, a heavy utilitarian cowboy quilt that functioned as a bedroll, was found primarily in West Texas.

For as long as women have been quilting, there have been artists among them, stitchers who devoted time and talent to creating a statement of beauty that went far beyond simple necessity. Early quilts frequently demonstrate magnificent workmanship that comes only from very early training. Young girls were often taught to sew and quilt by age six. In our family there is a quilt pieced by one of our mothers when she was six years old. The piecing is far from perfect, but it was a first effort. Today she is a master quilter who has taught thousands of people how to quilt.

Many times the quilts that are cherished in Texas are simple utility quilts, made for cover to keep a loved one warm. They may have seen hard use, they may be stained or soiled, there may be a hole or a frayed binding, but still they speak of love and still they warm our hearts. Other quilts were made for "best" quilts. These were always special. Carefully stored away in tissue paper, they were brought out only rarely to be unfolded and enjoyed. Perhaps they were made for a wedding

or a hope chest or a longed-for baby—whatever the reason, they were treated gently, and they have survived to tell us of the abiding love of beauty and the creative spirit that played such a part in the otherwise hard lives of our ancestors.

These quilts are an expression of the quilter's spirit that now must be interpreted by family members she may never have known—perhaps even strangers with no family connection, but with a deep appreciation for quilts as art. The quilts serve as tangible remembrances, reminders of times gone by, when girls learned to ply a needle at four, to piece at six, to quilt for the family by thirteen, to marry at fifteen, to be mothers at sixteen, and, perhaps, to be widowed at twenty. So much life in all those stitches.

As a historical and cultural record, quilts have the rare capacity to stir people's emotions and memories. The quilt has indeed endured, as this quotation from *Anonymous Was a Woman* proves: "The quilt, that most anonymous of women's arts, rarely dated or signed, summarizes more than any other form the major themes in a woman's life— its beginnings, endings, and celebrations retold in bits of colored cloth. In bridal quilts, patchwork coverlets for daily use, parlor quilts, album quilts . . . even in widows' quilts—a woman said everything she knew about art and life" (pp. 10–11).

ACKNOWLEDGMENTS

WE WOULD like to thank our partners, the two other members of the Texas Sesquicentennial Quilt Association Board of Directors, Suzanne Yabsley and Kathleen McCrady, for their innumerable contributions to this effort from its conception to its completion. We also want to acknowledge gratefully the invaluable advice and assistance of TSQA's Executive Council: Virginia Hartnell, McAllen; Ethel Howey, San Antonio; Janet Mullins, Fort Worth; Judy Murrah, Victoria; Sharon Newman, Lubbock; Jean Roberts, Midland; Anne Tuley, Tyler; and Lynn Young, Houston.

A very special acknowledgment goes to Sharon Risedorph and Lynn Kellner, of San Francisco, California, who are responsible for all of the quilt photographs.

For their assistance in making this book a reality, we wish to thank Maurice Bresenhan, Jr., Jewel Patterson, and Helen and Vernon O'Bryant, for their significant contributions; Vi McCorkle and Wilma Anderson, for preparation of the manuscript; and all the many friends and supporters who encouraged us in this endeavor and contributed to its completion. Most of all, we thank the people of Texas who brought their quilts for consideration, in continuation of the age-old tradition of sharing among those who love quilts.

INTRODUCTION

"Man may work from sun to sun,
But woman's work is never done."
—Old Saying

MAKING QUILTS is simple today. Quilt stores stock a multitude of fabrics, many different kinds of battings, threads in every color of the rainbow, patterns in every size, and books to tell us how to quilt. None of that existed for the pioneer woman in nineteenth-century Texas. If she came to Texas early, perhaps around the time the Republic was established in 1836, she found an isolated environment that forced the people who lived there to be totally self-sufficient. Survival was the main concern—surviving Indian raids, droughts, hurricanes, blizzards, malaria, and the awful loneliness that pioneers mention repeatedly in their diaries.

To make a quilt in early Texas was not something that was undertaken lightly. Shelter first, food second, protection from the elements in the form of clothes and bedding third—those were the priorities of the pioneer. The cotton had to be grown, cultivated, chopped, picked, ginned, and carded. Thread had to be spun on spinning wheels, cloth woven on looms and dyed by hand, then the quilt top pieced. The cotton for the batting had to be grown, picked, ginned, and carded. Then the quilt could be quilted. None of this was easy, nor was it fast. Making a quilt in early Texas was a slow, tedious process, and the quilts that survive prove that the settlers truly believed in the old adage: "If something is worth doing, it's worth doing well."

In searching Texas for quilts made before 1936, we found many instances of hand-woven and home-dyed fabrics used in quilts from 1850 to 1890. Many authorities contend, however, that home-manufactured goods died out in America after 1830–1840 when the nation's textile industry went into full production. In further researching this contradiction, we found references to much later weaving and dyeing, particularly in the South after the Civil War. Since Texas was, to a large degree, settled by Anglo-Americans from the Southern states, especially Kentucky and Tennessee, it is not surprising that many of the old handicrafts and their tools were brought with the women who came to start new homes.

Many of the Southerners were drawn to Texas because of access to large tracts of low-priced land. Between 1791 and 1835, first Spain, and later Mexico, authorized *impresarios* to bring in groups of settlers and provided land grants amounting to more than 26 million acres. After the Texas Revolution, the government of the new Texas Republic granted headrights of land ranging from 320 acres to 4,605 acres to heads of families and to single men. This policy was continued until statehood in 1845 to encourage settlement of the new nation.

With those settlers came their quilts, their spinning wheels, their looms, and their cards for carding cotton. Safford and Bishop, writing in *America's Quilts and Coverlets*, point out that "home-fashioned textiles . . . continued to survive in the country districts, particularly in Kentucky and Tennessee," long after the art died out in other parts of the country (p. 14). Orlofsky, in *Quilts in America*, states: "There were always people who continued to spin and weave their own goods long after it became unnecessary; and those of little prosperity and those who lived in rural and frontier areas would continue to make homespun for decades to come" (pp. 179–180). She also makes the point that technical development did not spread instantly across the nation, and that the varying degrees of technical achievement produced both primitive and sophisticated textiles at the same chronological time. "As the settlement and development of the country progressed at different stages, advanced textiles were produced in the urban areas while the rural interior areas produced more primitive types. Fabrics were probably home woven in the West at the same time the most beautiful printed textiles were manufactured in the East. Thus, in one section of the country wood blocks were used, and, in another, roller plates; manufactured goods in the East, homespun in the West" (pp. 321–322).

This theory was proved, especially regarding the Southern areas, when C. W. Hume, editor of the *McCreary County Record* in Kentucky, reported finding the Oscar Blevins family living in primitive conditions in an old log house as late as the close of World War I. He found then that "the women spun and wove all the clothing they wore. They . . . were almost completely self-sufficient." His report is related in John Irwin's oral history book, *A People and Their Quilts* (p. 17). In Irwin's discussion of Rufus Eledge's handwoven quilt is found one of the best descriptions of the rigorous process of making cloth for quilts: "Not only did every thread have to be spun on the crude spinning wheel and then woven one by one on the loom, but the steps in preparing and processing

the material before spinning were simply prodigious. Old timers said that it took at least sixteen months to produce linen fiber . . . Cotton had to have every one of the multitudinous seeds removed . . . It took ten times as long to spin thread for a blanket as it did to weave it, and it took ten times as long to prepare the fiber as it did to spin it. So, several hundred hours were required just to make the cloth for a single quilt" (p. 18).

In early Texas, homespun was also a way of life. Mary Crownover Rabb, one of Stephen F. Austin's original Old Three Hundred colonists, came to Texas as a sixteen-year-old bride in 1823. She discusses spinning and weaving in *Travels and Adventures in Texas in the 1820's*, as recounted in *Texas Tears and Texas Sunshine*:

Then your pa made me a camp and covered it with those old boards. I went to spinning and spun enough thread to make forty-six yards . . . and wove it out in the open air and sun without any covering. Your pa made the loom in two days. Then I wove another piece of cloth that was good and thick for clothing before we got any shelter for the loom. Then your pa built a good house. He made it twenty feet square. He hewed the logs down to about six inches thick, and then he made a shed for the loom. (P. 14)

The house was made of logs. [She was at this time living at Indian Hill near LaGrange, Texas.] They made a chimney to it. The door shutter was made of thick slabs split out of thick pieces of timber, and the way we fastened the door, they bored a hole in one of the logs inside close to the door shutter, and then we had a large pin or peg that was drove in hard and fast of nights, and then the Indians could not get in. We had an earthen floor in our house.

I was in my first Texas house, and Andrew Rabb made a spinning wheel and made me a present of it. I was very much pleased, and I soon got to work to make clothing for my family.

. . . I was left alone with my little babe, and . . . I could hear the Indians walking around the house many times of nights. I had to take a padlock and chain and fasten Tormentor to the house. I thought the Indians was trying to get the horse from the house. Sometimes I thought they would cut his head off just because they could not get him. Now lonely as I was, after rising early in the morning and attending to making cornmeal for the day, I kept my new spinning wheel whistling all day and a good part of the night, for while the wheel was roaring, it would keep me from hearing the Indians walking around hunting mischief. (Pp. 8–9)

John Rabb left to claim his headright of land; on his return, they packed everything they owned on one horse and made the move, "with my spinning wheel put on top" (p. 10). They finally reached their land and started to build a frame house, while Mrs. Rabb began spinning under a tree. After the house was up and roofed, Mr. Rabb decided to move nearer the river where they had no house or camp. In Mary Rabb's words, "We put up a quilt and a sheet for a tent. I got the head of my wheel under the tent. I got to spinning again. . . . The mosquitoes and sand gnats was so bad that it was impossible to get any sleep . . . I would pick the cotton with my fingers and spin six hundred thread around the reel every day and milk my cows and pound my meal in a mortar and cook and churn and mind my children" (pp. 12–13).

Women made their own cloth throughout the Texas Revolution and into statehood as an everyday task. They had ample supplies of cotton to work from, because Texas was a major cotton-growing state and many of them lived on cotton farms and plantations. However, by the Civil War, printed calicoes were both popular and easily available. That was soon to change. As the Texas women sorrowfully watched their men and boys march off to a war most of them did not want but vowed to support, they were watching the end of a way of life. The women left behind in Texas, and all over the South, were indeed left with a "hard row to hoe," an old cotton-growing expression.

Many of those at home suffered from lack of food, clothing, and medical supplies. An anonymous Texas woman who lived through the war describes how the women managed to survive, as recorded in *Texas Tears and Texas Sunshine*:

The old-fashioned spinning wheel, loom, and knitting needles were brought into requisition by our noble women, who worked busily through the days of the storm that was the war, and far into the night, to supply the soldiers at the front and the dependent members of the family at home with needed clothing . . . the greater part of what was needed was obtained by our own invention. For medicines, in many instances, we used barks, roots, and herbs, as the Indians do. For soda, we burned corncobs and used the ashes. For coffee, there were various substitutes, such as parched sweet potatoes, rye and okra-beans. Dry goods were not to be had, except in very small quantities, and at fabulous prices. Calico of the best quality cost fifty dollars a yard, Confederate money. (P. 105)

Mary Byson of Red River County, Texas, wrote to her friend Margaret Butler in Louisiana in 1864: "Times are hard but I do not think we ought to complain. I have been wearing home-spun dresses this winter to save my calico. I am in hopes the war will end this year. Sister Susan has lost three sons since the war commenced." (Her letters are preserved in the Butler Family Papers in the archives at Louisiana State University.)

One of the most evocative descriptions of life in Texas during the Civil War and how it affected the women now reluctantly serving as heads of households is found in the letters of Rebecca Ann Patillo Bass Adams writing to her soldier husband from a plantation near Fairfield. These letters were first published in 1962 in *The Hicks-Adams-Bass-Floyd-Patillo and Collateral Lines, Together with Family Letters, 1840–1868*; excerpts are reprinted in *Texas Tears and Texas Sunshine*:

I am needing some wool cards, but there is none in the country. The cotton cards that I have been using for wool are nearly ruined. The teeth are pulled nearly straight. . . . I have the wool but I don't want to ruin another pair of cotton cards. Mr. Caldwell has returned I hear, he has cards for sale with a good many other goods. Mrs. Garrett went in to see them, she says he has the highest price for everything. . . . It has been some time since Mary had done any weaving, she has a severe bone felon on her finger, but I think it now is getting well. Grayson cut it open twice. I have had Souvenia spinning for some time. Jane cooks in her place four days in the week, she spins faster than any of the others. (P. 135)

I gave twenty-one dollars for one coffee pot and four tin cups, gave ten dollars for a quire of paper, a sheet of which I am writing on now. . . . Mr. Caldwell has goods such as I would like to buy but his prices are too high, one hundred dollars for a calico dress,——— from five to seven dollars. (P. 139)

I have woven two hundred fifty yards of cloth. Would have had more but for the bone felon on Mary's finger and the cold weather.

The children's next aprons and dresses must come out of the loom. I have enough calico to make them all one dress a piece that must be saved for Sunday wear. Their dresses ought to be woven before very long as their old ones are wearing out. (P. 140)

In the 1930s during the Depression, a WPA group was authorized to interview former slaves about their lives in the South. This interview with Silvia King, a former slave who had been abducted from Africa by slave traders and ended her days in the cotton-growing Brazos bottom-lands in Marlin, Texas, was first published in 1941 in dialect in *The American Slave: A Composite Autobiography*. "Dere was spinnin' and weavin' cabins, long, with a chimney in each end. Us women spins all de thread and weaves cloth for everybody, de white folks, too. I's de cook, but times I hit de spinnin' loom and wheel fairly good. Us bleach de cloth and dyes it with barks . . . On de cold winter night I's sot many a time spinnin' with two threads, one in each hand and one my feets on de wheel and de baby sleepin' on my lap" (IV, 292–293).

In *Texas Folk Art*, Cecilia Steinfeldt points out: "Isolation nurtured self-direction, self-discipline, and ingenuity. Able to wrest a living from the land, those Texans were just as successful at fulfilling their own needs for self-expression. This situation produced a wealth of naïve, untutored artists who worked primarily to please themselves" (p. 9). Whether the farm and ranch women were working to please themselves or working to warm their families is debatable even today when quilts are widely accepted as textile art. But that they felt no obligation to adhere to traditional color schemes, that they felt free to combine whatever they had on hand as attractively as possible—even if it meant having brown leaves on blue flowers—that they saw their surroundings stripped of extraneous detail, just as their lives were, and reduced to the bare essentials of their environment—the rattlesnake, the Texas sun, the windmill, the log cabin, the schoolhouse—cannot be refuted.

Vitality, energy, and determination all pour out of these Texas women's brilliantly colored works. The shades of the sun, the land, the blue of hundreds of miles of open sky, the orange of the Indian paintbrush—these are the colors of the Texas quilter's palette. With them she created striking quilts that have lived long past her own lifetime and still bring joy to other generations.

Home-dyeing was an important part of the frontier woman's life. Handwoven linen came off the loom a dark gray; cotton ended up a pale beige—neither was white or brightly colored. That came with bleaching and dyeing. Prior to 1856 and the introduction of aniline dyes from Germany, women had to rely on natural dyes produced from bark, berries, roots, and leaves and

used various mordants to "set" the color in the dye-resistant cotton.

In Texas, blackjack oaks, sumac, pokeberries, and agarita bushes were used in dyeing. Agarita berries "make the prettiest yellow color you ever did see," recalls Minnie Glaeser, our great-aunt and long-time Texas quilter from the Sabinal area. The settlers were dependent on the growing seasons for their dyes, for natural dyes did not store well. "Recipe books" for dyes were kept, too. Sara Hinton of Houston owns a stunning Star of Bethlehem Medallion quilt made entirely of hand-dyed fabrics for which the family once had every recipe.

Blue dyes came from the leaves of the indigo plant, which grew in many locations in the South. Browns were produced from the bark of butternut, black walnut, hemlock, and maple trees. As explained in Rita Adrosko's landmark book on home dyeing, *Natural Dyes and Home Dyeing*, "standard procedures for dyeing with bark called for stripping it from the trees, chopping it into fine pieces, and boiling it," creating a "bark soup" to which other ingredients could be added, depending on the color needed.

A soft red or terra-cotta color was found to be produced by clay dyeing using the red clay that is found in a band across the Southern United States reaching from South Carolina through East Texas. (See page 42 for a more thorough discussion of red clay dyeing.) To produce certain colors, dyes had to be mixed, and the women moving west had to learn the right combinations or risk ruining a batch of cloth that would have to be used anyway, ugly or not. Emma Caroll Seegmiller, recalling her youth (in Alexis de Tocqueville's classic *Journey to America*), remembered seeing large dye pots of indigo, steeping wild greasewood to make a good yellow dye, and mixing the two to produce a pretty green.

In the *Indianola Scrap Book*, Eudora Moore writes of the Yankee occupation in 1863 of this small coastal town now washed away by too many terrible hurricanes: "After the Yankees left, a great deal of castoff clothing was found. Mother boiled it in lye water, rinsed it thoroughly and dyed it with pomegranate rinds or pecan hulls and made it into clothes for the boys" (p. 104). For years after the aniline dyes became widely available, the old natural dyes continued to be used side by side with the new ones. However, by the end of the nineteenth century, most home-dyeing in America had ceased, even in Texas. The only exceptions were the mountainous and rural areas of the southeastern quarter of the country where traditional methods survived far from the mainstream of American life.

When World War I disrupted the export of the aniline dyes from Germany, the United States suffered a "dye famine" that jolted American chemical manufacturers into developing dyes to be manufactured in this country. "Fabrics dyed in the U.S. during the first part of the war often lost their color in the first laundering," reports Verla Birrell in *The Textile Arts* (p. 380). And they continued to fade. However, American dye companies corrected this condition after World War I when they were issued licenses to use dye patents formerly held by the enemy. By 1919, 4,500 basic German patents on drugs and dyes had been licensed to allow the manufacture of vat dyes and dyes of faster colors. This almost guaranteed the obsolescence of home dyeing. The one exception to that general rule was the home dyeing of the small cotton sacks that tobacco was sold in between 1925 and 1935. During the Depression, these sacks were saved by many Texas women until they had enough to piece together a simple quilt. They carefully ripped the seams of the sacks to make them into rectangles, then washed and dyed the sacks, ironed them, and pieced them together into a quilt. One such quilt found in South Texas was made of Bull Durham sacks dyed red and blue to resemble a flag.

Unfortunately, it is not always easy to distinguish home-manufactured textiles from store-bought ones. Homespun is often unrecognizable to one unfamiliar with the differences in textiles, because there are both very fine and very coarse grades of homespun and because some manufactured goods have the textured, slubbed quality of homespun. Nor is it easy to distinguish home-dyed fabrics, particularly when some of the aniline dyes themselves were not fast and they faded and blotched much the same way that nonfast natural dyes would.

In Texas, an entire quilting culture grew up around cotton, not surprising in the state that at present produces 35 percent of all the cotton grown in the United States. For more than a century, cotton has been a major crop in Texas, and, since 1880, Texas has annually led all the states in cotton production with an average of almost 4 million bales a year.

18

The stories of chopping cotton, picking cotton, hoeing cotton, and carding cotton are legion in the state. Many of the experienced quilters who have passed their half-century marks clearly remember childhood on a cotton farm. They can quickly demonstrate how cotton was carded by hand and remember all too well that their mothers required them to card the cotton to an exact, specific thickness so that all of the finished batting would be the same and would not be lumpy. To card cotton by hand requires the use of a pair of cotton cards with wire-like "teeth." The cotton is combed through these teeth to fluff it up, even out its thickness, and remove any lumps or seeds that remain after the ginning process. Many Texas farms had their own cotton gins on the premises; there is even a Cotton Gin, Texas, located in the Cotton Belt that sweeps across the state. One Victoria area quilter who quilted during the Depression remembers making a Butterfly quilt from cotton she picked, took to the gin herself, and carded by hand. Our great-grandmother, who lived on an eleven-hundred-acre cotton farm near Sabinal, always insisted that the men set aside a bale for her quilts each time the cotton was picked. She then put her thirteen children to work carding the cotton so that she'd always have batting ready when she put a quilt in the frame.

Norma Buferd captured life in the Texas cotton country perfectly in *The Quilters*:

When it was cotton-pulling time, Mama and us girls would go out in the fields too. At that time we was just pulling cotton enough to fill the quilts. Now that turned out to be a good lesson learned because later in the depression, after I was married, I pulled cotton for money . . . Mama showed us how to pick the best cotton for the quilt batting. (P. 68)

Then at home we cleaned and carded the cotton, working it till it was flat like a soft cloud . . . Even the men used to like smoothing and pressing the cotton with their hands. When the pieces were carded into about one foot by five inches, we laid these side by side, slightly overlapping on the quilt backing until it was completely covered up. Then we put the pieced top on like a sandwich, and rolled the whole thing up until the quilting bee. (P. 71)

Mary Alma Perritt Blankenship settled on a cotton farm near Lubbock around 1902–1905, when the area was just developing. She tells her story in *The West Is for Us*, recounted in *Texas Tears and Texas Sunshine*: "We had plenty of time to be still and know God. He was our nearest neighbor. . . . There were times . . . when our loneliness would almost panic us . . . We . . . wondered if we were the only people inhabiting the earth. . . . Our rainy days in the winter were spent . . . carding cotton batts, quilting, patching, and tall tale swapping" (p. 252).

Spinning, weaving, dyeing, picking, and carding cotton—the tedious, back-breaking, bone-wearying drudgery of the Texas woman. Up until the late 1870s, the rural woman didn't have the option of easily purchasable fabric in town, at the settlement, or from traveling peddlers. What she had was self-reliance and courage. She learned early the wisdom in the old saying: "Use it up, wear it out, make it do, or do without."

To understand the ordeals involved with producing cloth at home, it helps to understand first just how scarce fabric was in early Texas. Farms and ranches were isolated, sometimes more than a day's ride from civilization. Months might go by with the woman of the family seeing no one but her husband and children. The man was sent to town for provisions and necessities; the woman made her peace with whatever he brought home. The effort required to get through each day meant that little energy was left for making trips to town, and town was a long, long way away for many women.

Because access to new fabric was neither easy nor inexpensive, Texas women often resorted to adornment of what they already had on hand: lavish embroidery on a Crazy quilt of coarse wool scraps, delicate appliqué embellishing a Dresden Plate quilt made of flowered feed sacks, fancy quilting on a tobacco sack coverlet, children's tiny hands and feet lovingly traced onto patchwork made of the meanest scraps, badly worn quilts taken apart to reuse the batting or the backing or to be used whole as linings for heavy quilts to use on Texas sleeping porches. All these were characteristic of the frugality that ruled the life of a Texas quilter, challenging her ability to create beauty from leftovers and discards.

"When women artists were allowed to follow their own creative impulses, their work ranged over an enormous area . . . Not knowing women were supposed to favor delicate lyrical design, they were free to do that . . . but also to work out the most precisely mathematical geometrics or strongly rhythmic natural forms. They made political, personal, religious, abstract and every other kind of art. Women quilt makers enjoyed this freedom only because their work was not even considered art, and so they were exempt from the harrassment experienced by most women artists.

"Left in peace, women succeeded on their own in building a design tradition so strong its influence has extended almost 400 years and which must today be acknowledged as The Great American Art."

QUILTS, THE GREAT AMERICAN ART

ONE HUNDRED YEARS OF TEXAS QUILTS

When we started the Texas Quilt Search, we were told by authorities not to expect many fine old quilts to come out of what had long been a frontier area. We were told that those quilts were limited to Eastern areas settled far earlier than the Lone Star State. We were warned not to be disappointed. After three years of research, thousands of miles of travel, and hundreds of hours interviewing quilt owners, we can say with certainty that Texas and Texans proved them wrong. Texas is a rich repository of treasures from the past, quilts with stories to tell that demonstrate their worth not only as art but also as a cultural record of a pioneer people.

Pictured here are sixty-two quilts either made in Texas prior to the state's Centennial in 1936 or brought to Texas before 1936. Because Texas actually started as a land dependent on migration to settle millions of empty acres of often hostile territory, it seemed unfair to exclude those quilts that, with their owners, had picked up stakes and "Gone To Texas" years ago. Just as the men and women from South Carolina, from Tennessee, from Kentucky, from Alabama put down roots and turned Texan, so can these quilts now claim long-term Texas residency.

Through the years a controversy has raged over the origin of the "Gone To Texas" phrase. For many years in the Texas public schools, students were taught that when a farm family had ex-

hausted their land elsewhere they would pack up everything they owned, abandon the old farm, scrawl "GTT" on their doors, and head for Texas with its promise of cheap fertile land and a new beginning. Their neighbors knew, when they came across the "GTT" scrawl, that the family would not be seen again.

However, Cecilia Steinfeldt, one of the guest curators for this project, presents another view of "Gone To Texas" in *Texas Folk Art*:

> At the time of the westward expansion, the initials G.T.T. acquired a special meaning. They stood for "Gone to Texas" and were usually associated with those unfortunate enough to have fallen afoul of the law—those more adventuresome spirits who dared to take advantage of the potential of a wild and untamed land. In 1884, Thomas Hughes wrote a book entitled G.T.T., where he observed: "When we want to say that it is all up with some fellow, we just say, 'G.T.T.,' as you'd say 'gone to the devil' or 'gone to the dogs.'" Certainly not all of the early Texas settlers could be considered lawless, but a common denominator of earthiness and arbitrariness became a sort of catalyst influential in the origin of the state's naïve art tradition. (P. 12)

Whatever their origins, all these quilts are now Texas quilts. They have been examined, studied, and documented. They were selected based on several criteria: first and most important, they were selected on visual impact; second, they were selected for their historical importance; and, third, they were selected on the basis of family documentation.

The result is a book that reflects the many stunning quilts in Texas. The title "Lone Stars" refers not to the traditional Lone Star quilt pattern, as many might expect. Instead, it was chosen to reflect the fact that each of these quilts is a star in its own right and that each of the quiltmakers was a lone artist. Working in isolation in many instances, working under often primitive conditions, working with frugality ever uppermost in their minds, working to leave behind a record of having lived, loved, and toiled, these quiltmakers succeeded in bequeathing something of value to the generations to come. "I reckon everybody wants to leave somethin' behind that'll last after they're dead and gone. It don't look like it's worthwhile to live unless you can do that" (Aunt Jane of Kentucky, ca. 1900, taken from *Anonymous Was a Woman*, p. 106).

LONE STARS

A Legacy of Texas Quilts,
1836–1936

MOSAIC STAR QUILT

43" × 49"
Cotton

ca. 1825

Quiltmaker Mary Hopkins Hayne.
Made in the Carolinas and brought to Cotton Gin,
Freestone County, in 1866.
Owned by Frances Grimes Yeargin.

THIS fragile little crib top, never quilted, was destined to be a Texas quilt although its origins are in North or South Carolina, for it was brought to Texas not once but twice, over a span of seven years. It is hand-pieced, of course, since it predates the sewing machine by about a quarter of a century, and it is constructed with one of the oldest known forms of patchwork, English-pieced hexagons. In English piecing, the hexagons are formed over paper templates, then whip-stitched together and the paper removed. Here the hexagons are joined to form stars.

In the four corners of the quilt top, cut-out bouquets of chintz flowers have been appliquéd using the eighteenth-century broderie perse technique, a method of appliqué in which motifs of a chintz print are carefully cut out, rearranged into a new design, and appliquéd down onto a background fabric. Three sides of the border consist of alternating squares and right triangles; the top border is a regular pattern of right triangles. Some of the stars are readily apparent; others, because of fading and deterioration, are not as well defined. Several stars are carefully centered with a single flower.

The fabrics used in this piece are primarily early nineteenth-century chintz, but they have lost their luster. These fabrics are particularly good examples of the 1825 period and provide definite clues to dating the piece. For example:

– The dull red is madder dye, not aniline; therefore the quilt is pre-1856, when aniline dyes were developed.

– Backgrounds of some of the printed fabrics are composed of tiny, almost indistinguishable dots with intricately detailed floral overprinting (note red and green prints in center of brown star); therefore, the quilt was made after 1815, when roller printing was developed.

– There are rainbow roller prints showing shading of color from dark to light with motifs printed on top of the shading (see azure blue print in upper-right corner of close-up). This indicates a date around 1825, by which time roller printing had been highly developed.

– Drab-style prints emphasizing yellow, buff, and brown, with no red or purple (see examples below brown star in close-up), are used, which points to 1800–1825.

– Designs are small in scale, printed in reds or greens resembling coral or seaweed on busy grounds (see rosy print to upper right and lower right of center star in close-up); roller printing and machine grounds were prevalent around 1825.

All these clues indicate a circa 1825 date.

Mary Hopkins Hayne, the great-great-great-grandmother of the owner of this crib top, lived between 1776 and 1856. She married her first husband, Dr. Isaac Hayne, the son of a Revolutionary War veteran, in 1793 while she was living in the Carolinas. Family history does not specify whether Mrs. Hayne lived in North or South Carolina, but based on the inclusion of some imported fabrics in her quilt top and the formality of her design, it seems likely that she may have lived near Charleston, South Carolina. The family would have had easier access to imported goods brought by ship to a Southern port, and the Charleston area is known for its chintz appliqué quilts.

Mrs. Hayne had her last child in 1802. Allowing approximately twenty-two years per generation, which is an accepted norm for quilt dating since women married and started families so early, it is quite possible that her granddaughter, Eliza Fannie Parks, could have been born in 1825. This would coincide with the approximate date of the crib quilt.

Eliza Fannie's daughter, Frances Crockett McKenzie, moved to Texas with her parents in 1866, leaving the war-ravaged Carolinas and bringing the cradle top with her. They came by way of sailing vessel from Mobile to Galveston and traveled by wagon to Cotton Gin, Texas, in Freestone County. Frances moved to Alabama in 1878 after her father died, and she took the quilt with her. There she married a member of the Johnson family in 1885. The couple moved back to Texas in 1885 and brought the quilt with them on its second trip to Texas. They settled in Navasota in Grimes County. The quilt that was destined for Texas has remained in the Lone Star State ever since.

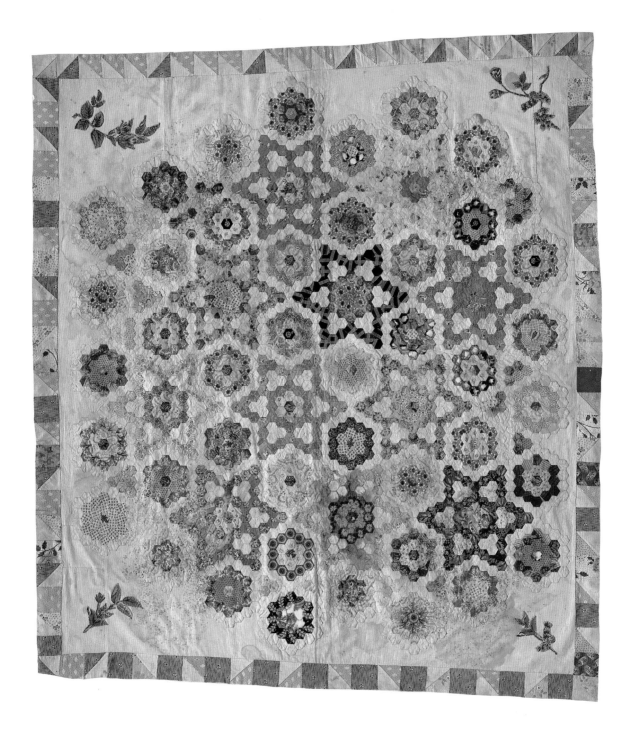

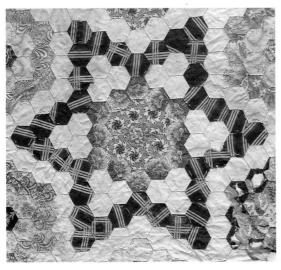

RISING SUN QUILT

100″ × 88″
Cotton

ca.1825

Quiltmaker Mrs. Josiah Barrow.
Made in Alabama and brought to Hillsboro, Hill County, in 1900.
Owned by Mary Paul Gibson Braswell.

FASCINATING fabrics, probably imported, an unusual and complex pattern, and the addition of a row of half-suns to adorn the pillows at the head of the bed make this an extraordinary hand-pieced quilt.

Rising Sun or Georgetown Circle are the names most often given for this pattern. According to *Romance of the Patchwork Quilt in America*, "Rising Sun is an intricate pattern but not enough so to daunt the quilter who aspires to a design both beautiful and unusual. There are several variations of the Rising Sun both pieced and appliquéd" (p. 79).

This is a disciplined yet harmonious quilt. Its twelve hand-pieced red, green, and white whirling disks and four half-disks are edged with tiny red and yellow triangles and are contained within the strong grid of the green set, creating an impression of controlled circular movement.

Quiltmakers were delighted when textile manufacturers developed the capacity to print small flowered calicoes like these because they provided variety for their piecing. This quilt would be far less complex and rich if the colored prints had been solids, or if they had been large florals. In the red calico, the black design is beginning to deteriorate, an inevitable and irreversible process that is caused by its dye.

Rising Sun is beautifully quilted, with tiny baskets of flowers and floral vines in the white muslin corners of each block. The quilter carefully changed thread when quilting the green borders and sashing, so that the color of the thread wouldn't compete with the pattern. This is called contrast quilting because the colored stitches stand out when the white back of the quilt is viewed.

The quilt is backed with homespun cotton, a fact confirmed by the great-great-great-granddaughter of its maker, its present owner, who also noted that the batting is cotton the maker had hand-carded. In the rural South, hand-carding of cotton, home spinning, weaving, and dyeing were not unknown even as late as the 1930s.

Mrs. Barrow passed her Rising Sun on to her daughter, Harriet E. Barrow Gray, who gave it to her daughter, Mattie E. Gray Gibson. Mrs. Gibson brought it to Hillsboro in 1900 and left it to her son, Paul, in 1918. He, in turn, left the quilt to his son, Derwood Reginald Gibson, in 1965. Upon D. R. Gibson's death in 1973, his daughter, Mary Paul Gibson Braswell, inherited the Rising Sun.

BASKET OF FLOWERS CHINTZ APPLIQUÉ QUILT

87″ × 87″
Cotton

Started 1828, *finished* 1868

Quiltmaker Mary Ridley Mims Prothro.
Quilted in Wallings Ferry, Gregg County.
Owned by Ruth Eleanor Young Huddle.

DELICATE, graceful, and formal, this highly balanced chintz appliqué quilt is constructed using the eighteenth-century technique known as broderie perse. This method allowed the most frugal use of fabric because out of only a small amount—one yard, for example—could come all the appliqué motifs for a full quilt and the fabric could be cut to best advantage without waste. This was especially important in the case of scarce, expensive, often imported chintz. The method itself gave birth to the slang term "chintzy," meaning tight-fisted or cheap.

At first glance, the appliquéd shapes surrounding the basket of flowering branches seem to be random; upon closer study, it is clear that the eight largest shapes are mirror images of each other, cut from folded fabric. The four mid-sized shapes are a perfect match, and the remaining four smaller motifs were cut freehand from the few remaining scraps. Only the smallest pieces were left, and these were used to form the basket.

In this quilt, flowering branches of a printed chintz have been cut out as units and appliquéd down in general outlines, a departure from the eighteenth-century method of cutting the design out exactly by the printed lines and very carefully rearranging the stems, blooms, and leaves before appliquéing. A few examples of the more complex method of broderie perse can be seen, most easily in the blooms appliquéd over the basket.

This serene, uncluttered quilt is quilted in a charming chain effect connected vertically with curves that resemble the curve of a teacup or of clamshell quilting. The quilting is very fine, as is the blindstitch appliqué work. The blindstitch was most commonly used after 1800; in the eighteenth century, a fine buttonhole stitch was often used for appliqué.

The basket is formed from narrow strips of chintz appliquéd in the proper shape. The damage visible at the base of the basket is caused from the iron tennate used as a mordant for the black and dark brown dyes in the print. Over the years, the iron tennate slowly eats away at the fabric, until all of the dark outlines and shapes disintegrate along the exact lines that were originally printed. Although this quilt is in exceptionally good condition for its age, the brown calico used for the binding is fragile and beginning to shatter.

Mary Ridley Mims Prothro of Edgefield, South Carolina, the great-great-grandmother of the present owner of the quilt, was born in 1804, married in 1824, and died in 1889. She began the appliqué in 1828, when her daughter Emily Ann Prothro was only three weeks old. At the time, the family was living in Georgia; in 1836, they moved to Randolph County, Alabama. The top was put aside at some point during the moves.

In 1844, before the Republic of Texas became the twenty-eighth state, the Prothro family moved to Rusk County, Texas, now part of Gregg County. In 1868, on Emily Ann Prothro McPherson's fortieth birthday, three generations of Prothro women quilted the chintz quilt.

In 1870, the family moved to Hallsville, in Harrison County, where they built a home that stood more than one hundred years. There were nine children in the Prothro family; six generations are buried in the Hallsville Cemetery. Much of their plantation land is now covered by Lake Cherokee. The quilt owner was thirteen years old when she first saw the quilt after her grandmother's death in 1927. It was left to her aunt, who in turn handed it down to her as a symbol of the perseverance of the women in her family.

An interesting coincidence: Out of more than three thousand families in Texas whose quilts were documented, two chosen for this book each lost close kin at the Battle of Mansfield, also known as the Battle of Sabine Crossing, during the Civil War: the Prothros lost a son, and Harriett McDavid, who made the Ark and Dove quilt, lost her husband.

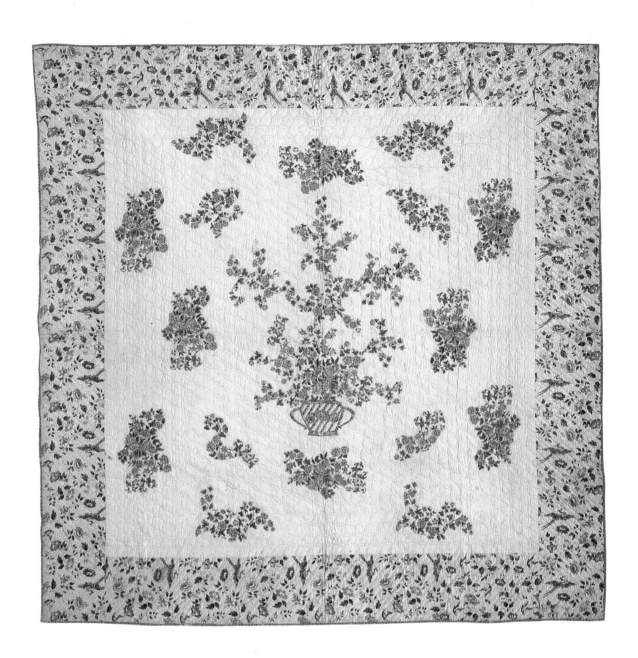

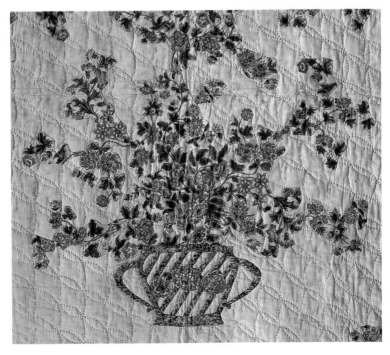

LOTUS FLOWER QUILT

86½″ × 101″
Cotton

ca. 1835 *(original design)*

Quiltmaker unknown.
Made in Bagwell area, Red River County.
Owned by Ruby Mars.

AN EXCEPTIONALLY large hand-appliquéd quilt containing formal design elements found in quilts and needlework through centuries, this quilt is a naïve interpretation of the Lotus Flower. There is an Egyptian inspiration for the Lotus Flower quilt design and, though it and a companion design, the Lotus Bud, were uncommon, they are sometimes found alternately in the same quilt.

According to *Pieced Work & Appliqué Quilts at Shelburne Museum*, symbols played an important part in nineteenth-century quilt designs: "It is strange therefore to find a representation of the lotus flower used as a quilt pattern, for in old legends, the fruit of the lotus was fabled to cause forgetfulness of care and create a state of indolence. Such character traits would never have been tolerated as acceptable social behavior in the 19th century" (p. 57). References to dreamy "lotus [or lotos] eaters" crop up in literature from Homer to Tennyson.

Virtually the same type of elongated, drooping flowering tree growing from a disproportionately small pot can be found pictured in a decorative cotton hand towel worked by Elisaeet Rauch in Pennsylvania between 1800 and 1850 in the book *Plain & Fancy: American Women and Their Needlework, 1700–1850*, by Susan Burrows Swan.

The hand quilting on this quilt is as integral and important to its look as is its appliqué, for it is worked in closely spaced diagonal rows of quilting about one-quarter of an inch apart, which add textural interest. The center portion of the quilt is embellished with a decorative vining feather quilting design, which is repeated in the borders. All have a variation of the Lotus Flower between the feathers. Ripple quilting, where the quilting stitch follows the outline of the design element, is also used to fill in the borders.

Knots on the back of the quilt, sometimes less than three inches apart, could indicate one of two things. Either the quilter didn't know about hiding her knots by "popping" them into the batting layer of the quilt, a highly unlikely prospect from a woman who put as much quilting as this into her work, or she was working with recycled thread of such short lengths that she was unable to hide her knots. This is certainly in keeping with the "waste not, want not" philosophy of quilters, who were some of the very earliest recyclers. *Quilts in America* quotes an 1865 diary entry that discusses removing temporary basting threads and winding them on a spool for reuse. It also discusses Martha Washington's frugality, which included unraveling her worn gowns and fabric scraps, winding them on bobbins, and reweaving them into chair and cushion covers.

The present owner of this quilt, Ruby Mars, knows only that the quiltmaker was her great-grandmother and that she made the quilt about the time Red River County, in the northeastern corner of Texas on the border with Oklahoma, was organized in 1837. She probably lived in what is now the tiny town of Bagwell, as Mrs. Mars' grandfather, who fought in the Civil War, was a blacksmith in Bagwell when he died about 1922. His daughter inherited the quilt and it was passed upon her death to her niece, Mrs. Mars.

LOVE APPLE QUILT

98″ × 82½″
Cotton

1849 *(dated)*

Quiltmaker Ambrosia Jane Smith Perrin.
Made in Chillicothe, Missouri, and brought to
Waco, McLennan County, in 1898.
Owned by Kathryn Simms Sprecher.

THE LOVE APPLE, or tomato, was thought to be poisonous and not edible prior to 1850, but the plants were grown for their bright red fruit as ornamentals in many flower gardens. This design is frequently used because it allows space for extremely ornate quilting, which is exemplified in this quilt.

Made as a marriage quilt in 1849, the date that is embroidered on the back along with the initials of the maker, this Love Apple owes as much of its beauty to its quilting as it does to the elaborately hand-pieced and hand-appliquéd blocks and border. It is quilted with single hearts and double hearts, which form a butterfly with heart-shaped wings, as well as with leaves from plants. The quiltmaker has quilted a small pair of embroidery scissors in the bottom border just above the third flower from the left corner.

The elaborate border of small-scale Love Apples provides a spectacular frame for the quilt; it is actually more intricate than the sixteen single-blossom blocks and is perfectly planned to turn the corners without a break. The quiltmaker has added the extra leaves around each flower to reflect more accurately the way the tomato blossom is surrounded with greenery. The quilt, which is in pristine condition, is very flat, indicating that a thin batting was used to allow the quiltmaker to showcase her exceptionally fine quilting stitches.

A girl pieced tops together for many years before her marriage. Her wedding quilt or engagement quilt was her "masterpiece," taken from the male guild custom of requiring a masterpiece before an apprentice could achieve the status of "master." This emphasis on producing a masterpiece before marriage was particularly appropriate, since marriage was virtually a woman's only option for employment until the twentieth century. Tradition called for a girl to complete at least thirteen quilts before her wedding—the thirteenth was her bride's quilt. It was often all white, usually stitched with hearts, as is this one, and exemplified her very best work. Notice how carefully the vine in this quilt is constructed so that it presents an unbroken, lushly curving line. Had the line been broken, quilting tradition foretold a short, unhappy life for either the maker or the marriage.

When a girl was ready to marry, she held a quilting bee to quilt the tops in her hope chest. This was often the announcement of her engagement, and all the women of the community were invited to quilt. The tops may have been made much earlier, when the bride was learning to sew, but they were saved until she was ready to marry because the batting and backing were the only real expenses involved in the quilt.

This tradition of marrying with thirteen quilts continued in our immediate family as late as 1934, when Jewel Pearce Patterson married in San Antonio, bringing with her thirteen quilts that she and her family had made for her wedding. She married C. C. "Pat" Patterson from Gilmer, Texas, whose mother, convinced that "idle hands are the Devil's workshop," had made each of her two sons thirteen quilts for their own hope chests. In doing so, Myrtle Patterson was carrying on a nineteenth-century tradition best explained in *Folk Art of Rural Pennsylvania*, a 1946 book by Frances Lichten:

> *Part of the entertainment provided for the feminine guests at a girl's wedding was to display the quilts and coverlets she had made, the visible proof of her accomplishments as a needlewoman, but the bridegroom also brought to the new establishment certain amounts of similar gear as a contribution of his own family. Though perhaps somewhat lacking in fancy, and in the intricate stitchery of twin hearts which the bride-to-be dreamily lavished on her best quilts, the dowry gift of quilts and coverlets furnished by the bridegroom's mother represented a tradition which was likewise never ignored. They too were always exhibited before the appraising eyes of the feminine wedding guests, equally expert needlewomen. (P. 172)*

Ambrosia Jane Smith Perrin was the maternal grandmother of the owner of this splendid Love Apple quilt. She was only seventeen when she made the quilt for her wedding to Cary Allen Perrin in 1849. The Perrins moved to Texas in 1898 and settled first in Dallas, then in Waco. They had nine children, although only three lived past childhood. According to family history, Cary Perrin drafted the pattern for his fiancée's quilt and also drew the unusually beautiful quilting patterns.

TRAPUNTO QUILT

75″ × 77″
Cotton

ca. 1850

Quiltmaker unknown but related to the Meeks family.
Made in West Virginia and brought to Texas around 1900.
Owned by Sue Colly Kreidler.

A SPLENDID example of early trapunto white-work quilt, this piece is formally designed around a center medallion, reminiscent of eighteenth-century quilts. The medallion is surrounded with an interlocking detailed feather chain. The outer border consists of an elaborately scrolled feather design, lushly curved to turn the corners perfectly, the mark of a master quilter. Other details of the quilt include delicate leaves, sunflowers, bluebells, and pineapples, one of the symbols of hospitality. The magnificent stipple quilting, very close stitching that flattens the background around the designs, creates another dimension to the quilt. Handmade knotted fringe surrounds the quilt on three sides, an early alternative to binding.

One of the best discussions of stuffed-work quilts can be found in Patsy Orlofsky's out-of-print book, *Quilts in America*:

The effect of stuffing is to raise the design above the surface and provide it with a three-dimensional quality. It was done from the back of the quilt, which was usually a loosely woven material. This enabled the quilter to separate the loosely woven threads with a stiletto or bodkin and force in bits of cotton or wool until a thick padded effect was achieved in a leaf or petal or grape. Then the threads were pushed or scratched back together again, closing up the hole. After the quilt was washed there would be no evidence of the separation. Some quilters made a tiny slit in the back, then pushed in the stuffing, and then neatly sewed up the slit. However, this was a later practice and considered taboo by the expert quilters, because it violated their rule of thumb that the back should be as nearly indistinguishable from the front as possible. The old-timers prided themselves on being the only ones to discern which had been the underneath side in the frames and which had been the top. There are many examples of stuffing in high relief on a background of very tight stippled or thimble quilting. In these instances, when there is quilting, the stuffing is done after the quilting has been completed. (P. 186)

Many trapunto and white-work quilts are quilted so finely that they contain more than a million stitches. The quiltmaker who attempted a white-work quilt was creating a purely decorative object; she was every bit as much an artist with her needle as any painter of the period with oils and brushes. Trapunto work actually originated in Italy.

The designs on this white-work quilt show no evidence of marking and may have been drawn on with a needle and quilted before the needle line faded, a method often used in the eighteenth century and early nineteenth century and even in the twentieth century by quiltmakers in the hills of West Virginia and Tennessee.

As Orlofsky reports:

The choice of a technique for marking the quilt was an important one, because in many cases the needleworker, especially when she had a very fine heirloom quilt in her mind's eye, had no intention of washing her quilt even once—and certainly not if it wasn't dirty. So the marking medium, if possible, had to be immediately fugitive. It was for this reason that the really finicky quilters would scratch closely around the template with a sewing, rug, or yarn needle or similar instrument, holding it almost parallel to the work surface with a slight but steady pressure kept on the pointed end. When the template was removed, the scratched line showed clearly enough to be seen, and this indentation would last, it was hoped, until the sewing was finished. (Pp. 138–139)

Entire sets of tin teardrop-shaped templates made by hand in graduated sizes and fitted into their own teardrop-shaped tin case have been discovered (one is in the collection of one of our mothers), and it is thought that these could be pressed down hard enough to leave a lasting impression for quilting without having to mark up the quilt with pencil lines.

Little is known about the maker of this magnificent quilt. Her great-grandson, a Mr. Meeks, brought it to the Rio Grande Valley area around 1900. It was sold at an estate sale and purchased by the owner, along with the quiltmaker's wedding dress and a navy wool bathing suit complete with bloomers and a sailor collar. "I couldn't believe they were selling this quilt, especially since their grown daughter was at the sale. She just wasn't interested," stated the owner.

BLEEDING HEART QUILT

102″ × 86″
Cotton

ca. 1850

Quiltmaker Elizabeth Winfrey Harrison Denton Beck.
Made in Clinton County, Kentucky, and brought to
Paris, Lamar County, in 1879.
Owned by Ollie Beck Jarvis.

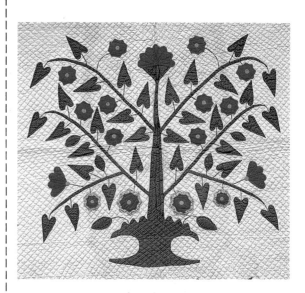

THIS early quilt, called Bleeding Heart because its heart-shaped leaves resemble the plant of the same name, is a variation of the flowering tree, or Tree of Life, motif found in Oriental rugs, in Indian palampores, and in other forms of needlework showing Eastern influence.

Trees have always had religious significance, from the age of the ancient Greeks, who believed they were inhabited by dryads or demigods, to the age of Christianity. To Christians, the tree at various times has stood for the tree in the Garden of Eden, for life everlasting if evergreen, for the Resurrection if deciduous, and also for the Cross representing the Fall and the Redemption. It is interesting to compare this relatively sophisticated Tree of Life variation to the more naïve one on page 77.

An exceptional hand-appliquéd quilt, the Bleeding Heart is in extremely good condition for its age. The brown lines that are visible are due to the quilt or a portion of it being wet and the water evaporating slowly. It is made of red and green cotton on a white muslin ground. The red is a pink-red typical of the 1850s, and the green is a dark, colorfast green from the late 1840s. The binding method used was popular in the second and third quarters of the nineteenth century and consisted of inserting piping (in this case red) between the quilt top and the backing, which was brought around, folded, and stitched. The quilt is heavily and closely quilted by hand in an allover crosshatch pattern forming a half-inch grid. Instead of signing her quilt with a cross-stitch name or using a stencil especially made for her, this quiltmaker has chosen a much more subtle method of leaving her mark for years to come. Very carefully and deliberately, she has quilted over the crosshatching in one place with her own personal symbol, clamshells. There is no other reason for this intrusion into her perfect quilting except that she was leaving a message.

Mrs. Jarvis said that her grandmother quilted the Bleeding Heart for her trousseau. "It was so beautifully made no one could have done it with little ones underfoot," she said.

Quiltmaker Elizabeth Winfrey Harrison Denton Beck was born in 1829 and died in 1871 at forty-two, leaving an infant daughter less than a year old and two other daughters and two sons by her second husband, the Reverend Francis E. Beck. She also left one son and one daughter from her first marriage, to Isaac Roberson Denton.

The Reverend Beck raised his children alone, migrating with them from Kentucky to Paris, Lamar County, in 1879. His and Elizabeth's fourth child, Charley Clinton Beck, later moved with his wife and four daughters from Paris to Hanford County in May 1903, after which two sons and another daughter, the Bleeding Heart's present owner, Ollie Beck Jarvis, were born.

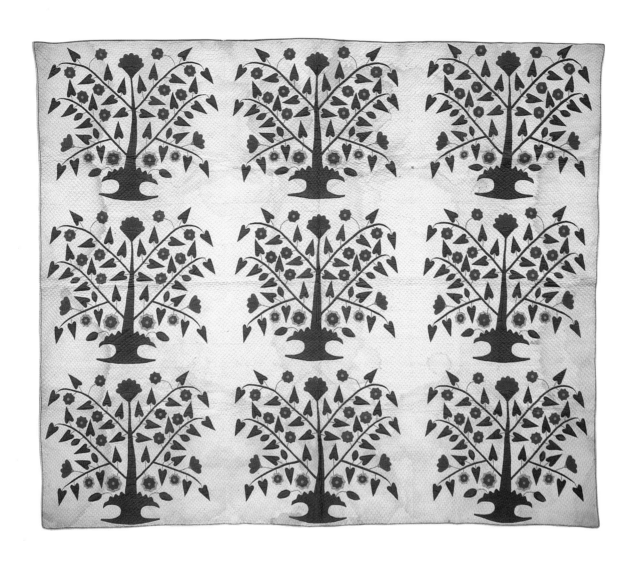

DOUBLE IRISH CHAIN QUILT

69″ × 74″
Cotton

1854 *(dated)*

Quiltmaker Harriet Sophia Fyler Spicer.
Made in Amboy, New York, and brought to San
Benito, Cameron County, in 1910.
Owned by Jean Brady Fox.

A BEAUTIFUL quilt with all elements in perfect harmony, this Double Irish Chain with eight-pointed stars has the look of early indigo-and-white woven coverlets. Such woven coverlets were primarily produced in the northeastern states, and the similarity between the coverlets and this quilt is both striking and not surprising since the quiltmaker was also a weaver in New York.

The same design sensibility that produced woven coverlets produced this crisp and orderly quilt. It is organized just as many coverlets were, with an allover design bordered on three sides, the lower two corners marked by a design element or signature blocks.

It most closely resembles a double-weave jacquard coverlet called Medallion with Rose Tree and Picket Fence border in indigo and white, which was made in Jefferson County, New York, in 1842 and which is pictured in *America's Quilts and Coverlets*. Perhaps Harriet Spicer, the maker of this quilt, was influenced by or even herself wove similar coverlets. It also somewhat resembles a better known style, the Snowball coverlet with Pine Tree border.

In this quilt, the allover design is a hand-pieced Double Irish Chain in an indigo print, with hand-pieced eight-pointed indigo print stars in the counterpane areas. The intricate border consists of hand-appliquéd fenceposts with embroidered pickets and what appear to be bold hand-pieced palm trees, a happy coincidence since the quilt's current home is the Rio Grande Valley. Undoubtedly, however, they were meant to be the rose trees or oak trees more typical of coverlets. Either way, they make a strong frame for the central design.

There is a stylized cartouche in each bottom corner, and the quilt is simply quilted by the piece and bound with the same indigo print cut out of the straight grain.

The quiltmaker, Harriet Sophia Fyler Spicer, was born in 1820 in Sullivan, New York, lived for a time in Wisconsin, and had three children. This was a "presentation quilt" begun before the birth of her firstborn and completed two years after his arrival.

Cross-stitched into the corners of the quilt in red are these inscriptions: "Patience, Industry, Economy, Prudence, Ingenuity, Encouraged" and "Presented to William Porter Spicer / by his mother, Harriet S F Spicer / April 1st 1854."

Mrs. Spicer had a "tragic marriage," according to her descendants. She separated from her husband and returned to Amboy, New York, to a life of poverty, supporting herself by quilting, spinning, and weaving for others. She died in 1879 at the age of fifty-nine.

The son for whom this quilt was made never married. William Porter Spicer, known to his relatives as "Uncle Port," homesteaded with this quilt in South Dakota during the 1880s and came to South Texas in 1910 with a land party to develop the Rio Grande Valley, bringing his quilt with him. The year after his arrival, he died in the influenza epidemic of 1914. The quilt passed to his brother, the grandfather of its present owner, Jean Brady Fox.

According to Mrs. Fox, her great-grandmother called the quilt "Pennsylvania around the Square," although no one knew why. Mrs. Fox has inherited other examples of her ancestor's needle art in addition to this quilt, including embroidery, hemstitching, knitting, crocheting, and white work on all kinds of clothing and household items.

Harriet Sophia Fyler Spicer

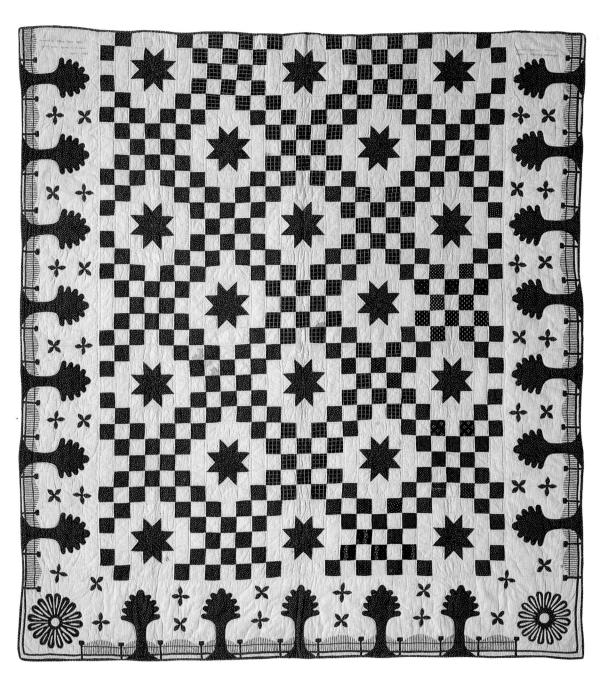

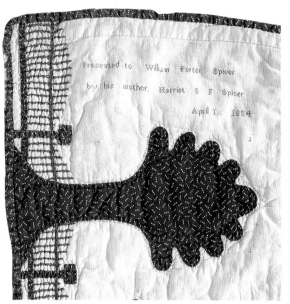

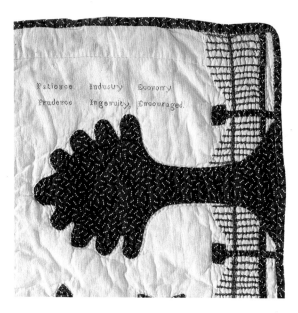

PRAIRIE FLOWER QUILT

93″ × 99″
Cotton

1855 *(dated February 10, 1855)*

Quiltmaker Jane Shelby.
Made near Daingerfield, Morris County.
Owned by Zue Connor Gibbons.

NINE graceful urns of flowers on this hand-appliquéd and quilted Prairie Flower quilt give an initial illusion of perfect symmetry that is altered when one examines its elements individually.

Each of the trios of flowers has a naïve quality echoed in the somewhat primitive handles of the urns from which they spring. The buds of the central rose are pieced similarly to the Rose of LeMoyne or Mrs. Harris' Colonial Rose and emerge from a single branch of leaves that form a candelabra.

The vine adds a wonderful decorative effect to the quilt and is unique in that the quiltmaker chose not to have the sashing vines grow equidistant toward the center row of floral urns, but instead had one vine grow across two-thirds of the quilt, another across only one-third. This apparently was a conscious decision on the part of the maker since all the vining was appliquéd in a number of equal lengths, then assembled for the sashing and border.

The quilt is quilted in an allover grid pattern in the white muslin and outline quilted in the urns, leaves, and stems. Contrast quilting, where the green vines, stems, and leaves were quilted in matching green thread, is easily seen on the quilt backing. This quilting gives an unusual textural effect to the greens.

It's likely that the outer petals of the roses were once a different color, probably a green, and have faded to the pale tan we see today.

This beautiful pattern is also known as the Missouri Rose and Rose Tree, as well as Prairie Flower. The maker named her original variation of the design Mississippi Beauty, as that was her home state. On the back of the quilt is an inscription in ink on a muslin rectangle:

The quiltmaker, housekeeper for Judith Connor's bachelor brother-in-law, William Mayo Connor, came with him to the Daingerfield area in 1857. The present owner of the quilt, Zue Connor Gibbons, the great-granddaughter of Judith Connor, is unsure if the "persentation" date on the quilt is accurate. She acquired the quilt around 1940, in a drawing for family treasures.

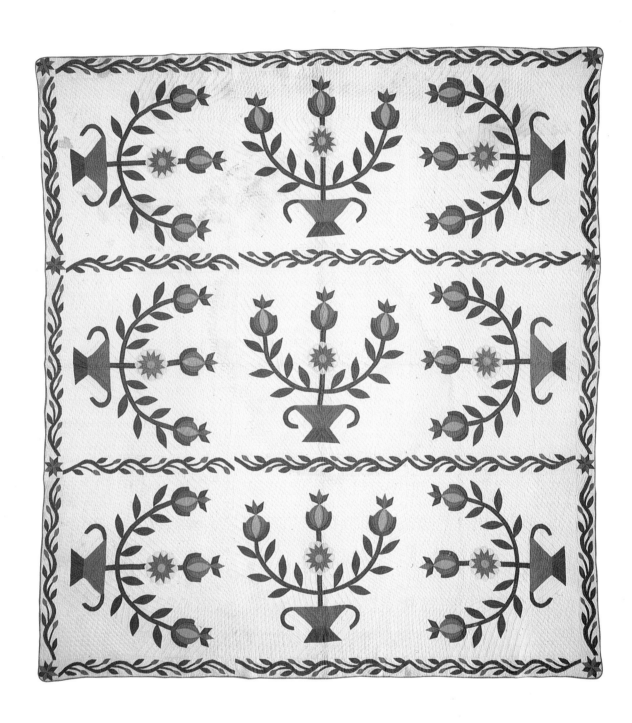

WHIG'S DEFEAT QUILT

74" × 80"
Cotton

ca. 1855

Quiltmaker Gail C. Worden.
Pieced in Georgia and quilted in Whitewright,
Grayson County.
Owned by Anne Long Tuley.

WARM terra-cotta centers in this beautiful old hand-pieced quilt design called Whig's Defeat are its most unusual aspect. The pattern, also known as Sunflower, Broken Circle, and Indian Summer, is one of several quilt designs containing a political commentary.

Around 1840, a political dispute arose over a lovely quilt pattern, called by one party the Whig Rose and by another the Democrat Rose. When Democrat James K. Polk was elected president over Whig Henry Clay in 1844, however, a new quilt pattern, Whig's Defeat, was designed, which put an effective end to the contention. This particular Whig's Defeat incorporates imported fabrics, most notably the green print that is used for the background fabric and the diamonds in the sashing. But it is the unusual solid rosy beige fabric that makes this quilt so special. This color was likely obtained from home dyeing with the red clay so abundant in the quiltmaker's home state of Georgia. Home dyeing continued for generations in the South after the Civil War, far longer than previously suspected, and the solid fabric in this quilt in 1855 would have been home dyed more often than "store bought."

A band of red clay deposits runs from South Carolina around through many of the Southern states into East Texas, and folklore has had it that the clay was often used for dyeing, although there was little documented evidence of such activities. In researching this book, we found several references and many personal recollections about clay dyeing and, in *Vegetable Dyeing*, by Alma Lesch, published in 1970, a set of instructions for dyeing fibers with natural substances, including clay. Lesch offers a recipe for dyeing wool or cotton using terra-cotta clay, a reddish clay used by potters, to make a dye. She indicates that various clays in a dyer's own area can be used to produce differing shades of brownish-orange.

An elderly black woman who attended the Nacogdoches Quilt Day remembered as a little girl going to a river near the old city to the "community dye-hole" and dyeing fabrics there. The method most frequently used was to bury fabric in the moist red mud until it was the desired shade. According to her, the longer the fabric was left, the redder it got, and all shades of red could be obtained because the clay was an excellent, fast dye. Her recollections were confirmed by Dr. James Corbin, the curator of the Stone Fort Museum in Nacogdoches, who indicated that

he'd ruined many white tee shirts and socks "stomping around in that red dirt" on field expeditions. A Mississippi-born Texas quilter, Wilma Hart Anderson, said she was often admonished not to play in the red clay "because it won't come out."

This quilt has nine nicely hand-pieced blocks set together with sashing of pieced diamonds, which are also used on two sides of the quilt. The other two sides have pieced triangles, and the quilt is finished with a narrow white binding. The quilting is a simple overall rainbow design.

The quiltmaker, Gail C. Worden, was born in 1840 in Georgia and married in 1855. Her quilt top was pieced for her wedding and was quilted when she arrived in Whitewright, Grayson County, Texas, in 1856, the year her first child was born.

"It is obvious it was quilted later and I can imagine that she quilted it and thought about home. The quilting is not as fine as the piecing and perhaps that was all she could manage with her pioneer role," said Anne Long Tuley, Mrs. Worden's great-great-granddaughter. Mrs. Tuley inherited the quilt from her great-grandmother, Josephine Worden Long, because of her interest in quilting. "I had never seen it before. It was definitely considered a 'special quilt' and used very little," she added.

Love of quilts and quilting was passed down in this family along with the Whig's Defeat. The present owner said her great-grandmother "was known to quilt with her neighbors many days as soon as they could 'clean up after breakfast,' and as long as they could. My father told me they had one friend who could not quilt to suit them and they tried to think of ways not to hurt her feelings but to keep her from quilting."

This was not uncommon. Patricia Mainardi, in *Feminism and Art History*, reprinting her classic essay from *Feminist Art Journal*, notes that "there are many stories of women whose stitches were uneven being sent to help in the kitchen, or of the quiltmaker herself ripping out poorly done work and re-doing it" (p. 35).

And, in *Yesterday's Quilts in Homes of Today*, published in 1930, Carlie Sexton discusses a quilting bee where only the very best quilters were allowed to quilt—the others pieced or cut blocks for another quilt, and the younger women, presumably less experienced quilters, threaded needles and helped prepare dinner.

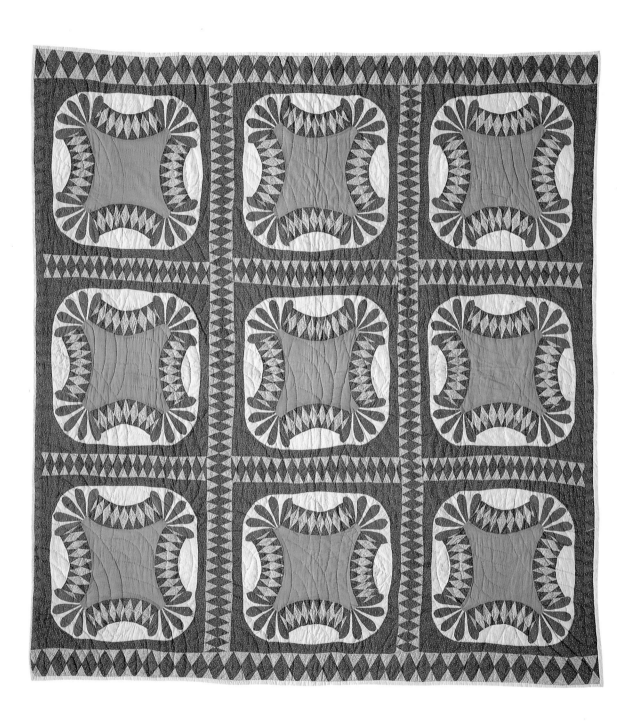

FEATHERED STAR QUILT

67″ × 84″
Cotton

ca. 1855–1865
Quiltmaker Cynthia Jane Campbell Keith.
Made in Dublin, Erath County.
Owned by Phillip A. Holcomb.

A HANDSOME, graphic quilt, this Feathered Star reflects the precision of a master quilter. The perfectly pieced stars are strongly emphasized by the deep indigo sashing and contrasting red-and-white Nine Patch blocks. The quilt contains over sixteen hundred tiny hand-pieced triangles and is beautifully hand-quilted in straight lines about one-half inch apart, which create a textural complexity.

The sashing strips are machine-pieced. This fact provided some guidance for dating this quilt, since the sewing machine was not invented until 1846 and did not achieve widespread use until the Civil War. The brilliant red that is used provided another clue, since the aniline dye required to produce this shade was not available until the mid-1850s. The strawberry binding is unusual in a quilt that displays such strong graphic sensibilities and may indicate that the quilt was re-bound years after it was made. Family history dated the quilt very specifically at 1848; however, 1855–1865 is more likely.

The sharp colors and high contrasts of this Feathered Star are evocative of the harshness of early ranch life in the Texas Republic. What is surprising about this quilt is that Mrs. Keith was able to obtain enough of the dark blue print to maintain visual continuity, despite frontier conditions.

Mrs. Keith, the great-great-grandmother of the quilt's owner, was born April 21, 1822, and married in Texas on July 15, 1837. Two years later, on December 5, 1839, her husband, a veteran of the Texas battle for independence, was awarded land in Red River County by the Republic of Texas. She reared fifteen children; one son was killed by Indians in 1864.

Cynthia Jane Campbell Keith with her husband, Gabriel

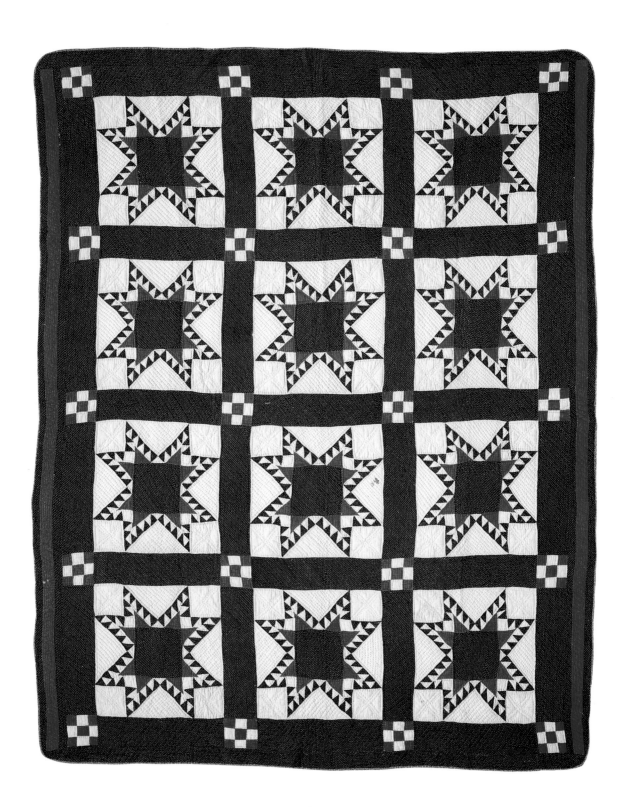

45

SAWTOOTH STAR QUILT

61" × 81½"
Cotton

ca. 1859

Quiltmaker Ruthie Fugate Parkey.
Made in Claiborne County, Tennessee, and
brought to Mankins, Archer County, in 1888.
Owned by Ebb Kelly Jones and Judy Jones Puder.

AMBITIOUS piecing, a charming related border, and graphic Sawtooth Stars—all combine to produce a bold, handsome quilt with verve and personality. The emphasis on the solid green squares that interlock the stars in an unusual setting is an imaginative treatment that adds interest to this beautifully planned quilt. The negative space in the counterpane blocks has a visual impact all its own and provides excellent contrast to the strong pieced image.

The piecing is not perfect, although it is extremely effective. Some points are cut off, the green squares are not truly square, and the border emphatically does not turn the corner but goes off in every direction. Yet the creativity and unrestrained gaiety conveyed by the quilt are not diminished by this imprecision; instead, such a light-hearted approach to detail only enhances the quilt's charm.

The quilting is extraordinary. A bride's quilt, it is embellished with hearts, but in addition to this lover's symbol, four more-elaborate quilting patterns, including flowers, are used throughout the counterpane blocks. Double quilting is also used. The stars are quilted by the piece and also cross-hatched. Tulips are quilted into the border.

The quilt uses a hand-carded cotton batting. When the quilt is held close to the light, it is obvious that the batting is still full of hundreds of tiny cottonseeds. There is no easy answer to why the seeds remain in the batting. The cotton gin had been invented early enough (1793) that the cotton could have been mechanically ginned to remove the seeds. Coming from Tennessee, a slave state, the owner could have had slave women to pick out the seeds by hand. Still, in a quilt that was obviously meant to be a "best" quilt, this step was not taken—an anomaly for the time.

The quilt is in exceptionally good condition; it is not even marked by the fold lines that are almost universally seen in nineteenth-century quilts and caused by age. According to the owner, "One of the main reasons this quilt is in such good condition is that the long-time housekeepers [Miss Laura Huffman and Mrs. Lydia Fuchs] aired the quilts often and refolded them to avoid folding along the same creases." (Miss Huffman and Mrs. Fuchs were the housekeepers on the Parkey Ranch in Mankins, Texas.)

Ruthie Fugate Parkey was born in 1840 in Claiborne County, Tennessee, where she was married in 1859, when this quilt was made. She had seven children between 1860 and 1873. In 1884, her husband, Milton Green Parkey, and two of her sons came to Texas to homestead land, ending up in Mankins, in Archer County. After the men had established the family in Texas, Mrs. Parkey and another son came from Tennessee around 1888, leaving the two older sons behind to care for the family farm there. Part of Mrs. Parkey's journey was by river flatboat.

When she arrived, the family lived first in a dugout, which was not unusual for ranches at that time or place. In *Texas Tears and Texas Sunshine*, Mary Taylor Bunton described a typical dugout: "Can you . . . imagine people living in dirt houses? That was what a 'dugout' was—just a good-sized square hole dug back into the south side of a hill. . . . There were no windows in the dugout and only a dirt floor. In times of storm a wagon sheet or tarpaulin was fastened across the doorway" (p. 230).

The Parkey family lived in the dugout only until their big brick house could be built. By 1900 they had over 5,000 acres; by 1939, the ranch had grown to over 30,000 acres. By 1957, the family holdings had grown to include three ranches in Archer, Baylor, and Erath counties. Mrs. Parkey died in 1926 at the age of eighty-six.

The present owners, mother and daughter, purchased the quilt after the estate was divided about fifteen years ago. Their information about the quilt and the family history is taken from personal interviews with Tennessee relatives of Ruthie Fugate Parkey, from a history of the Parkey Ranch included on page 26 of a privately published pamphlet, *Archer County, Texas Centennial*, and from Parkey Ranch information in the 1954 book *Big Ranch Country*.

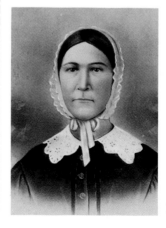

Ruthie Fugate Parkey

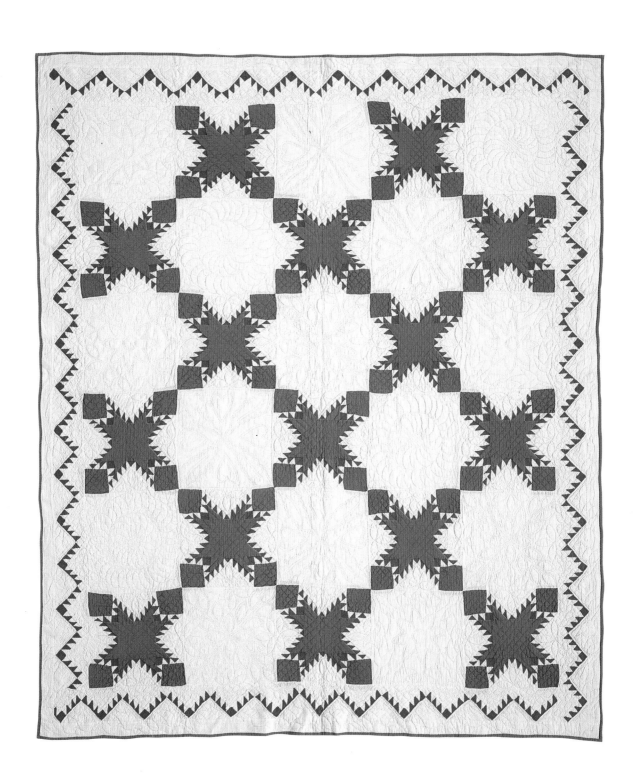

RAMBLING ROSE QUILT

105″ × 96″
Cotton

ca. 1860 *(original design)*

Quiltmaker Dorothea (Dolly) Keyes McClanahan.
Made in String Prairie, Lee County.
Owned by Rosa Eugenia Peebles Lewis.

AN IMAGINATIVE, whimsical, almost idiosyncratic design created in the rich blacklands of Texas just before the outbreak of the Civil War, this quilt can be viewed as a testimonial to the lush crops Texas land can produce when there is rain.

Made in Texas for the wedding of Mrs. McClanahan's daughter, Nancy, the quilt is a creative adaptation of the traditional Rose of Sharon, long the favored bridal quilt design. It also strongly resembles the Rose Tree or Prairie Flower in the use of a trilobed floral design often used as a symbol of the Trinity, according to *Quilts in America.* The design features a wandering rose springing out at odd angles from the primary motif; one of her great-granddaughters remembers that the family knew this design as the Rambling Rose, which is certainly descriptive of the free-form effect of the wayward flowers.

Beautifully appliquéd by hand, the quilt is quilted with triple-grid quilting to produce a heavily textured effect. The leaves are also triple quilted, and some contrast quilting is used. The centers of a few of the roses feature a tiny, indistinct print instead of a solid color. The quilter did not concern herself with consistency but instead created each of the rose arrangements freehanded, so that there are many differences from block to block. For example, some of the stems do not connect to the central rose, and two center roses are formed by different placement of colors than are the other ten.

This quilt has many interesting and original elements to its design, which raises the possibility that the quilter created it based on her own family tree. If so, the eight leaves could represent her eight children stemming from the central rose as a symbol of her own marriage, and the rambling roses and buds could result from the natural branching off as children married and left home to start new families.

Dolly McClanahan, great-great-grandmother of the present owner, was born in Georgia in 1802, moved with her family to Tennessee and then to Alabama, married James Milton McClanahan in Lawrence County, Alabama, in 1820, and died in 1892 at the age of ninety. The McClanahans moved to Texas in 1846, the year after Texas became a state.

At the time of the McClanahans' move, Texas led the nation with its liberal homestead policy. Cheap land—320 acres to anyone willing and able to work it—drew settlers from all over the nation. To a state that was land rich and people poor, this policy had enormous benefits; to landless people or to those who worked or inherited small farms in other states, the promise of so much land must have seemed worth overcoming any obstacle. Family history does not record the reason the McClanahans moved to Texas, but it is certainly possible that they, too, came for land.

The McClanahans, with eight children ranging from age twenty-three to infancy, came to Texas in covered wagons on a grueling, six-week journey. They left behind family and position (Milton McClanahan served in the Alabama House of Representatives and the Alabama State Senate from 1834 to 1846; he resigned his Senate seat to move to Texas) and moved ahead to a cotton farm on Yegua Creek in an unknown frontier. Their homestead was located on String Prairie in Burleson County, now Lee County, near Lexington. This land is still in the family.

During the Civil War, all of the sons of the family fought in the Confederate army; the family owned twenty slaves at the time of Milton's death in 1861. After Reconstruction, when ex-Confederates could again hold office, one son, John, served in the Texas Legislature from 1884 to 1888, continuing the family tradition of public service.

The Rambling Rose quilt was made for the quiltmaker's daughter, Nancy McClanahan, for her marriage to Sam Pinckney Peebles. It was intended to be handed down to the oldest child of each generation, and this tradition has been followed. The quilt was first left to Nancy's son, Eugene, then to Eugene's son, Sam, and later to Sam's daughter, Rosa, the present owner, who was born on the quiltmaker's birthday. This sense of family responsibility for the beautiful creation of a long-ago relative is still strong—Rosa's son, Raymond, brought the quilt to the Corpus Christi Quilt Day even though his mother was out of town, saying, "I knew I needed to bring this. Mom would want to share it."

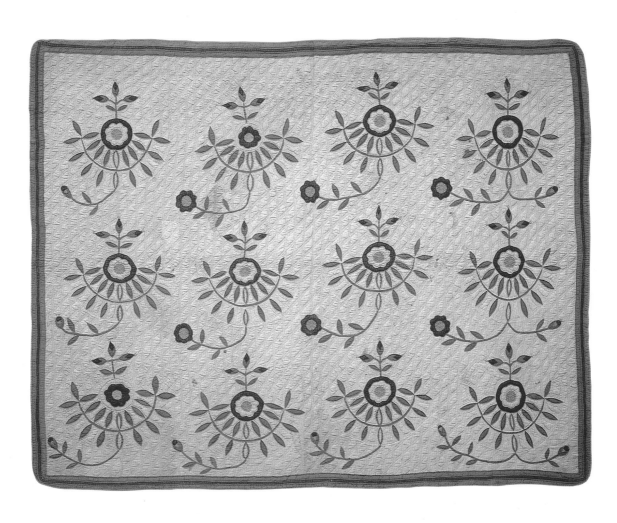

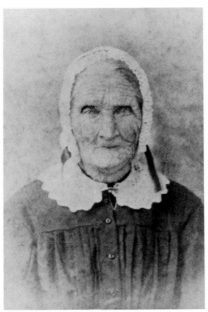

Dorothea (Dolly) Keyes McClanahan

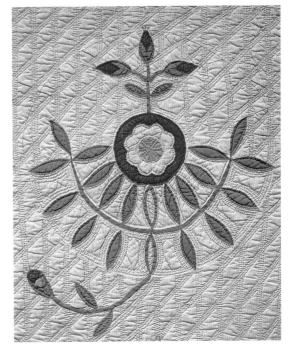

FEATHERED STAR QUILT

80" × 97"
Cotton

ca. 1860

Quiltmaker Jane Hoard Hubbard.
Made in Hill's Prairie, Bastrop County.
Owned by Barbara Leigh Rees.

RICH, vibrant colors, a spirited Flying Geese border, and meticulous workmanship combine to make this quilt a visual treat. The red blocks alternately recede to serve as counterpoint to the stars and float above the surface of the quilt as individual design elements, creating an interesting optical illusion. Carefully contained within the abstract border, which repeats the sawtooth motif, the twenty handsome feathered stars are emphasized by perfectly executed double clamshell quilting in the counterpane areas. The juxtaposition of the angularity of the pieced block and the curved lines of the quilting design is both unusual and effective.

The quilt contains a particularly beautiful green-and-black printed fabric that is beginning to show slight deterioration. The use of this much yellow in the green-and-red combination is unusual for this time period, but adds the additional optical effect of a secondary star.

The Hubbards came to Texas in 1838 with a party of eleven kinfolk, all of whom were either in their teens or in their early twenties. It took nine days to cross the Gulf of Mexico from New Orleans to Columbia, where the party had to wait in camp two months for the rivers to go down and the land to dry out enough for the teams of oxen to travel. The entire trip took four months of arduous travel to reach Bastrop County, where the Hubbards occupied a small log cabin in the valley of the Colorado River six miles from the town of Bastrop. Jane Hoard, the quiltmaker, married Robert W. Hubbard, veteran of that long trip, and settled in Hill's Prairie. She died as a young woman, and her children were reared with the help of a widowed sister.

The quilt has been passed down through the family. Jane Hoard Hubbard's granddaughter's name is written on a piece of tape sewed to the quilt, which indicates that it was once in her possession; then it was handed down to the aunt of the current owner. The quilt was given to the present owner because her aunt "hated the colors because they were too bright—not the pastels of the Depression that she was used to."

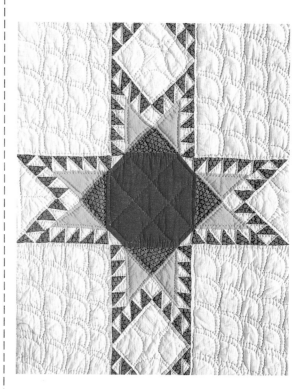

50

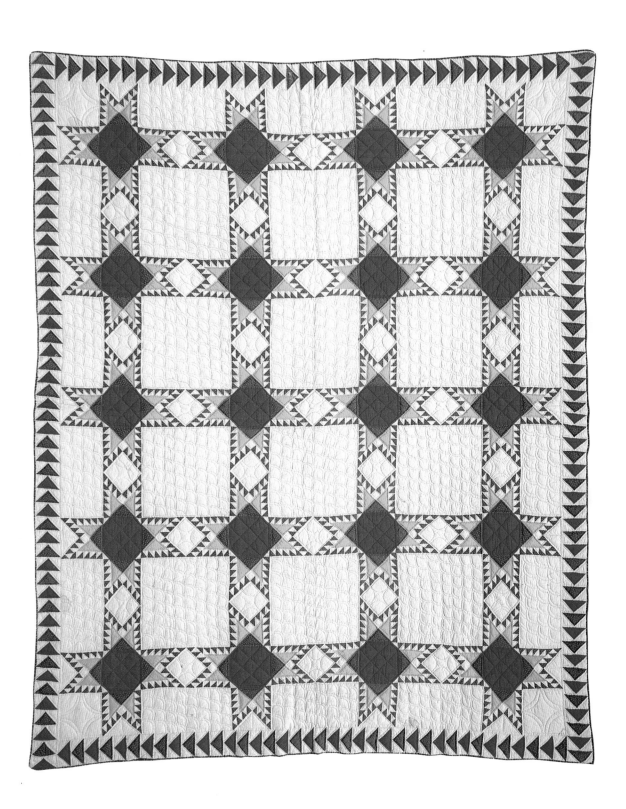

ARK AND DOVE QUILT

70″ × 86″
Cotton

ca. 1860

Quiltmaker Harriet Lucinda Acker McDavid
Russell.
Made in Rusk County.
Owned by Diane Lawton Mayer.

WAS this folk art quilt created as a plea to Heaven for rain to end a devastating drought or as a prayer for peace to head off the sorrow of the Civil War? Either reason would have been compelling. According to the *Handbook of Texas*, "a drought in 1860 ruined crops all over Rusk County to add to the misery and discord in the dissension over the slavery issue and secession" (II, 517). Texas entered the Civil War with divided loyalties—according to the *Handbook*, probably one-third of the people of Texas opposed secession—but went on to support the Confederate cause during the war.

While we do not know the motivation for Harriet Russell to make this quilt, we do know that another quilt almost exactly like it exists in Utah and was featured on the cover of Sandi Fox's book, *Quilts in Utah*. The Utah quilt was made about the same time as the Texas quilt and was taken there in the 1930s by a woman who migrated to Utah from another state. Did she come from East Texas originally? Had she and Harriet Russell known one another? Is this an original design copied by one of the women or is it a little-known pattern available during the Civil War era? If the Ark and Dove were a common pattern, it seems certain that some of the important quilt reference books would discuss it, yet we have not found mention of this pattern anywhere except in the Utah book.

This graphic quilt can have two interpretations: if it was planned with religious significance, then the ark is indeed Noah's Ark and the doves are the sign of rebirth as told in Genesis: "And the dove came in to him in the evening; and lo, in her mouth was an olive leaf pluckt off: so Noah knew that the waters were abated from off the earth." For a frontier woman deeply involved with the land, a severe, life-threatening drought such as Rusk County suffered in 1860 was cause enough to make a quilt that dealt with water and hope.

However, if the quilt is viewed in the context of the unsettled political times preceding the Civil War, another interpretation becomes apparent. The ark would represent the nation itself, with the doves becoming eagles, the national symbol. In this context, the design could be viewed as an appeal for unity, for peace, in the face of almost certain war.

Only one of the doves has a realistic embroidered eyebrow and eye; all of the other eyes are simple buttonholed circles. The doves are hand-appliquéd with a running stitch, rather than a blind stitch. In addition to the wings, the body of each dove is designed with a scalloped effect to represent feathers. The two doves resting on the Ark are totally out of proportion, another of the folk art characteristics of the quilt. Outline quilting, some double quilting, and a few examples of triple quilting around the Ark and flowers are used. Bordered on top and bottom only, the borders are quilted in a clamshell design. The green of the stems and leaves is an example of "fugitive" green and has faded with time and exposure to light-to-pale tan. It was once a dark, vivid green.

Harriet Acker McDavid Russell, great-great-grandmother of the present owner, was born in 1843 in South Carolina, married and moved to Texas in 1859, and died in 1919 in Ben Wheeler, Texas, at the age of seventy-six. She made the quilt for her first baby, a daughter born October 17, 1860. Widowed at twenty-one when her first husband, Richmond R. McDavid, was killed in April 1864 at the Battle of Mansfield (also known as the Battle of Sabine Crossing), the last major effort to invade Texas during the Civil War, Mrs. McDavid had to rear her little girl alone.

The little girl for whom the quilt was made was known only as Annie for her first few years "because her mother was so busy nursing the Confederate wounded who were recovering in her home that she couldn't be bothered picking a name," according to family tradition. "At the request of one of the wounded men who 'sorely missed his sweetheart,' Annie was named after the sweetheart and thus became Annie Eugenia Florence McDavid." The quiltmaker later married Captain Creighton Buchanan Russell and had eight more children.

Harriet Lucinda Acker McDavid Russell
with her daughter Annie Eugenia Florence McDavid

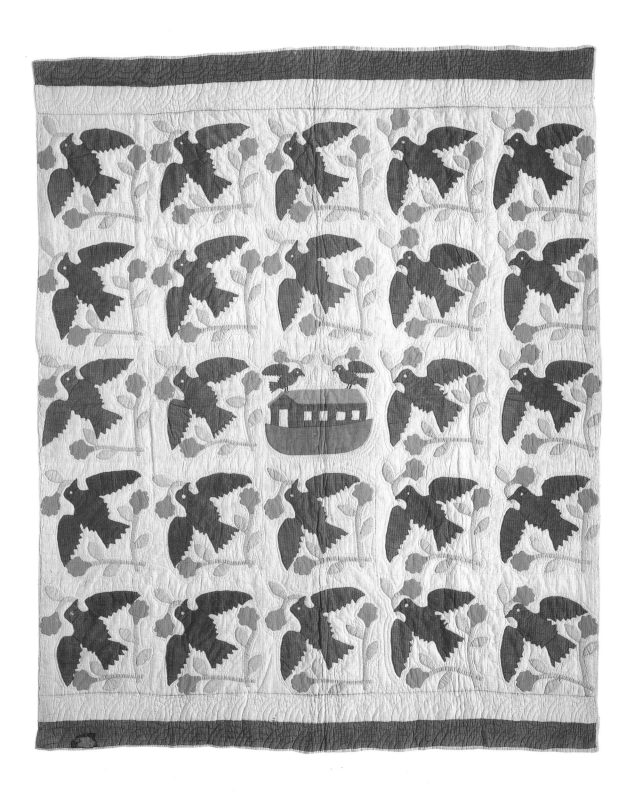

ROSE OF SHARON WITH BUDS QUILT

96″ × 72″
Cotton

ca. 1860−1865

Quiltmaker Margaret Wright Dickerson.
Made in Missouri and brought to Atoka, Coleman
County, around 1875.
Owned by Iris Mitchell O'Rear.

LUSH and elegant, formal and eloquent, this Rose of Sharon is everything a masterpiece quilt should be, raised to the height of elaboration. Trapunto, multilayered appliqué, magnificent floral blocks, exquisite needlework, beautiful color, bold border design, perfectly planned corners—this quilt has it all—even silk tassels on all four corners.

The glory of this quilt lies in the superb stuffed work, which adds both texture and dimension. The trapunto designs are stuffed so heavily that they reflect a dull gleam, a patina like that of well-used silver.

Two matching baskets full of flowers are used in the center of the quilt, with each individual design stuffed from the back. An unusual, exotic flower is featured in each basket and in other designs throughout the quilt. The designs rise in relief above a background completely flattened with many rows of straight line quilting no more than one-fourth inch apart.

The quilting is superlative. It would be impossible for the quiltmaker to have achieved finer stitches: in some places twenty-two stitches per inch can be counted on the top side of the quilt. That type of stitching is usually possible only with one of the older treadle sewing machines, but every stitch in this quilt has been put in by hand. A very thin cotton batt has been used, probably prepared completely by hand with great patience, for there are virtually no seeds visible in the batting. Even in mechanically ginned cotton, some seeds will usually remain.

The roses are textbook examples of the best multilayered appliqué: each full rose has five layers; each half-opened rose in the border, three layers; and each bud, two layers. The appliqué was first done with a running stitch, overlaid with a perfect chain stitch, executed by hand, outlining every piece and every layer. This technique provides an added dimensional quality to the quilt.

The formally constructed quadruple swag and tassel border with its half-open roses and scalloped edges is a bold design statement that balances the drama of the incredible work in the center panel of this narrow quilt. The corners, in particular, deserve discussion. The appliqué design, the swag and tassel, turns each corner smoothly and gracefully, the mark of a master quilter. Even the quilting design has been care-fully planned and a curving feather created to fill precisely the space left between the border design and the edge of the quilt on the lower corners. This design, too, has been heavily stuffed so that the corners assume an importance emphasized by the rich silk tassels.

According to family history, the quiltmaker was only sixteen when she made this spectacular quilt for her wedding, thought to be during the Civil War. Yet she exhibited the great proficiency that a lifetime of training with a needle brings. To have accomplished this quality of work at a young age almost staggers the imagination.

Margaret Dickerson, the great-grandmother of the present owner, is another of those early quilt-makers whose exact histories have been lost through the years. The family believes that she was born about 1845 and knows that she died in December 1916 in Pasadena, Texas. She made the quilt for her Civil War–era wedding, and she brought the quilt with her when she moved to Texas from Missouri about 1875. In 1874, the third of her four children was born, the owner's grandmother, Gillie Dickerson Mitchell. The Dickerson family lived on a farm at Atoka, Texas, in Coleman County. After her husband died, the quiltmaker moved to Houston to live with a son and his family, where she cared for a grand-daughter until the little girl died at age four from diphtheria.

According to the quilt's owner, Mrs. Dickerson "took the train from Pasadena to Hamlin, Texas, in 1915 or 1916 to visit her daughter, Gillie, who was my grandmother. She had a small trunk with this quilt in it to give to her daughter. My grand-mother later gave the quilt to my aunt, Winnie Mitchell Bell, and in 1980, she gave it to me."

A particularly interesting point about Mrs. Dickerson's quiltmaking is that she and her sister, Lula Wright (married name unknown), made three quilts. One was the quilt shown here. The second one was made by Lula and might have ended up in the Pasadena-Houston area although no details on it are known. The third quilt was made for their brother, Van Wright of Alvin, Texas, who later moved to San Diego, California. The family has been told that this third quilt is now in a museum in the San Diego area, but this has not yet been confirmed.

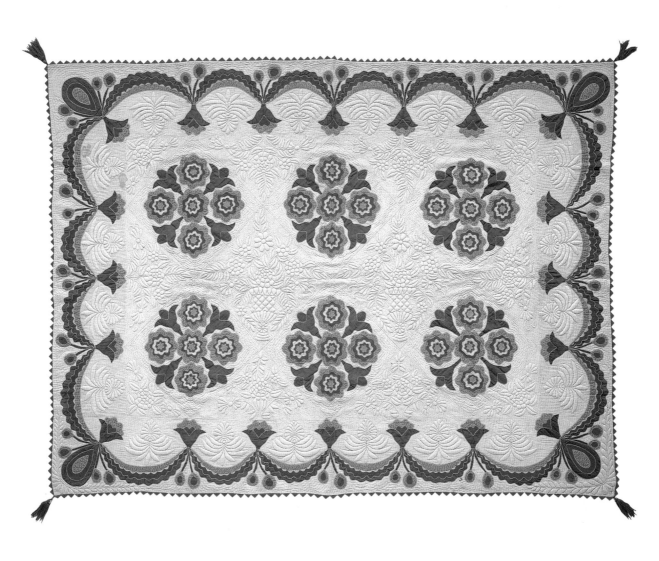

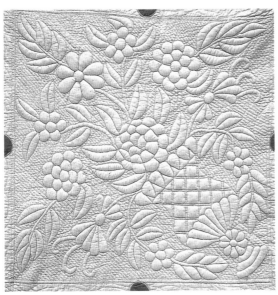

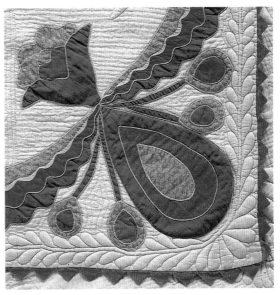

DEMOCRAT ROSE QUILT

70" × 83"
Cotton

*ca.*1865

Quiltmaker Mrs. Joseph Grigsby Smyth.
Made in Newton County.
Owned by Mr. and Mrs. Needham B. Smyth.

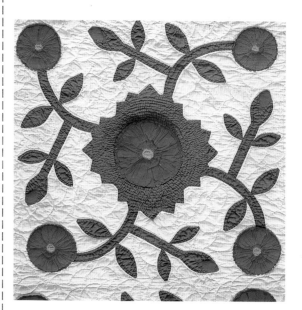

A STUNNING appliqué quilt with stuffed roses, this quilt could just as easily be named the Whig Rose or the Tea Rose, both names ascribed to this design by *Romance of the Patchwork Quilt in America*. However, for Texas, Democrat Rose is the perfect name, since from the end of Reconstruction after the Civil War until 1978, Texas was Democratic for one hundred years.

This Democrat Rose is typical of an entire genre of appliqué quilts produced between 1860 and 1870 because it is so beautifully executed in brilliant red and green, examples of the vivid aniline dyes that became available after 1856. The colors are as true today as they were when the quilt was made, almost certain proof that it was seldom used.

Hand-appliquéd and hand-quilted in an engaging design that serves to flatten the background so the roses stand out in high relief, this quilt "breaks the rules" with the heavily stuffed roses, which stand up almost three-fourths of an inch from the surface of the quilt. The large green leaves around the center roses are heavily quilted in concentric circles to flatten them completely; this quilting adds yet another dimension to the heavily textured quilt. The roses, both large and small, are constructed by a technique called ruching, which allows the look of fullness without resorting to multilayer appliqué.

The free-spirited quilt is framed by a very formal tulip border with perfectly curved leaves, not an easy accomplishment. Bound in bright red, the quilt has a freshness and innocence that add great charm.

Mrs. Smyth, grandmother of the owner, was married in 1868 to Joseph Grigsby Smyth, who joined the Confederate army at the age of sixteen to fight in the Civil War. He was a lumberman until 1891, when, for health reasons, they moved to Uvalde, Texas, in Uvalde County. In Uvalde, Mr. Smyth was active in ranching, banking, and general mercantile until his death in 1915. Regrettably, very little is known about Mrs. Smyth except that she was a very skilled quiltmaker.

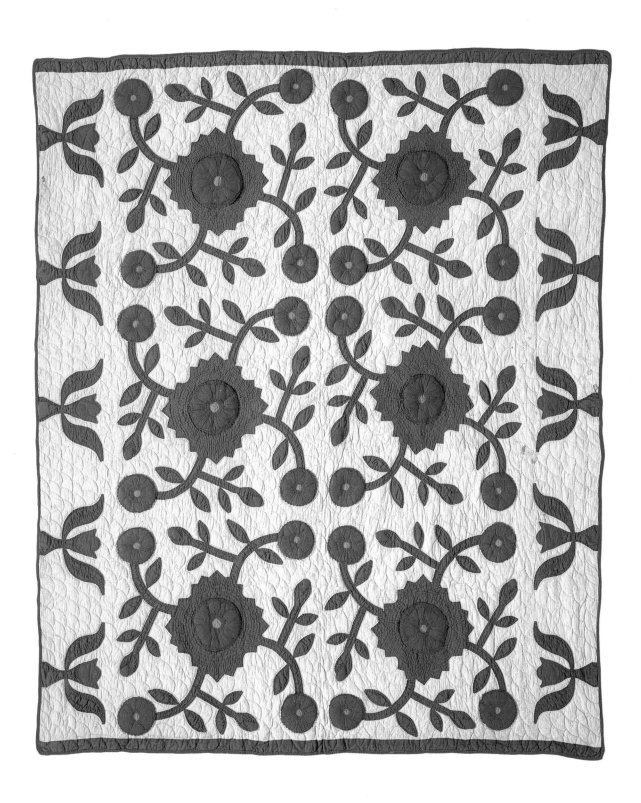

TEXAS STAR
FRIENDSHIP QUILT

74″ × 87″
Cotton

Quiltmaker Margaret Ann Eppright Johnson.
Made in Liberty Hill, Hopewell Community,
Williamson County.
Owned by Pamela Rau Moore.

THIS EXUBERANT hand-pieced, appliquéd, and quilted cotton quilt made by thirteen women was presented to one of their number, Margaret Ann Eppright Johnson, for her wedding on May 20, 1868.

Twelve pieced gold five-pointed Texas stars appear to float on the muslin ground, their dark green centers anchoring them at random angles that recall starfish. Elaborate roses and buds on a green print vine border the quilt, which is bound in red and contains an early repair. Intricate floral designs are quilted into the spaces between the stars, and the names of the women present at the quilting bee where this quilt was finished are quilted around the main stem of the vine border and, in three places, in the body of the quilt. The quilting designs and names are rather heavily marked in pencil, usually considered a detriment to a fine quilt if the marks don't wash out. This quilt, however, was obviously highly prized and kept for special occasions, as it has never been washed. Today, the pencil markings that still show must be considered something of a plus in that they allow us to see easily the signatures and quilting designs. The gold stars are quilted in a crosshatch design done in blue thread. Knots are visible on both top and bottom, rather than being hidden in the batting layer of the quilt, as is accepted practice.

This is an excellent example of a friendship quilt, made when women gathered at a quilting bee to quilt a fancy pieced or appliquéd top for a special occasion, such as the birth of a baby, a graduation, or to welcome or bid farewell to a favorite minister. It was customary for all of the quilters to sign or initial the quilt and sometimes to add admonitions, sayings, or quotations. Frequently, these quilts were kept for "best" and received only light use, which is one reason many of them have survived in such good condition.

In 1875, Luvenia Conway Roberts, the bride of a Texas Ranger, described an early Texas quilting bee as follows in *Reminiscences of Six Years in Camp with the Texas Rangers*:

The frontier people were not without their social pleasures. Amusements were not frequent nor were they elaborate, but they were enjoyed all the more because they came so seldom. I recall spending a very enjoyable day at a quilting bee. While the fingers plied the needle, tongues were equally busy. At noon all repaired to the dining room, which also served as a kitchen. The table groaned under the burden of rations . . . When twilight began to fall, the young men gathered in for a dance. And a dance it was. The old time square dance was most popular . . . The dance lasted until daylight. Many came from long distances, and then it was Indian country. I did not spend the night, for I had Ranger protection and went home at twelve a.m. (P. 14)

The quilt's owner, Pam Moore, says the quilt was given to her by her grandmother, who had inherited it from her mother, Margaret Ann Eppright Johnson. According to family history, Moore's great-grandmother, who lived from 1850 to 1938, was a farmer's wife in Williamson County who never worked outside the home. Her education was "about average for that day and time," and she busied herself with many kinds of needlework, including sewing clothes for herself and seven children.

If her education was average, though, her wedding quilt shows that her imagination and creativity were not. Rather than piecing or appliquéing the usual rose, flower basket, or double wedding ring quilt, she chose what appears to be an original design with a star for each person who helped her quilt it and who signed it—Lou Moore, P. T. W., M. J. E., Mary Brachta, Mollie C. Penick, Louise Johnson, Emma Eppright, Laura Penick, Mattie Woodson, Maggie Johnson, Mollie Fisk, and Airis Johnson.

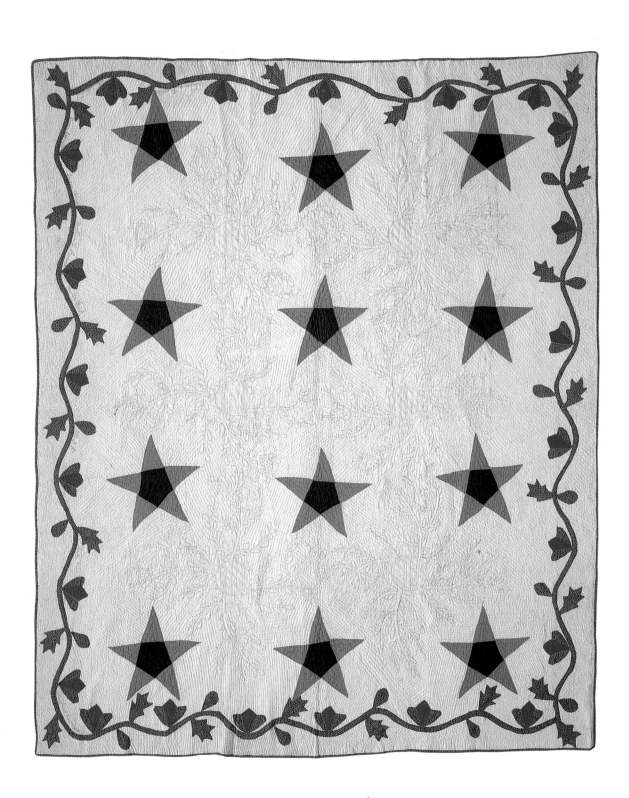

LOG CABIN QUILT

64″ × 72″
Wool and velvet

Quiltmaker Martha Virginia (Virgie) Morris Moore.
Made in Florence, Williamson County.
Owned by Mary Love Berryman.

SOMBER and disciplined, this Log Cabin quilt shows how repetition of simple images can produce a powerful artistic statement. In this, as in many other quilt designs, the nineteenth-century quiltmaker was far ahead of the painters of her day.

Patricia Mainardi, in *Feminism and Art History*, says that a comparison of the quiltmaking art at that peak period with what was happening in painting in America at the same time would show that quiltmakers anticipated modern painting by at least 150 years. "A repeat pattern of cubes in space, for example, was known as 'Baby's Blocks' (to quiltmakers). The fact that it is more common for contemporary male artists to call this type of design by a scientific or mathematical name merely points up the different content this visual symbol evokes in different lives," she notes (p. 338).

Even as early as the 1920s, Ruth Finley, in *Old Patchwork Quilts and the Women Who Made Them*, called quilts "futuristic—in both color and form" and added, ". . . would it be heresy to suggest that modernistic art is reminiscent of folk-crafts, the creations of which have gone so completely out of memory as to seem now strikingly novel" (pp. 108–109).

Distancing the viewer from a quilt by displaying it on a wall or seeing it in a photograph can crystallize and give perspective to its inherent forms. This particular quilt is one in which such viewing better demonstrates its artistic command of light and dark than when viewed as traditionally used on a bed.

There were many variations on the Log Cabin quilt when this quiltmaker was working, and development of additional variations continues today. This subdued and dignified quilt is in the Courthouse Steps variation. Many courthouses in Texas were built with entrances on all four sides and steps leading up to each entrance. In this variation, the Log Cabin blocks are pieced so that the logs form the steps leading to the deep wine velvet center blocks, which represent the courthouse, in keeping with the tradition that Log Cabin blocks were centered by warm-hued colors. There is much use of wool in this quilt, and it is handpieced. It is bound simply and not backed.

Quiltmaker Martha Virginia (Virgie) Morris was born in 1847 in Winchester, Franklin County, Tennessee, and moved with her mother, brothers, and sisters to Travis County, Texas, after her father died in 1852. Two years later, they moved

to the head of Berry's Creek, near Florence, eighteen miles northwest of Georgetown, Williamson County.

She married a man who had fought in the Choctaw Grays, Company K, 15th Mississippi Infantry, C.S.A., in the Civil War and was wounded in the right leg in the battle of Shiloh. In the battle of Nashville, he lost his little finger and also received a bullet in his hip. Nevertheless, he walked 140 miles home to get his "hand trimmed" and receive treatment. After the war, he moved with his family in covered wagons to Florence, arriving on Christmas Day.

Virgie Morris and John Thomas Moore were married February 11, 1869. This quilt was part of her trousseau, an unusual selection because of its dark hues, but perhaps because of the rich, formal fabrics it was deemed suitable for a winter wedding. The couple had their first baby the next year and later moved to Ballinger, Runnels County, with their family, where they lived until Mrs. Moore's death on March 18, 1912.

The quilt was handed down in the family, and its current owner, Virgie Moore's great-granddaughter, Mary Love Berryman, was given it by her mother. Mrs. Berryman has the following obituary of the quiltmaker in her family papers:

Mrs. Martha Virginia Moore, wife of T. J. Moore, died Monday morning at six o'clock at the home of her daughter, Mrs. A. S. Love. Age 64 years.

Mrs. Moore had been feeble for some time and her death was not unexpected, but leaves a sadness in the home where it occurred and among the many friends of the family. Deceased is survived by a loving husband who was at the bedside when the death angel removed from this world a life that had been spent in usefullness and transplanted it in a world where sorrow and sickness can not go, and where the loved ones shall meet again . . .

—Banner-Leader,
*Ballinger, Texas
March 23, 1912*

Martha Virginia (Virgie)
Morris Moore

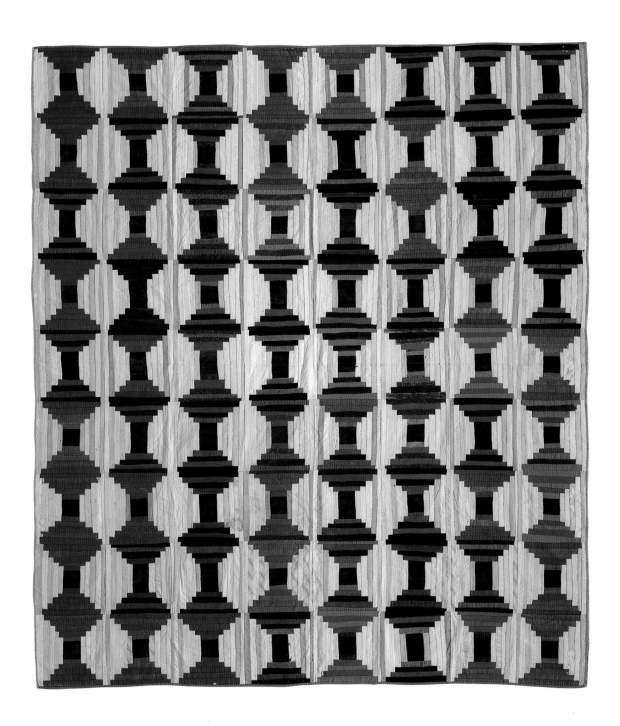

RAIL THROUGH THE MOUNTAINS QUILT

69" × 89"
Cotton

ca. 1871

Quiltmaker Ellen Priscilla Miller Williams.
Made in Monroe County, Kentucky, and brought
to Ellis County in 1891.
Owned by Mrs. R. C. Lovelace.

QUILT names were changed as the quiltmakers moved across the country to settle new lands. The New York Beauty design evolved into the Rocky Mountain Road as the pioneers moved west and, later, during the religious revival following the Civil War, it was renamed the Crown of Thorns. The quiltmaker called this variation Rail through the Mountains.

Using triangles as abstract images of mountains or rocks was a natural step, and the curves of the design reflect the winding path as it spiraled up the mountains. The Blazing Sun motif represents the brilliance of the sun from the vantage point of a mountain peak. The sashing with its double row of sawteeth and extra stripes symbolizes the railroad running through the mountains.

The significance of the design is revealed only when the blocks are joined; then it is possible to visualize the railroad tracks. This creates a "readable" abstract form expressing an idea—the difficulty of crossing over a mountain or mountain range—in geometrics, without resorting to direct representation.

This quilt differs from other similar styles, such as New York Beauty, in the use of more-complex pieces in the fan-shaped corners, the sashing, and the unusually small, tedious-to-piece triangles. There are 2,544 of these triangles in the quilt.

The heavy quilting succeeds beautifully in adding texture. Hearts are double quilted each time the curves meet the straight sawtooth strip and again in the center of each small sun motif, which presents a strong probability that the quilt was made for an engagement or wedding. The sawtooth element is repeated in the sharp diamond grid pattern quilted in the center of the blocks and in the sashing. The quilt is entirely hand-pieced and hand-quilted. It was bound by inserting red piping in the binding as it was applied, a technique often used between 1855 and 1875.

Ellen Priscilla Miller Williams was the grandmother of the present owner. She was born in 1855, married in 1879, moved to the Ellis County area of Texas about 1891, and died in 1928. She made this spectacular quilt when she was sixteen as part of her trousseau when she was first engaged. The doctor she was to wed died before the wedding could be held, and the quilt was packed away. She later married James Buchanan Williams, and the quilt was no doubt brought out to celebrate the marriage. A farm wife, she had six children and made each of them a woolen coverlet. According to the family, "She reared and sheared the sheep, carded the wool, spun it into thread, and wove coverlets, all while she was rearing her family."

Ellen Priscilla Miller Williams with her husband, James Buchanan, and their children

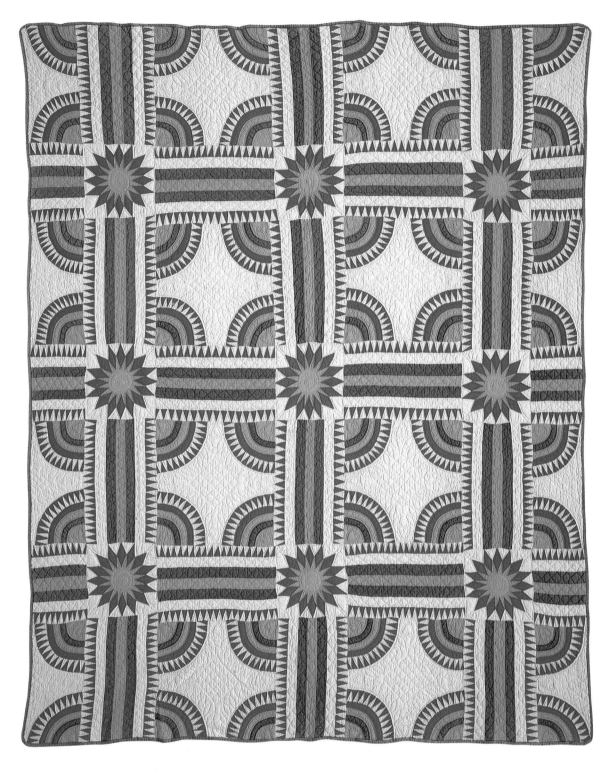

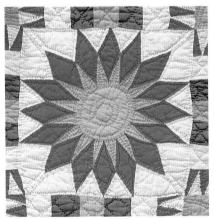
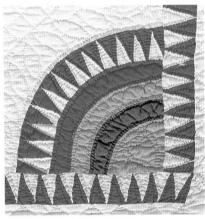

SUGAR LOAF QUILT

67" × 83"
Cotton

ca. 1873
Quiltmaker Annie Dorthea Walker Folmar Askey.
Made in Alabama and brought to LaRue,
Henderson County, in 1879.
Owned by James Harmon "Pete" and Frankie Lee
Gouger Westbrook.

Annie Dorthea Walker Folmar Askey

A SOPHISTICATED sensibility distinguishes the conception of this quilt although its execution indicates more naïve skills. It is hand-pieced of ten teal and ten gold triangles alternating with six white ones to produce the cone-shaped "Sugar Loaf" that fills each of the sixty-four blocks. The set is of pink cotton and the back is brought around to the front for the binding. The quilt is hand-pieced, and it is quilted by the piece as well as channel quilted.

The piecing is quite precise, but the quilting is rather uneven. Sometimes this indicates one person pieced the top and another did the quilting. It can also indicate that the person who may have had the leisure time to devote to careful piecing had a change in her life that gave her less time to spend on the quilting. With this quilt, the latter is accurate, for the quiltmaker pieced the top in 1872 when she was carrying her second child, Mary Frances Folmar, grandmother of Mr. Westbrook; she then quilted it in 1873, with two small children to tend.

An interesting aspect of this quilt's history is that it is through a daughter-in-law who married into the quilt's family that the history of the quilt and its maker has been traced. From conversations she has had with her ninety-year-old mother-in-law, one of the quiltmaker's granddaughters, we know, for instance, that Annie Dorthea was a tiny person, so short that in a regular chair her feet never touched the floor, and that she wore long full aprons, was a renowned cook, and a particular housekeeper who scrubbed her white hickory floors with white sand.

We know that her motto, "If anything is worth doing, it is worth doing well," expressed her feelings about her quilting and sewing and that her industriousness caused her to spin both cotton and wool thread on her spinning wheel and to teach her daughters and grandchildren how to crochet, tat, weave, knit, and embroider. She also liked to tell them stories about life on the family plantation in Alabama and of her experiences during the Civil War. She married in Alabama in 1869, migrated to Henderson County, Texas, in 1879, was widowed in 1884 and remarried the same year, and then moved to Anderson County, where she lived until her death at ninety-three in 1943.

According to Frankie Westbrook, her mother-in-law recalled of Annie Dorthea: "She had courage, backbone, and sweetness. She made good use of the needlework heritage handed down to her by her ancestors. She was a grand person, a fine lady."

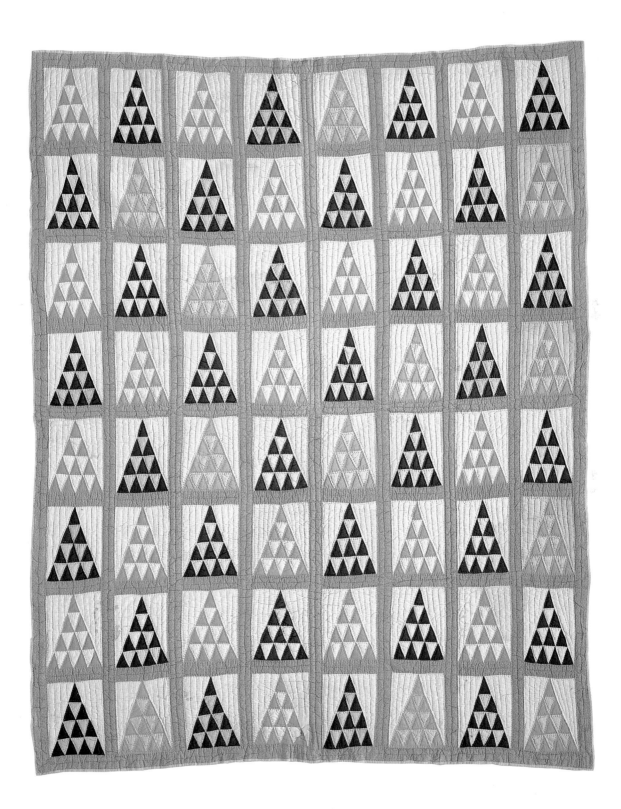

WILD GOOSE CHASE QUILT

86½″ × 74″
Cotton

1874 *(dated November 1874)*

Quiltmaker Margaret E. Aiken Cody Means.
Made in Jackson, Georgia, and brought to
Lampasas, Lampasas County, in 1885.
Owned by Herbert Arthur Means.

A HANDSOME, geometric quilt in earth colors of gold and brown on white muslin, this Wild Goose Chase quilt shows great emphasis on careful hand-piecing and quilting of many small triangles. These represent the geese in a quilt pattern that first became popular during Civil War days.

This very orderly quilt has twenty-one pieced blocks of 166 small triangles alternating with twenty-one counterpane, or white-work, blocks, each elaborately quilted in such motifs as hearts, leaves, violins, and baskets of flowers. The brown triangles in each pieced block link to form a dark and visually striking grid, which is contained by three borders of brown, white, and gold finished with a brown binding. The corners are emphasized with small Nine Patch blocks of the same colors in a careful and sedate fashion appropriate to this low-key yet masterful quilt.

The quiltmaker was discreetly but dramatically demonstrating her skills, for her pieced blocks contain a total of 3,480 triangles, or geese. Her counterpane blocks show off tiny quilting stitches, which in one block form "TWC" and "M. E. Aiken" and carry the message "When this you see think of me Nov 1874," appropriate since this quilt was made for her wedding. The initials GBC in the same block likely are those of another family member. An interesting point about this inscription is that the writing is much more primitive than one would expect from such an expert quilter.

Note the outsized small "e" and the undersized capital "E." It's possible that the maker was an extremely accomplished needlewoman who had little or no formal schooling. If it was difficult for her to "make her letters," this quilt becomes, even more, a labor of love.

According to the owner of this quilt, his grandmother did indeed make it for her marriage to T. W. Cody, which took place around December of 1874, shortly after the quilt was completed. The Codys had one daughter, Carrie, in 1876, prior to leaving Jackson, Georgia, for Lampasas, Texas. Mrs. Cody was widowed and, about 1889, married Ruben Lee Means, son of an army Indian scout, with whom she had four children by 1899. In 1901, the family moved to Valentine, Texas, where Ruben was a rancher and an ordained Baptist minister and Margaret was a homemaker until her death at eighty-six years of age in August 1942.

Margaret E. Aiken Cody Means, *right*,
with daughters Katheryne, *left*, and Carrie

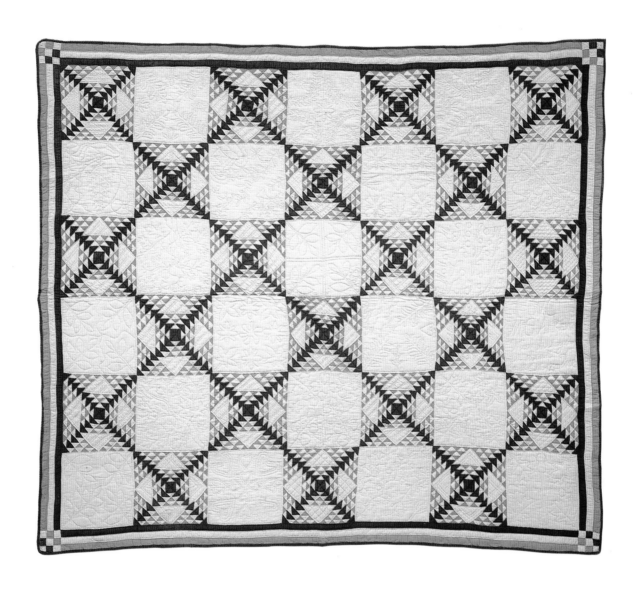

MEDALLION QUILT

75" × 87"
Cotton

ca. 1875

Quiltmaker Nannie Everett Herring.
Made in Newton County, Mississippi, and brought
to Blossom, Red River County, in 1917.
Owned by Billie Woodle Sharp.

MEDALLION quilts are among the earliest of American patchwork designs; they have their origins in eighteenth-century chintz appliqué quilts. It is most unusual to find a Medallion quilt as late as the fourth quarter of the nineteenth century, however, unless it is centered with a commemorative square celebrating the nation's Centennial in 1876.

It is also uncommon to find a Medallion quilt that is not a square, for most of the early quilts in this style were invariably the same size on all four sides to fit the huge beds of the time. This quilt, however, has had additional sawtooth rows added at the two ends to lengthen it into a rectangle, more suited to the narrower beds of the late nineteenth century.

The quilt is centered with a Rose and Buds block with four roses in the corners; stems were deleted from the buds. A narrow sawtooth frame surrounds the center with a double rose-and-white border utilizing irregular Four Patch blocks at the intersections. The next row of border designs is based on the age-old Star of LeMoyne, a pattern of French origin named after the Le-Moyne brothers who founded the city of New Orleans in 1718. The name of the LeMoyne Star was often simplified into the Lemon Star, probably stemming from the pronunciation efforts of settlers in a land where education was still not commonplace. According to *Romance of the Patchwork Quilt*, all pieced Lily and Tulip designs are based on this famous pattern and vary only in the number of diamonds used.

The final rows of the border are designed with large triangles composed of many small triangles. This border is a variation of the Birds in Air pattern, in which the triangles represent an abstraction of birds or geese flying in formation.

The design of this Medallion quilt is eloquent and speaks of the desire of the quiltmaker to create something of beauty, for it is obviously too complex for a simple utility quilt. The workmanship is good, but as Jinny Beyer points out in *The Art and Technique of Creating Medallion Quilts*, "most of the medallion quilts from 1850 on reveal neither the attention to detail nor the fine workmanship of earlier counterparts" (p. 50).

The quilt contains excellent examples of fourth-quarter-nineteenth-century textiles, including handsome copper-toned fabrics with rust and black stripes that are used in the triangles and some stars. The iron tennate in the dye that produced the black has eaten away the fabric almost completely, clear evidence of inevitable dye damage typical of the period between 1870 and 1890. Upon close inspection, it is also possible to see small holes in one of the outer borders where something was spilled on the quilt long ago. This unknown substance, possibly coffee, tea, or medicine, has, through the years, caused deterioration that exactly follows the shape of the stains.

Made in Mississippi after the Civil War, this Medallion also proves the theory that many old handwork methods were kept alive in the South long after they have passed out of fashion in other areas of the country. This quilt is a perfect example: made in the late nineteenth century, all of its components are derived directly from a style of quiltmaking that was then at least seventy-five years old.

The quiltmaker, great-grandmother of the present owner, lived in Newton County, Mississippi, between 1848 and 1918. She probably married in the early 1860s, for this quilt was made when her firstborn son, Benjamin Everett Herring (born 1868), was a child and given to him upon his marriage in 1898 to Emma Elizabeth Ferguson.

In 1917, the Herrings left Mississippi to move to Blossom, Texas; they lived in Red River County until their deaths. The quilt came to Texas with them and has been handed down in the family since that time.

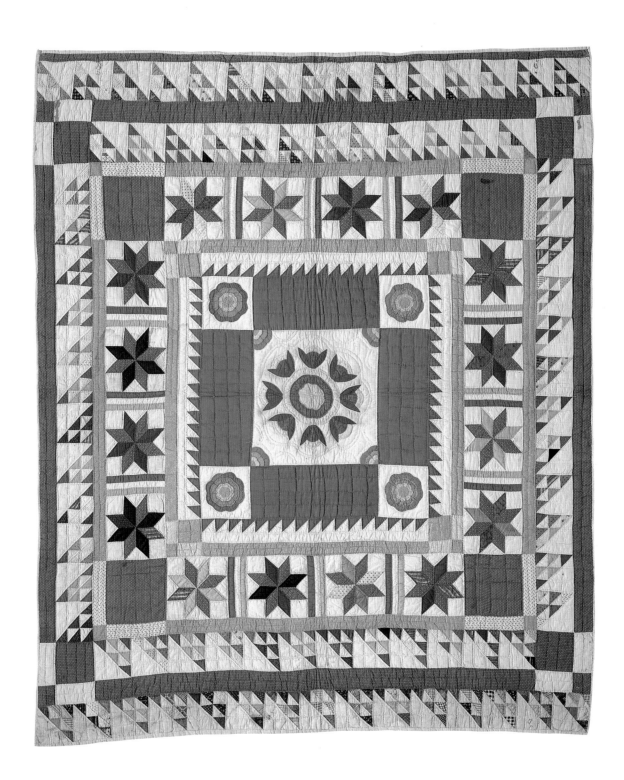

BLAZING STAR QUILT

69″ × 82″
Cotton

ca. 1875
Quiltmaker Mary Denman.
Made in Lufkin, Angelina County.
Owned by Claudia Horton.

THIS dynamic design is a classic Texas country quilt—vivid colors, naïve charm, thick cotton batting, and concentric rows of "toenail" quilting—"stitches so big you can catch your toenail in them getting into bed," as described by old-time rural quilters across the state. It is hand-pieced with coarse, contrasting thread and bound by bringing the back to the top and whipping it down.

Despite its departure from the highly acclaimed formal quilt—an elegant piece with fine, fancy stitching—this Blazing Star compensates for its casual workmanship with great spirit and a visually arresting style. It would have been impossible to produce fine quilting stitches on this quilt because of the thick batting, purposely bulky to provide extra warmth. The quilt is in unusually good condition, with wear and fading primarily on the fold lines, which suggests that it was either saved for special occasions or, because of its weight, used only when a "Blue Norther" hit. (Texas "Blue Northers" are famous for moving fast enough to cause drastic drops in temperature, sometimes bringing in enough cold air to drop the temperature from 90° to 30° in less than an hour.)

Star quilts have always been popular in Texas, particularly in the nineteenth century. Blazing Stars, Touching Stars, String Stars, Texas Stars, Cowboy Stars, Lone Stars—all were adopted by the state's quiltmakers as symbols of the new Republic and, later, the Lone Star State. Because the diamonds could be cut out of small scraps of fabric, allowing them to use up what they had on hand, the stars were especially well suited to frontier life, where nothing could be thrown away for fear it might be needed tomorrow. It is unusual to find a Star quilt made of all new fabric, as this one is.

The drama of this quilt might be overlooked if one were to focus entirely on the quality of the workmanship, yet as Patsy Orlofsky reminds us in *Quilts in America*, "Our response to the finished quilt is now sometimes very different from the original feelings and intentions of the maker. We admire certain pieced quilts for the sophistication of design when at the time they were made, they would have been dismissed at the county fair, or by other needlewomen, as badly sewn" (pp. 86–87).

The handsome brown-and-gold Blazing Star has been handed down in Mrs. Denman's family for several generations, always remaining in Angelina County.

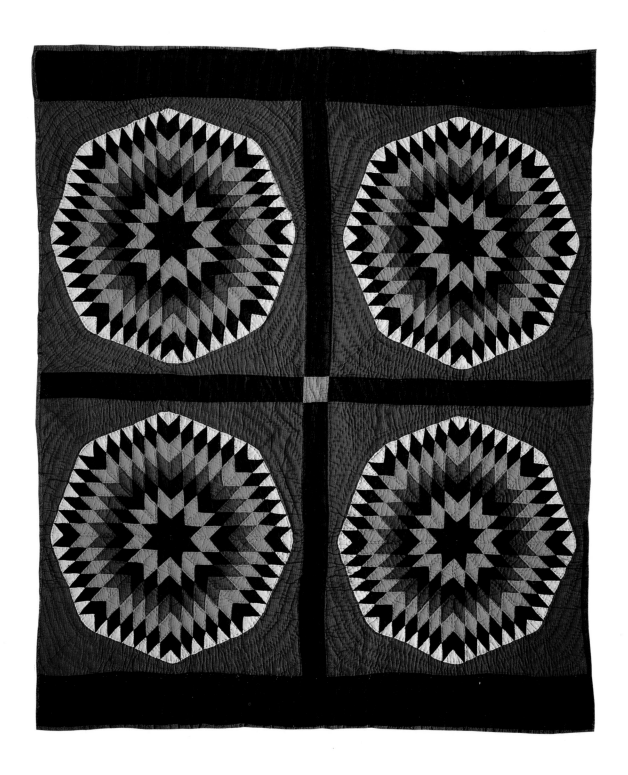

CROWN OF THORNS QUILT

72" × 81"
Cotton

ca. 1875
Quiltmaker Virginia Catherine Sears Griffin.
Made in Whitewright, Grayson County.
Owned by Dorothy G. Biffle.

Virginia Catherine Sears Griffin

"STRAIGHT is the line of Duty, Curved is the line of Beauty" says a verse from an early American sampler. It could easily be a quiltmaker's maxim, for utility quilts were usually the product of simple straight-seam piecing, while best quilts were often ones with curves, such as curved-seam piecing or fancy appliqué.

When a magnificent Crown of Thorns in excellent condition such as this comes along, with all of its curved-seam piecing, tiny, needlelike pieced rays, and two exquisite twelve-pointed pieced stars in the junctures of the set, it's apparent that a master quiltmaker was intent on producing a "company" quilt. This pattern is also called New York Beauty and Rocky Mountain Road.

Eleven red rays and twelve white ones, all hand-pieced, fill the corners of six full blocks, six half-blocks, and two quarter-blocks. Although the design is hand-pieced, the white strip at the top and the strawberry print binding were added by machine. The strawberry print used for the binding was widely available at the time this quilt was made.

This Crown of Thorns is quilted in narrow, concentric rings in the fan-shaped corners of each block, the set has quadruple quilting, and the remainder of the quilt is handsomely quilted in a one-half–inch grid.

The quiltmaker, Virginia Catherine Sears, who was born in 1860 near Whitewright, made this quilt when she married at sixteen, which accounts for her ambitious undertaking and also for the hearts quilted into it. She and her husband, John Griffin, lived on a farm until he acquired and operated a store in Gainesville. Kate Griffin died in an automobile accident in 1937 at seventy-seven while returning to Gainesville from visiting relatives in Whitewright.

The Crown of Thorns passed to the Griffins' daughter, who left it to her son, Morris, and his wife, Dorothy G. Biffle.

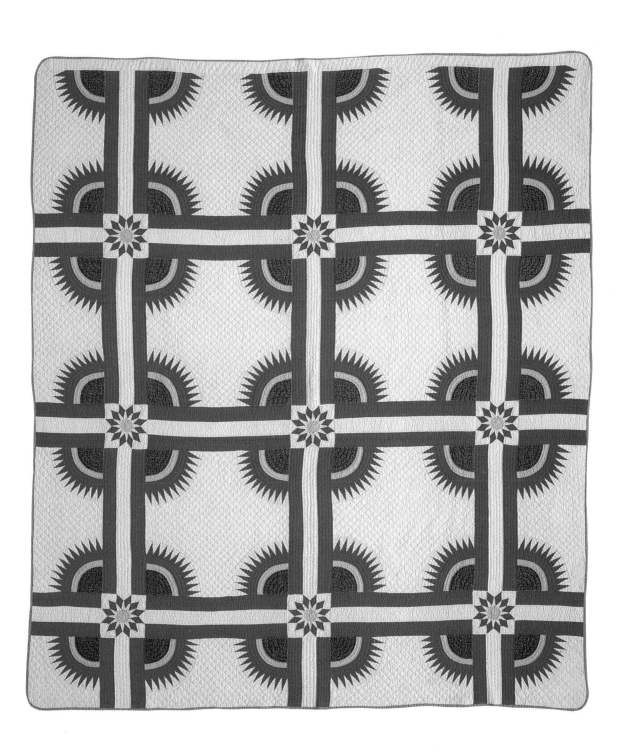

VASE OF ROSES AND CHERRIES QUILT

84″ × 84″
Cotton

1876 (dated)

Quiltmaker Josie Davidson.
Made in Virginia and brought to Amarillo, Potter County, in 1905.
Owned by Dixie Davidson Ryan.

A STUNNING design that mixes flowers and fruit stemming from the same branches, this quilt has a fascinating visual quality full of contradictions to the eye. The strong circular image, reinforced through the use of the round cherries, is contrasted by the equally strong vertical image of the narrow vase and long, slender stem. The quilt has a naïve, almost primitive aspect, yet the workmanship, particularly the appliqué and the quilting, is quite sophisticated.

Dated September 18, 1876, and initialed "JPD" in the quilting, this strongly visualized quilt seems to have a story to tell. However, many of the people who could shed light on the quilt's tale are no longer living. It must have been made for a happy occasion, for the imagery is joyful. The simple vining border has had outstanding workmanship lavished upon it, even to the effort of planning the border to turn the corners, yet the border design is much plainer than the rest of the appliqué. The branches bear what appear to be cherries and rosebuds in an imaginative disregard for the reality of agriculture, and the hovering roses are both whimsical and stylistic design elements that add symmetry. The design of the roses repeats the basic rose pattern found in such quilts as President's Wreath, Rose of Sharon, and Wreath of Roses. The cherries consist of perfect circles, a difficult task for even the most expert needlewoman.

The quilting is as beautiful as the appliqué, with five-pointed stars quilted into the centers of elaborately quilted wreaths. The border is quilted with feathers that also turn the corner masterfully. Most of the quilting is double quilting, demonstrating that the quilter was not content to simply outline quilt. Instead, she lavished twice the time and energy on quilting her quilt by running two rows of identical quilting throughout the piece. A heavily quilted, tiny gridwork flattens the surface behind the roses and cherries, and a curved feather wreath is quilted in the center of the four circular motifs. Embroidery stitches are used to create cherry stems.

The quilt raises several questions: Why did the quilter crowd in the two extra pots, each with a single rose, between the large wreaths? They seem unnecessary, yet they represent extra work. Were they symbolic? If she felt that those two sides demanded extra embellishment, then why not the other two sides? Why did she carefully use dark blue instead of green for the center of the two

Josie Davidson

large flowers and their leaves? It seems unlikely that she ran out of green fabric, since the vine is executed in green, even though the border is generally the last to be appliquéd.

The charm of this quilt lies in its oddity, in the folk art elements the quilter has used, perhaps deliberately, perhaps not. The stemmy flowers on the wandering vine, the out-of-proportion single pots between the large circles, the asymmetrical triple rows of cherries in the large circles, the use of cherries and roses together, the floating roses, the odd six-pointed star appliquéd in the center of every pot—specific touches of a woman who placed her designs where she wanted them to fit a vision only she could see, not where they should necessarily go.

Not much is known about Josie Davidson, the grandmother of the present owner, but the family estimates that she lived from the 1840s to the 1890s. However, since her last child was born in 1898, it seems more likely that the quiltmaker was born in the mid-1850s, married in the 1870s, and had her last baby when she was in her mid-forties. The date on the quilt may commemorate her wedding.

She and her husband both came from Sweden as young children, which may also provide a clue to the unusual folk motifs in this quilt. The quilter's husband "started a sawmill at Gate City, Virginia, and the family home was in an area called 'Poor Valley,' which was almost on the Virginia-Tennessee border." In 1905, their five sons came to Texas "to get rich laying track for the Santa Fe Railroad." Four of the men stayed in Texas; one brother returned to Virginia. The quilt has been handed down in the family to the present granddaughter. She notes that "from 1905 until this day, Davidson men have worked on the Santa Fe Railroad."

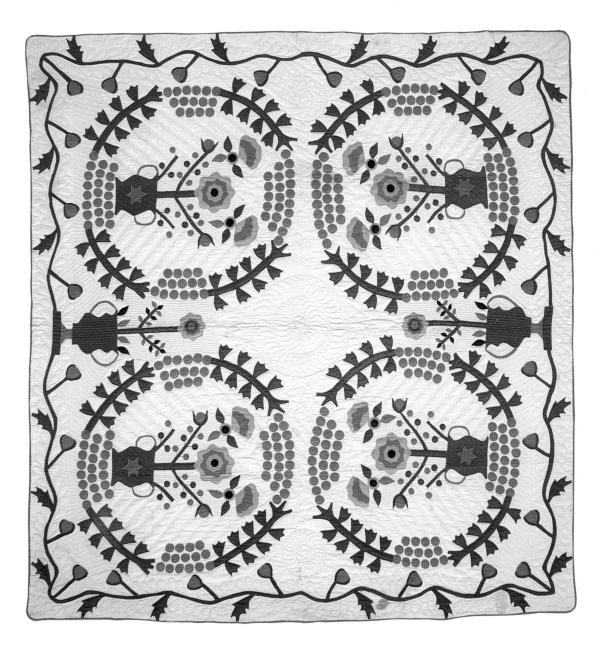

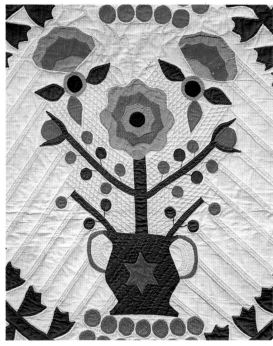

TREE OF LIFE QUILT

80″ × 74″
Cotton

ca. **1880** *(original design)*

Quiltmaker Mary Jane Jackson Mason.
Made in Cedar Creek, Bastrop County.
Owned by Jack D. Townsend.

DISCIPLINED repetition of original imagery makes this variation of a Tree of Life quilt one of the most exciting designs we saw in researching this book.

The design looks mystical, somewhat mysterious, and possibly reflects ties with another culture. It has been suggested by a native from the Czech-settled Panhandle community of Anton, Suzanne Yabsley, author of *Texas Quilts, Texas Women*, that perhaps it was made by someone with Czech origins or who was influenced by Czech culture.

Czechs were among early immigrants in Texas. At least two Czechs fought in the Texas Revolution, one of them a musician, Frederick Lemsky, who played "Won't You Come to the Bower?" when the Texans charged the Mexicans at the Battle of San Jacinto. There was a strong Czech presence in Central Texas, especially in Bastrop and Fayette counties, and this quiltmaker lived in Bastrop County near Czech settlements in Smithville and Rosanky. LaGrange, the county seat of neighboring Fayette County, was the site of the first Czech newspaper published in Texas. Other Czech-settled towns in Fayette County that still exist are Nechanitz, Praha, and Flatonia, where today an annual Czech chili cook-off is held.

The Czechs brought with them a long heritage of fine handwork and, while we have no information that indicates the quiltmaker was Czech, the prevailing culture where she lived obviously could have left its mark on her needlework.

That this quilt was made by a woman with well-developed skills in the needle arts is unquestionable. The design, which is an original adaptation of the ancient Tree of Life, is hand-appliquéd with perfectly even, small buttonhole stitches. There is a great deal of quilting with stitches that are virtually the same size and evenness, resulting in a quilt that lies very flat. It is ripple quilted; that is, quilting lines repeat the shape of the design elements to fill each block, just as a stone thrown in a pond creates ripples. The sashing is quilted in tiny diamonds, sixteen patches are quilted in the junctures between the sashing, and channel quilting is used in the two borders.

Dye remaining in the "valleys" of the stitches in some design elements tells us that when it was made, twenty or so years before the turn of the century, this quilt was even more vivid, for then they were a dark green in contrast to the other dark red and gold elements on the white muslin. The colors in this quilt are typical of those produced from aniline dyes. William Henry Perkin discovered the process for aniline dyes in Germany in 1856. These dyes were relatively inexpensive and easy to use and produced colors that were bright although not always fast in washing. Quiltmakers such as this one were quick to make use of the new range of colors they had to work with. Unfortunately, the green aniline dye turned out to be a "fugitive" dye, which has faded to the brown we see today.

While the workmanship of the quilt and its excellent condition are admirable, it is the puzzling concept behind its unique design that intrigues us. Quiltmakers have always incorporated symbolism into their designs, as have other needle artists. Unfortunately, the key to unlock the message of this quilt has been lost.

In it, two branches of the same flowering tree have produced strange fruit, both cherries or grapes and pears or what might be the old quilt pattern called Love Apple. The fruit, leaves, and root ball of the tree are connected to the trunk by fine embroidery. "The needlewoman cared not that she mixed palms and oaks, or that she had pomegranates and pineapples growing from the same tree as apples and cherries," according to Safford and Bishop in *America's Quilts and Coverlets* (p. 13).

Virtually nothing is known of the quiltmaker other than her name and where she lived. Mary Jane Jackson Mason's quilt was handed down in her family to Blanche Cameron Townsend, her granddaughter, who died in 1984. Her son, Jack D. Townsend, has inherited the quilt but none of its stories.

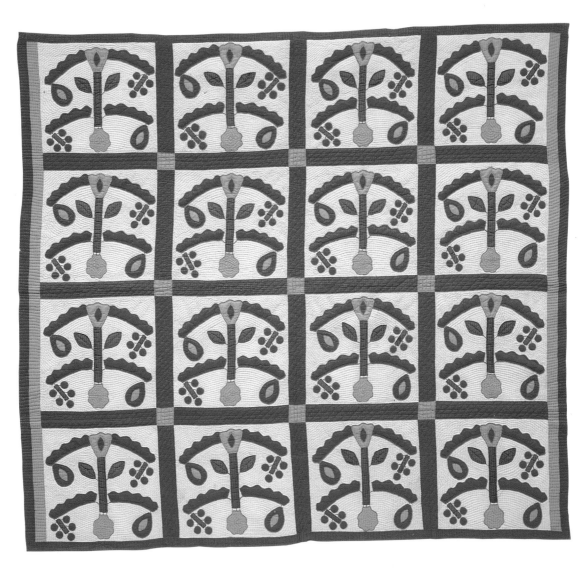

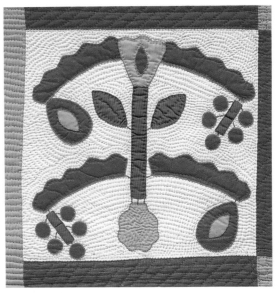

ROCKY GLEN QUILT

63½" × 78"
Cotton

ca. 1880

Quiltmaker Mary E. Roberson Floyd.
Made in Tennessee and brought to Comanche
County in 1884.
Owned by Lady Clare Roberson Phillips.

Mary E. Roberson Floyd

A PLEASING geometric design, all hand-pieced, this Rocky Glen quilt differs from most renditions of the pattern in the method in which it is set together—the large triangles point into the center. In a somewhat simplified version of this old pattern—which is known by several other names, such as Lost Ships, Sailboat, Eternal Triangle, and Merry-Go-Round—the quiltmaker has manipulated just the essential shapes of the design to convey a bold statement.

Constructed with triple sashing and small Nine Patch blocks at the sashing intersections, the quilt is backed with a home-dyed blue fabric that is now mottled and streaked from fading. The blocks also contain examples of fugitive green dye, which was originally a deep green and has now, inevitably, faded to a light tan. There are long thread tails still hanging from the surface of the quilt, and it is quilted with both blue and white thread.

Mrs. Floyd, grandmother of the present owner, "spun, wove, dyed, and sewed all the family clothing in Tennessee," her granddaughter recalls. "As a young person, I remember seeing her spinning wheel in Grandmother's room and seeing her spin thread after she came to Texas." The Floyd family initially settled briefly in Mt. Pleasant, "where the train they were riding to Texas jumped the track." Mrs. Floyd was born in 1847 and lived to be ninety-five.

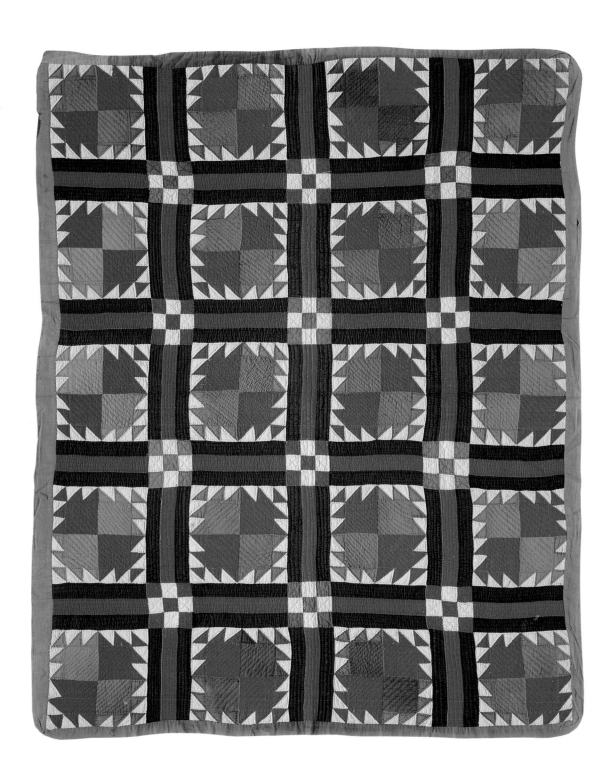

SAWTOOTH
VARIATION QUILT

80″ × 89″
Cotton

ca. 1880

Quiltmaker Margaret Cameron Slater.
Made in Jeromesville, Ohio, and brought to
Liberty Community, Carson County, in 1906.
Owned by Trula Jo Slater Sutton.

ANGULAR abstract images accentuated by the limited palette of indigo and white are multiplied many times over to create this strikingly graphic quilt, also known as Tiny Triangles.

Twenty-eight dark indigo print triangles alternate with thirty-six white ones in each half of fifty-six quilt blocks for a total of 3,584 tiny, hand-pieced "sawteeth." It is the regular, repetitive progression of these geometrically precise figures, as well as the play of light and dark, that gives this quilt its appeal.

Two bands of additional white triangles pieced onto the blocks in order to assure that the pattern would have "sawteeth" around all four sides indicate that this quiltmaker was greatly concerned with orderliness and regularity in her work. Four alternating indigo and white borders edged with narrow white binding finish the quilt suitably. Fewer borders would not have provided a strong enough frame for this composition.

In discussing the abstraction of images, used by both quiltmakers and painters, Jonathan Holstein, in *The Pieced Quilt*, states: "When geometric abstractions are drawn directly from nature or man-made objects, the objects are reduced to their basic forms and extraneous decoration is removed; the same general process occurred in the conversion of a bottle into the form it took in a Cubist canvas. The object retains its general characteristics in an abstracted form, and is immediately recognizable as bottle, house, flower. The quiltmaker, of course, because of the confines of the technique, necessarily geometricized her image, while the painter had greater latitude, and used that formation by choice" (p. 118–119).

Highly reduced geometric forms have long been used by quiltmakers as a "language" to represent certain things or carry certain meanings, just as colors and types of flowers provided coded messages commonly known in another era. This quilt pattern is related to Birds in Air, Wild Goose Chase, Flying Geese, Ocean Waves, Lady of the Lake, and others in its serial repetition of triangles to represent water or birds, often in flight.

Quiltmaker Margaret Cameron Slater pieced and quilted this Sawtooth Variation for her grandson, W. C. Slater, when he was a small boy. When he moved to Texas with his family in 1906 so that he could own his own farm, he brought his childhood treasure with him. His son, John Slater, inherited it upon his father's death and left it to his daughter, Trula Jo Slater Sutton, its present owner, who plans to pass it on to her eldest daughter. Mrs. Sutton has a tangible link to her great-grandmother other than her quilt, for her parents told her that they had taken her at seventeen months to Ohio so that her great-grandparents could see their first great-grandchild.

Margaret Cameron Slater with her husband, James Henry

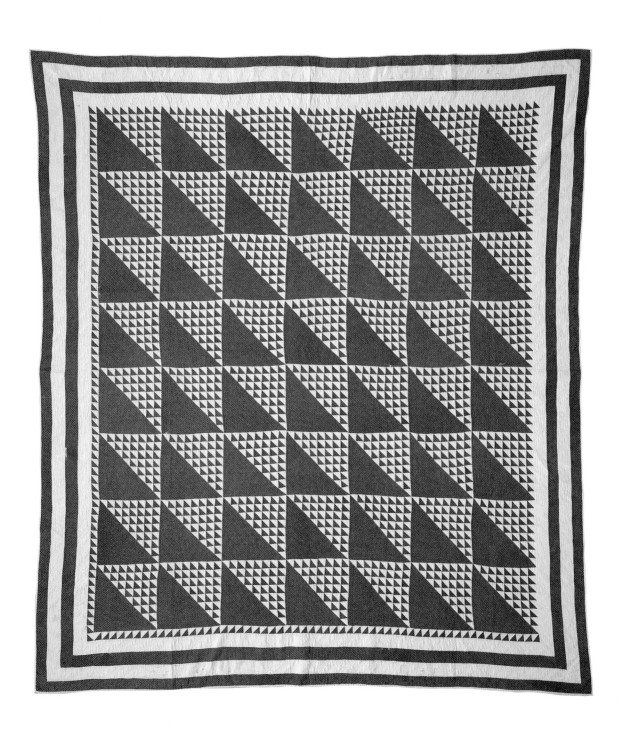

PRINCESS FEATHER QUILT

60″ × 60″
Cotton

ca. 1880

Quiltmaker Bashie Smith Christian.
Made near Waco, McLennan County.
Owned by Mrs. Jack T. Gorczyca.

EXUBERANT circular motion marks this lively Princess Feather variation, making the name Ben Hur's Chariot Wheel, one of its variations, an equally appropriate name.

This is a four-block quilt of hand-appliquéd red, green, and gold feathers with additional designs of crossed green oak leaves hand-appliquéd in the center and bisecting each side of the quilt. Oak leaves are frequently used to embellish these quilts. In comparison with the quiet, dignified air of the Princess Feather on page 89, this quilt calls attention to itself in every way, from its bright colors to its elaborately developed design to its intricate quilting featuring Dresden Plates of many different sizes.

Very fancy centers for the feathers composed of three-layer flowers encircled by red, green, and gold bands are appliquéd down onto the white background. The tips of the feathers, which are indicated by shallow serrations on one side only, are accented by tricolored balls repeated in the centers of the crossed oak leaves. These balls or knobs give the look of a medieval court jester's cap to the quilt.

The quilt has never been washed and was seldom used, indicating that it was a "special occasion" quilt. It was made by Bashie Smith at age fifteen for her hope chest, which explains why it was such a "tour de force." When she made her quilt, the quiltmaker, who was born in Lewisville, North Carolina, in 1866, lived with her parents on property in McLennan County owned by William I. Christian, a large landowner and Southern veteran of the Civil War. When his wife became ill, Bashie Smith helped care for her and, after her death, married the widower, who was thirty-one years older.

The present owner of the quilt, the quiltmaker's great-niece, said her great-aunt "often took leaves off trees and used them in her quilting." Bashie Smith Christian died in 1940 at age seventy-four.

Bashie Smith Christian with her husband, Bill

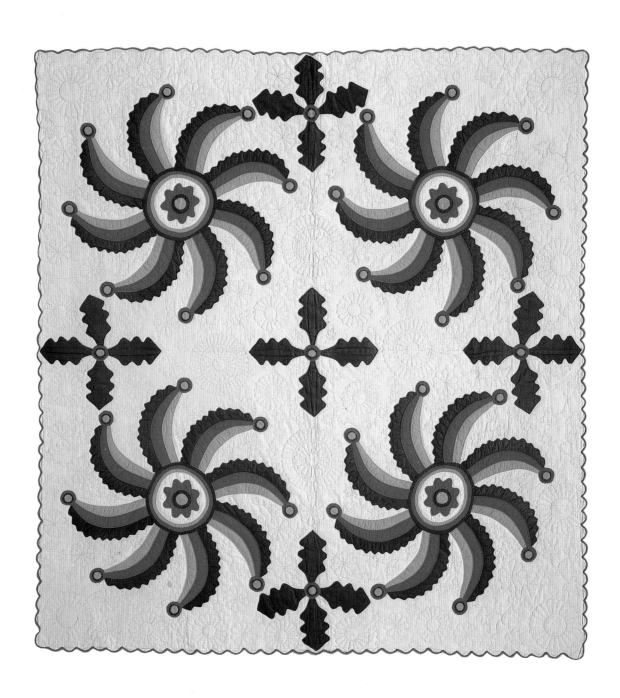

SOUTH LAND ROSE QUILT

65″ × 90″
Cotton

ca. 1880

Quiltmaker Sarah Thomas Jackson.
Made in Salty Community, Milam County.
Owned by Berniece Jackson Owen.

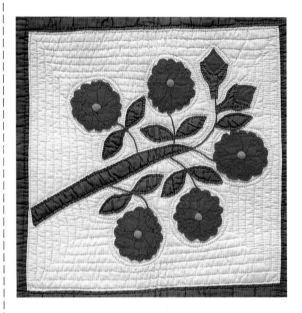

A RESTRAINED discretion characterizes this unusual South Land Rose. The rose and star are without question the two best-loved and most frequently used inspirations for both appliquéd and pieced quilt designs. This particular rose design has an almost Oriental look to it with its elegant simplicity and its beautiful execution.

The quilt is composed of twelve blocks of flowers, three across and four down, with five flowers, two buds, and nine leaves per block. The heavily ruched, or gathered, red roses with their stuffed orange centers are set slightly off the diagonal in each block. There is no stuffing behind the roses, but their ruching gives them dimension and realism. The sashing is green with a center red stripe down it. It is bordered with a plain green stripe and bound by bringing the back to the front on the straight grain.

The blocks making up the quilt are beautifully appliquéd by hand, then sewed together by machine. The design is heavily quilted and features double and triple outline quilting around the flowers and stems and geometric quilting to fill in the rest of each block. The quilting in the sashing is done in thread that matches each colored fabric.

Sarah Thomas was born in 1849 and married A. J. Jackson on November 10, 1866. Their first child was born the following year. A later child, born in 1873, remembered coming to Texas on a boat.

The Jacksons settled near Galveston when they first arrived, then traveled by covered wagon to Bastrop. They stayed with relatives for a short time before renting land on the Colorado River, where they farmed for about two years. They settled permanently in Salty Community, near Thorndale, in Milam County, Texas, where the South Land Rose was made.

The quilt was handed down from Mrs. Jackson to her son, thence to her grandson, who gave it to his sister, Berniece Jackson Owen in 1980 because she was the youngest in the family.

Mrs. Jackson was talented in many of the needle arts, in addition to quilting. With her husband, a farmer and carpenter, she was a pillar of the church and school in the community. Her granddaughter says, "One thing I will always remember about my grandmother was her homemade bread and coffee cake. She shared her cooking recipes as well as her patterns for quilts, sewing, or handwork of all kinds."

Sarah Thomas Jackson

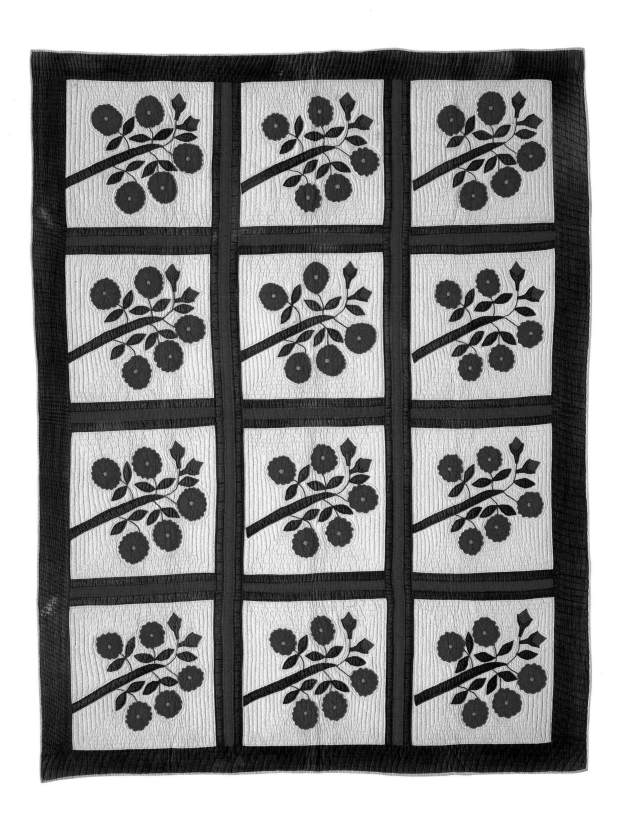

SAWTOOTH STAR QUILT

76" × 76"
Cotton

ca. 1880

Quiltmaker Susanah Mote Rush.
Made near Ennis, Ellis County.
Owned by Mr. and Mrs. Reagan Looney.

CRISP LOOKING, this Sawtooth Star, also known as a Feathered Star, is hand-pieced of green, gold, white, and strawberry print triangles and green squares pieced into a white ground. Thirteen scarlet squares, somewhat distorted, add an unusual and brilliant stroke of color, which combines with the strong design element of the sawtooth stars to create a spark that lifts this quilt out of the realm of merely pretty.

Forms, colors, and textures individually and when combined in a quilt draw from the viewer emotional responses. Holstein, in *The Pieced Quilt: An American Design Tradition*, quotes Bauhaus architect Walter Gropius: "Red, for instance, evokes in us other emotions than does blue or yellow, round forms speak differently to us than do pointed or jagged ones" (p. 121). Add to form and color the dimensionality of quilts and it is easy to understand their appeal to the eye and the touch. But just as strong is the appeal of quilts to the mind and the heart, as they call up images of home and family.

Quilting in this Sawtooth Star is of medium complexity and is done in triple rows that run diagonally across the entire quilt. Each group of three rows is almost exactly the width of a yardstick, and it was very likely that the quiltmaker marked her quilting thus. The common practice was to mark quilting designs with whatever household object was at hand—a saucer, thimble, or yardstick, depending on the shape desired, and a pencil or chalk.

Another very common practice in Texas was to use rainbow quilting. For this, a pencil, large pin, and twine acted as a compass. The pin was stuck into the quilt anchoring a length of twine, and the pencil was tied onto the twine at the length of the quilter's armspan. An arc of the arm produced rainbow quilt markings; rotating completely around the pin produced large circular quilt markings.

The art of quiltmaking was passed from one generation of women to the next, with children

threading needles for a quilting bee and learning from the quilters at work, including girls as young as six making their first quilt. From mother to daughter, quilting skills were transmitted along with the culture and values of one generation to the next.

This Sawtooth Star is a good example of such generational connections. Its maker, Susanah Mote Rush, is the mother of Melinda Florence (Flo) Rush Hall, who made the Four Seasons quilt described on page 144. Not only did Susanah pass on her quilting skills to to her daughter, but she also handed down her Sawtooth Star to her grandson, Reagan, and his wife, Lucy (Joe) Looney, the present owners.

Susanah and her husband came to Texas from Ohio, where they were Darke County Democrats surrounded by Republicans. In explaining why her husband's grandparents migrated, Lucy Looney says, "The Republicans would not neighbor with Grandpa and Grandma Rush, so they came to Texas to find some Democrats."

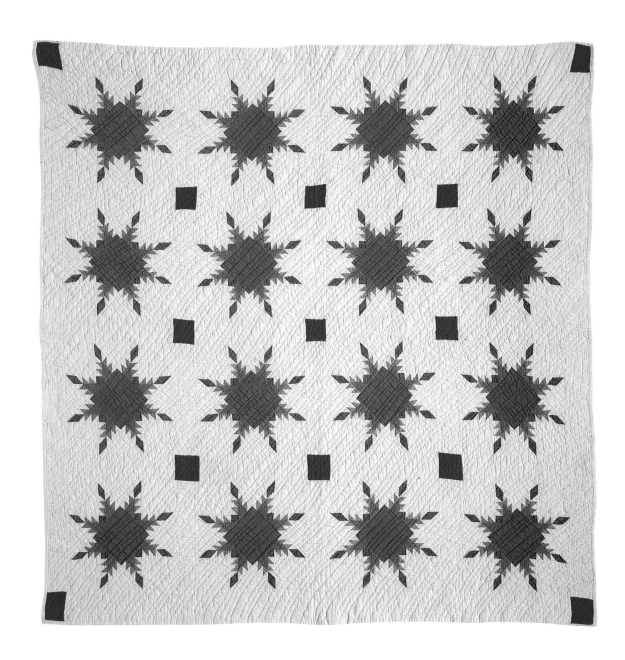

Susanah Mote Rush, *second from right*

PRINCESS FEATHER QUILT

82" × 86"
Cotton

ca. 1885

Quiltmaker Mrs. Andrew Jackson Berry.
Probably made in Baird, Callahan County.
Owned by Dr. Verna Mae Crutchfield.

APPLIQUÉD and quilting designs alike make use of this early pattern, which was especially popular in the mid-nineteenth century in spite of its complexity. The Princess Feather likely originated as Prince's Feather, in reference to the plumed emblem of the Prince of Wales. The design is also known as the Plume, and *Romance of the Patchwork Quilt in America* notes that the Princess Feather recalls plumes worn by knights and their ladies.

Traditionally, the Princess Feather had stars or flowers appliquéd in the center over the point where the feathers meet. When this is an eight-pointed star, the pattern is also called Star and Plumes. The typical Princess Feather consists of solid colors and has eight distinctly curved individual feathers in each of four large blocks.

This early Texas quilt is an interesting and perhaps original version of the design in which four crossed feathers, rather than eight, make up each block. There are nine small blocks rather than four large ones on the quilt. It is also missing the central motif of star or flower, is done only in red and green, and is somewhat similar to a pattern known as Maidenhair Fern.

This quilt's feathers were drawn, cut out, and appliquéd by hand onto the nine blocks, which were then pieced together with a border pieced around them, all by hand. In this particular variation, the feathers are highly stylized with pronounced serrations, which would have made it a difficult pattern to cut out and very time consuming to appliqué. It is quilted in an allover crosshatch design that resulted in one-half–inch squares.

The quilt has a very delicate, understated air about it, especially when compared to more typical Princess Feathers, such as the one on page 83. It is simply finished with a narrow red binding emphasizing its neat scalloped edge.

The quiltmaker was the second wife of Captain Andrew Jackson Berry, who fought in the Texas army in the Battle of San Jacinto, in the Plum Creek Fight against the Comanches near present-day Lockhart, and in the Confederate army throughout the Civil War.

While we know a great deal about Captain Berry, we know nothing of the quiltmaker, other than what we can surmise from her painstaking and beautiful work. As is so often the case, we can identify her only by her husband's name. Because of its complex pattern, because it was not a scrap quilt, and because it has survived in very good condition, we can assume this was a quilt made for a special occasion or event in her life, but we can only speculate about what it might have been.

The Princess Feather was handed down in Captain Berry's family and is presently owned by Dr. Verna Mae Crutchfield, stepdaughter of one of his sons, Bob Berry.

SUNFLOWER QUILT

88″ × 99″
Cotton

1885 *(dated)*

Presentation quilt made for Thomas Chatman Simmons.
Made in Kirvin Community, Freestone County.
Owned by Emmett Frank Hardie.

A GRAPHIC hand-pieced and quilted design with great impact, the Sunflower has an overall effect of controlled energy, with the radiating sunflowers each contained in a strong grid. Originally, before the dark green faded to olive drab, this version was even more vivid.

Two small mouse holes in the quilt have been recently repaired masterfully and are virtually invisible on the top side unless inspected at extremely close range. In line with current thinking among professional textile conservators, however, no attempt has been made to hide the repair from the back and the fact of the repair and the date it was made have been added to the documentation on the quilt. This will ensure that the integrity of the quilt is maintained and that future generations who inherit it will not be confused as to who did what to the quilt, or when.

The family history of the quilt is that it was made by women in Kirvin Community, Freestone County, some of whom hoped to marry Thomas Chatman Simmons, to whom they presented it. Each pieced a block, then joined in a quilting bee to set the blocks together and finish the quilt. One block is initialed "S E Davenport April 6 1885," another notes "Navarro Co," still another "Kirvin Community 1885."

Signature, presentation, album, or friendship quilts (the names are frequently interchanged although there are slight differences) were sometimes given to young men when they attained their legal majority at twenty-one years or when they had completed their apprenticeship in a trade or occupation. They were called Freedom Quilts and were the only quilts made especially for men. "In the old days a youth's arrival at years of legal discretion was an important event. No longer could his parents or guardian bind him out as an apprentice, take his wages, make him work at home for nothing or legally restrain his actions in any way. He was *free*," according to *Old Patchwork Quilts and the Women Who Made Them* (p. 192).

Tom Simmons' quilt is somewhat different from most in that all the blocks are the same design, rather than each being the product of the individual quilter's fancy, and because he was twenty-six when the quilt was given to him.

Traditionally, the Freedom Quilt was a gift from a young man's female friends, who were invited by his mother or sisters to piece blocks from scraps of their dresses, then attend a quilting bee to quilt them, "in reality for his future wife. For a boy's 'Freedom Quilt' always was laid carefully away against the time when he might add it as his gift to the dowry chest of his bride-to-be" (ibid.).

Born May 25, 1859, in Georgia, Tom Simmons was the second son of a Confederate soldier who came to Freestone County in the early 1880s. No doubt he sadly surprised some of the young ladies who presented him with this quilt, for he returned to his home state to marry Achie Anna Askew in October 1887.

Late in 1900, the couple traveled by train and wagon back to live in Kirvin Community, near Wortham, where they built a six-room house. In addition to farming, Tom was a carpenter and ran the local cotton gin.

Anna Simmons lost a baby in the spring of 1913 and died later that year of cancer. As was the custom, the oldest daughter, Ola Mae, had to raise the younger children. The primitive Baptist family had a hard rural existence, "living in log cabins near and with family" according to a descendant.

This Sunflower quilt was obviously treasured— it was never washed and probably never used, a luxury in a poor family. It traveled from Texas to Georgia, then back to Texas. The quilt was passed down to the oldest daughter, Ola Mae, whose friends also made a quilt for her when she married a man from Kirvin Community. She gave the Sunflower quilt to her oldest son, who in turn passed it on to his brother, Frank Hardie, because of the small mouse holes.

CARPENTER'S SQUARE QUILT

78″ × 78″
Cotton

ca. 1885

Quiltmaker Martha Harriet Kincaid Wilson.
Made in McKinney, Collin County.
Owned by Rebecca Wilson Huston.

CRISPLY dramatic, this indigo-and-white Carpenter's Square is a complicated maze of interlocking squares that form four white block X's featuring three rows of double quilting surrounding a central white diamond. It is meticulously hand-pieced of a very small indigo printed cotton fabric and white muslin and then channel quilted by hand. The march of the squares is contained by three one-inch borders of white, indigo print, and white, and the quilt is then bound in the same indigo print.

Antique indigo-and-white quilts are considered very collectible because they have a clean-lined look that appeals to all generations, and they complement many decorating styles. That appeal coupled with the relative rarity of the Carpenter's Square pattern makes this a special quilt. One reason the pattern is not common is that it is much more than an ordinary square, requiring mathematical precision in designing, cutting, piecing, and quilting.

The quiltmaker may have chosen this ambitious pattern because her husband was, among many other things, a carpenter. Perhaps this quilt was made for him or in his honor. He was also a surveyor, abstractor, realtor, farmer, and stockman, and his wife, Martha, was skilled in sewing, knitting, crocheting, and weaving, as well as quilting. She was born February 20, 1839, moved to Texas in 1841, married in 1855, had fourteen children (one stillborn), and died in 1899.

Her granddaughter, the present owner of this quilt, said her grandmother "attended a Dame School." "The Dame School was a combination nursery school, kindergarten, and first grade, run by a spinster or housewife who taught small children—boys as well as girls—their alphabet and instructed them in sewing and knitting. Fundamentals deemed necessary for the education of children were reading The Bible and sewing," according to *Quilts in America* (pp. 30−31).

The Dame School was a continuation of an English teaching method, according to Averil Colby in *Patchwork*: "Much patchwork was done in the dame's schools; simple rosette patterns or the windmill seemed to have been the most popular."

It is obvious that much of the work done in the Dame Schools was the work of children because the patches were sewn "with long stitches, short stitches, clean white stitches, and 'shady' white ones; some were small and even and some look like a row of broken talings, producing a strong conviction that the small boys had been included in the sewing class" (pp. 110−111).

This same granddaughter, when asked how she acquired the quilt, answered quite honestly, "I really do not know. It has been in my cedar chest for many years. My father had it. It's possible that I sort of 'latched' on to it!"

The quiltmaker's father was credited with bringing the first pig to Collin County, then territory within Fannin County. He helped organize the county, served as a soldier in the Mexican War, was loyal to the Union during the Civil War (having lived most of his early life in Illinois), was a justice of the peace in Collin County, and was a Mason.

As is so often the case, little is known of the quiltmaker's mother, other than her charming maiden name, Miss Temperance Rattan. Martha Harriet Kincaid Wilson, herself, was a major supporter of the First Methodist Church building fund in McKinney, donating both real estate and personal property. Her skill in the needle arts is all the more remarkable because she labored with a deformed left hand.

Martha Harriet Kincaid Wilson with her husband, George

INDIAN TEEPEE QUILT

72″ × 79″
Cotton

ca. 1885

Quiltmaker Mary Jane Reese Findley.
Made in Harmony Hill, Rusk County.
Owned by Ann Thomas Williams.

INDIAN teepees and quilted arrowheads give this bold, dynamic quilt great charm and character, transforming it from a simple geometric pattern composed of basic triangles into an evocative reflection of Southwestern frontier life. It is based upon the traditional Sugar Loaf pattern. However, when this quilt is compared to the Sugar Loaf quilt pictured on page 65, it is clear that it is the imaginative arrangement, or set, of this pattern that creates the striking visual effect.

The longer this quilt is studied, the more the optical illusions become apparent, for example, the four-pointed white star centered with a red square and bisected with green sashing. This effect is achieved by skilled manipulation of geometric forms. There are fifteen hundred small diamonds in this quilt, and the diamond shape is repeated in the quilting pattern used in the sashing. Arrowheads are quilted into the corners of each block, and around one block are three two-pronged arrowheads quilted into the sashing and irregularly spaced. Why? We do not know: perhaps Harmony Hill was located near one of the early Caddo Indian burial mounds found throughout East Texas, perhaps arrowheads turned up regularly when the fields were plowed. It's apparent that the arrowheads had some special significance to the quiltmaker, particularly in view of the teepee arrangement of the blocks. Rusk County, where the quilt was made, contains Lake Cherokee, named for the Indians who once inhabited the area under a Mexican treaty. The Indians were chased out of Texas in the Cherokee War of 1839 and tried as late as the 1960s to regain their land or rightful recompense.

Mrs. Findley, great-aunt of the present owner, was born in Harmony Hill in 1865 and married there in 1885, at the age of twenty. The Indian Teepee quilt was made as part of her hope chest.

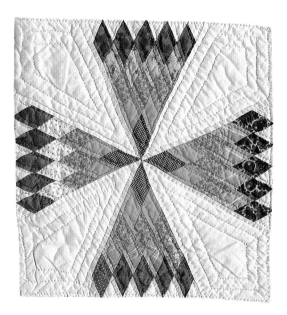

Mrs. Findley and her family moved to Vernon, Texas, in 1899. She outlived her husband and three sons. Her oldest son died of typhoid fever just before Christmas in 1909, and her husband fell victim to the same disease less than two months later, in 1910. According to the family, "she was brave, neat, and a good Christian woman."

Mary Jane Reese Findley

94

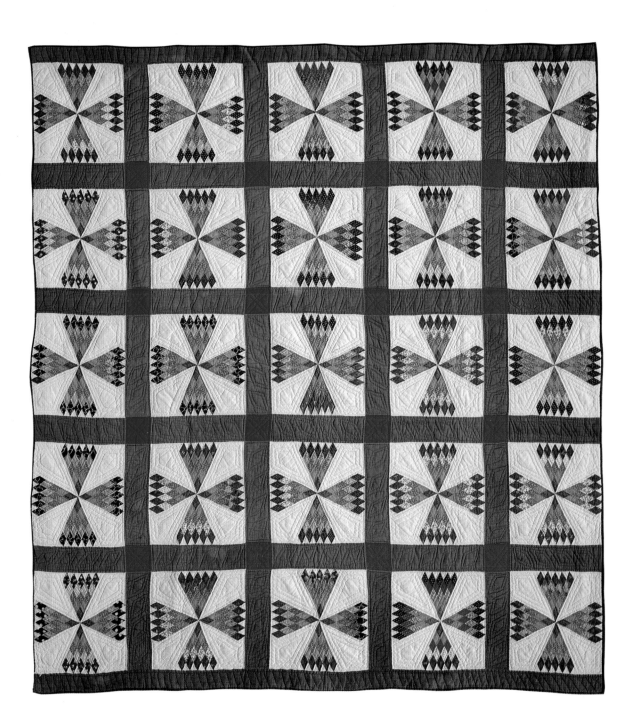

SUNBURST QUILT

62″ × 78″
Cotton

ca. 1885 *(original design)*
Quiltmaker Sally Beaird Lewellin.
Made in Elkins Community, Brown County.
Owned by Murl Lewellin Dobbs.

MORE complex than a Blazing Sun or its kin, the Mariner's Compass, this original design is both bold and visually fascinating. Alternate rays of the Sunburst are each intricately pieced of red and white diamonds; a smaller version of the rayed design, even more difficult to piece, centers each sun, and miniature suns are repeated in the twelve blocks of the set.

The vine sashing and border are actually pieced into the quilt, not appliquéd onto it. This is rarely seen and, because of its difficulty, is undertaken only by a master quilter. The quilt is entirely hand-pieced and hand-quilted, in double clamshells, sometimes in matching thread. The half-suns, which resemble rising or setting suns, were planned to cover the pillows at the head of the bed.

It is particularly interesting to note that this quilt is one of a pair of matching designs executed in different color combinations: this quilt is primarily red and teal with gold and green accents; the other quilt is predominantly green and gold. The gold in both quilts has proved unstable through the years and is sporadically fading to pale yellow. If the beige-green in the vine on this quilt is examined closely near the seam allowances, it is still possible to see vestiges of the dark green it once was. This fading is typical of "fugitive" green.

These long slender patches, tiny pieces, and sharp points are postgraduate work for any quilter. Mathematical precision and well-chosen colors make this quilt a particularly fine example of excellence in needlework. Pieced-work devotees will appreciate the dexterity displayed in the even, well-defined points and the neatness and exactitude of the angles. Since the quiltmaker had probably never studied geometry but used exact mathematical principles to achieve this design, the quilt demands even more respect for her skill.

A quilt so perfectly executed exemplifies many of the characteristics Jonathan Holstein cites in *The Pieced Quilt* as linking quilts to fine art: the manipulation of geometric forms, optical effects, color and form relationships, manipulation of linear effects, use of repeated images drawn from the environment, sequential use of images, and repetitive use of highly reduced geometric forms.

In this quilt, the design is a direct visual abstraction of a natural image, the sun. Color variations are not visible within the quilt itself but are certainly obvious when the two existing quilts are considered as a pair. Was it the quiltmaker's intention to make four of these quilts—one for each season? If so, could the gold and green symbolize summer; and the red and blue, winter? Both are critical seasons for anyone directly connected to the land as most early Texas quiltmakers were. In addition, the quilt shows definite optical variations and repeats highly reduced geometric forms, two more characteristics that link this quilt to fine art.

Sally Lewellin, the owner's grandmother, was born in Georgia in 1852, moved to Texas between 1870 and 1880, married a rancher in 1883 in Brown County, and died in 1949 in the same area. Because her wedding so closely coincides with the approximate date of this quilt, it is certainly possible that it was made as part of her trousseau of thirteen quilts. She was a child in Georgia during the Civil War and used to tell of being "afraid of the Northern soldiers who came through the country burning barns and driving off our mules and cows." More than three decades after her death, her granddaughter remembers her as "a very well read woman who loved home, family, people, and country. She was Christian in every respect."

Sally Beaird Lewellin

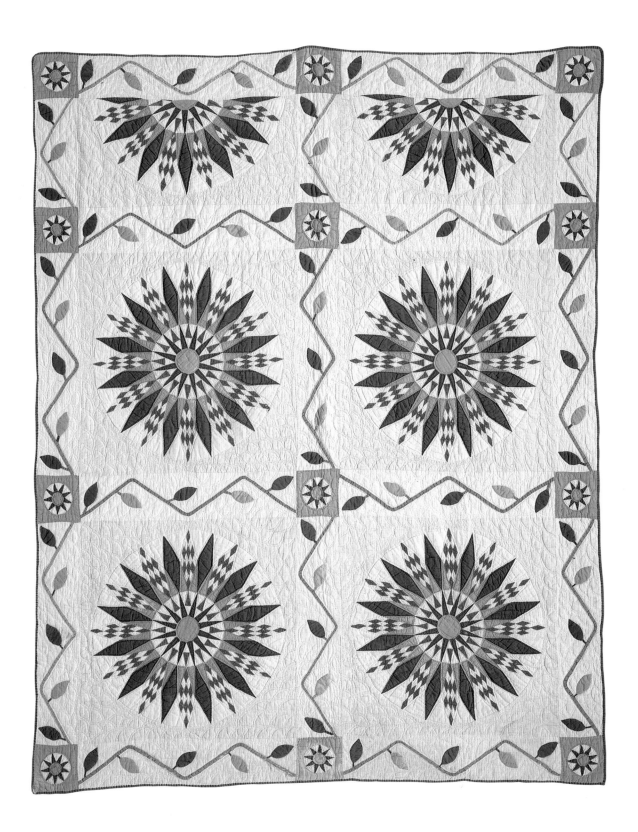

CRAZY QUILT

69" × 71"
Silk and velvet

1886 *(dated)*

Quiltmaker Sue Dee Grainger Brown.
Made in Houston, Harris County.
Owned by Dorothy Brown Jennings.

DATED through commemorative military ribbons found in the quilt, all of which cite the date 1886, it is possible that Mrs. Brown made this quilt as a wedding quilt for her marriage in 1887–88, for she lovingly centered her beautiful creation with a ribbon bearing the initials of the man she married, Orville Leroy Brown. 1886 was also the fiftieth anniversary of the founding of the Republic of Texas in 1836, and her grandfather, George Washington Capron, fought in the Texas War for Independence, so there was another reason for her to commemorate that year.

The quilt is lush and complex, cobwebbed with a myriad of fancy embroidery stitches typical of the Victorian period in which it was made. The general rule in dating Crazy quilts is that the smaller the pieces, the fancier the stitching; and the more silks and velvets used, the earlier the quilt. The larger the pieces, the fewer types of stitches; and the more wool used, the later the quilt. This piece meets all the criteria for an early Crazy Quilt, which again confirms the dating of the ribbons.

Among the commemorative ribbons used are five ribbons featuring the Lone Star of Texas and names of rifle teams participating in the Galveston Interstate Drill, August 1886. Prominently featured is a large souvenir ribbon from the Dallas State Fair and Exposition of 1886. It contains

Sue Dee Grainger Brown

finely etched renditions of the Exposition Building, Sam Houston, Ryan's Log Cabin in Dallas in 1840, the Alamo, the New Merchant's Exchange Building in Fort Worth, the "new" State Capitol, and the coat of arms of Texas.

A particularly interesting embellishment on this otherwise typical Crazy quilt is the hand-painted rear view of a Mexican soldier, complete with sombrero and crossed bandoliers. This design is located just above the large State Fair ribbon. The inclusion of the Mexican soldier was especially symbolic to the Grainger family, since the quiltmaker's grandfather had been a member of the ill-fated Mier Expedition into Mexico during the days of the Republic. In the quiltmaker's words, written as part of her application to join the Daughters of the Republic of Texas:

He joined the famous Mier Expedition and was one who drew the black bean, which was, as he said, a misfortune, as they were to be shot, and those who drew the white beans were to be taken prisoners. His buddy all through the War said to him, "you take my bean, as I have no family or anyone, and you have a wife and children back home." So they exchanged beans. Those who had the white bean were promised liberty but instead were marched on foot through arid country in Mexico. To allay their thirst, which was excruciating, they scraped prickly pears on the way to get moisture. The thorns from the pear caused their tongues to swell so they could not get them back in their mouths. Many of the men died under this torture. The other men were thrown into prison in Mexico half-starved and badly treated. Those who survived dug their way out and escaped. Only eight of those men lived to reach Texas again. One was my Grandfather G.W. Capron.

The border of the quilt is elaborately hand-embroidered on velvet and cut out to shape petals or tabs. The back is a beautiful wine sateen, machine quilted in a crosshatch pattern, typical of the commercially available backing fabrics manufactured in the 1880–1890 period.

Mrs. Brown, the grandmother of the current owner, was born in 1865 at the intersection of Fannin and Texas in Houston (now the downtown area), married in 1887 or 1888 in Houston, and died in San Antonio in 1932 at the age of sixty-seven. She lived in St. Louis much of her married life, and the family history on the quilt states that it won first prize at the St. Louis World's Fair.

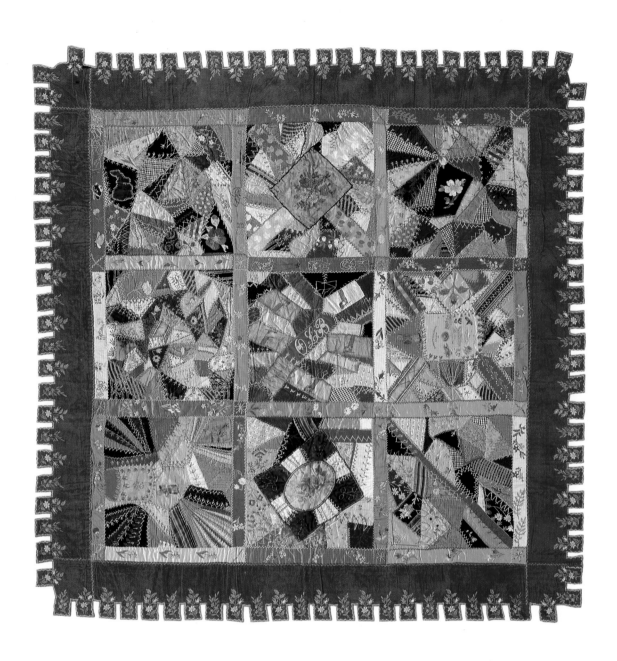

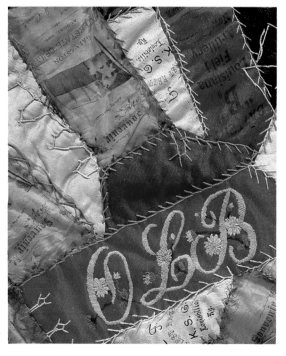

TEXAS QUILT

78″ × 84″
Cotton

ca. **1886**

Quiltmaker Nancy Rebecca Dickson Callan.
Made in Campbell, Hopkins County.
Owned by Billie Jean Callan Coldewey.

THERE could never be a question as to where this quilt originated: it spells out TEXAS in every direction! Graphic and dramatic, it is a classic among "word" quilts because it honors a state rather than the alphabet, a person, a date, or a piety. Each letter is pieced into the quilt individually, not appliquéd as might be expected.

Pieced "word" or alphabet quilts were popular during the last half of the nineteenth century; patriotic quilts came back into vogue with the Civil War and the celebration of the nation's Centennial in 1876. This quilt was made to celebrate the fiftieth birthday of both the quiltmaker and the Republic of Texas. The red, white, and teal blue that were used also carry out the patriotic theme, since the Texas flag is red, white, and blue emblazoned with a solitary star, the famous Lone Star. The fact that the quiltmaker's star has eight points instead of the requisite five does not detract from her intention but instead speaks to her obvious desire for symmetry and emphasizes that the quilt was designed to please the eye rather than be slavishly representational.

The one reverse S on the quilt may be a simple mistake, which does not seem likely because of the precision evident in the piecing of all other letters and the planning required to position each "Texas" so exactly. It may instead be a "deliberate error" related to earlier quiltmaking traditions. The legend of the deliberate error is age-old and found in many cultures, including that of the American Indian. Indian women used to create a minor imperfection or flaw in their pots or woven rugs to let the spirit of the piece escape. Many American quiltmakers believed that, since only God was perfect, to leave a deliberate error in your quilt was a mark of modesty and humility.

Nancy Callan, the great-grandmother of the present owner, was born in 1836 in Cherokee County, Alabama. She married fellow Alabaman George Washington Callan in 1861 and had nine children by 1879. She moved to Panola County, Texas, from Alabama at the time of her marriage. The family then moved to Hopkins County "so the children could get a better education," according to family tradition. Her husband died in 1885, leaving her to rear eight of her own children and two foster children. The TEXAS quilt was "made and quilted when she was taking care of a foster child who was very ill" during the year after her husband's death. Nancy Callan died in Rotan, Texas, August 1, 1912, at the age of seventy-five. She is buried in Sunny Point Cemetery near Greenville, Texas.

The TEXAS quilt is not the only evidence of Nancy Callan's loyalty to her adopted state— in 1875 she named one of her daughters after Texas—"Texanna" was born the year Texas celebrated its thirtieth anniversary of statehood.

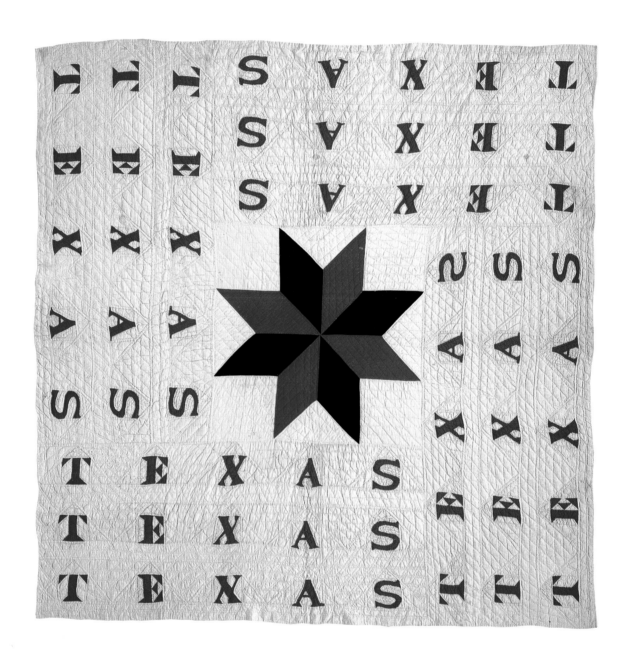

STRING STAR QUILT

72″ × 80″
Cotton

ca.1890

Quiltmaker Mary P. Turner.
Made in Marble Falls, Burnet County.
Owned by Alice Dawson Cheavens.

THIS quilt started out as contained and formally organized, but the quiltmaker's desire to create something different asserted itself before she was through.

Basically it consists of twelve blocks of hand-pieced stars, three of which across the top were left as half-stars. This indicates an economy of effort that is in accord with the maxim of all quiltmakers: "waste not, want not"—in conservation of her own energy and time as well as her materials. This practical quiltmaker saw no reason to piece more of the top row of stars than would be visible under the pillows. And while this looks unfinished when the quilt is seen in a photograph or used as a wallhanging, it would be undetectable on the bed for which it was intended.

The blocks are joined by green print squares repeating the print of the stars, and there are smaller print squares at the corners of the quilt itself. The quilting is a simple grid.

The quilt is planned so that the top row of half-stars and the row of stars on the bottom have center circles of strawberry print, with the same print repeated in a band across the stars' rays. The center two rows of stars have solid red circles with the same red repeated in the accent bands. However, the quiltmaker switched two blocks—the two on the right in the bottom two rows—so that they contain two blocks of their proper accent color and one odd block. This is her "deliberate error." To further emphasize this symbolic expression of her humility, she cut the accent fabric for the bottom right star from a red-and-white print rather than a solid red.

The inclusion of a deliberate error in her quilt would be in keeping with this quiltmaker's strong Baptist faith. Mary P. Turner was born in 1828 in Georgia and married in 1848, the same year the Treaty of Guadalupe Hidalgo ended the Mexican War, to a man who had fought in that war and who subsequently became a purchasing agent for the Confederacy, trading cotton for supplies from Europe through Mexico.

The Turner family had come to Texas, along with their relatives, the Ware family, in 1836 and settled in Columbus, Colorado County. Mary Turner's father-in-law was a large landowner who had many slaves. Her husband was the eldest son and, as such, became executor of his father's estate and the guardian of his younger brothers and sisters.

The couple prospered, owning land in Fayette and Travis counties, including some in the city of Austin, where they lived before moving to Marble Falls, Burnet County, where this quilt was made.

The quiltmaker, Mary P. Turner, was the great-aunt by marriage of the quilt's present owner, Alice Dawson Cheavens. Mrs. Cheavens was the executrix of the estate of her cousin, Nella (Penelope) Turner, granddaughter of the Turners and their sole heir, who left her considerable estate to Baylor University on her death in 1958.

Mrs. Cheavens said she is the "happy owner," not only of this vibrant quilt but also of other pieces of her Aunt Mary's handwork, because Baylor University trustees allowed her to keep family heirlooms.

Mary P. Turner

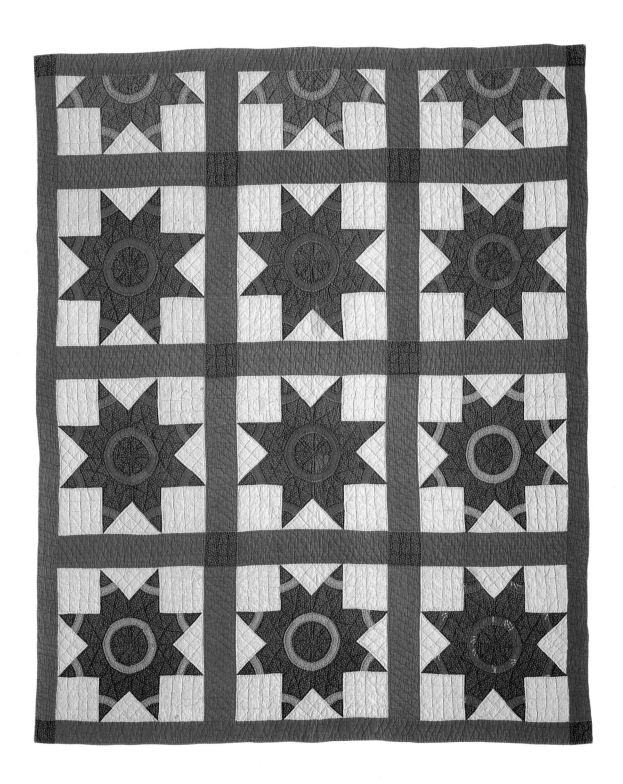

MEXICAN ROSE QUILT

92" × 94"
Cotton

ca. 1890

Quiltmaker Mary Ann Elizabeth Myers Armstrong.
Made in Smithville, Mississippi,
and brought to Kaufman, Kaufman County, in 1886.
Owned by Ruth Evelyn Keith Latimer.

A VERY orderly and beautiful red, green, and gold design appliquéd on white muslin, this Mexican Rose is more elegant than some variations of the pattern. Interestingly, the Mexican Rose originated about 1842, at the same time the Mexican invasions into the Republic of Texas were receiving widespread attention in the United States.

The appliquéd work in the quilt is truly superb. The edges of the red-and-green swagged border are delicately scalloped, the swags are separated by small red hearts, and the border continues its design as it turns the corner. The red in the quilt is beginning to show slight deterioration, and the fugitive green is just beginning to fade; however, it is basically in very good condition.

Quilting is excellent, with two rows of outline quilting around the appliquéd designs and four rows of outline quilting on the upper part of the swag border. Crosshatch quilting in a very even one-half–inch grid covers the rest of the quilt, which is then finished in a narrow dark green binding. Several skillful and unobtrusive early repairs can be seen in the binding, indicating that the quilt was prized highly enough to warrant extremely careful mending.

A formal, planned quilt, this Mexican Rose has a stately air about it that is quite different from scrap quilts. It was made from fabrics that probably were purchased especially for its construction or were saved for that purpose. "The fabric was cut to suit the quilt, not the quilt to suit the fabric" as an old saying goes. That fact, coupled with the great care taken in appliquéing and quilting and the small hearts in the swag border make it apparent that this was a "special occasion" quilt. Hearts were frequently quilted into special quilts. In some parts of the country, hearts were customarily added to engagement quilts destined for the bridal bed. However, they also found their way into quilts for other loved ones.

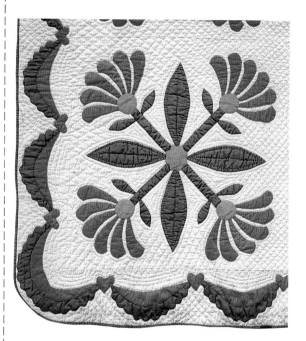

Following this custom of using hearts to mark special occasions, the quiltmaker made this quilt to celebrate the birth of her daughter, Mary Dora, born in 1867. Nineteen years later, when Mary Dora married, her mother joined the newlyweds in their move to Texas in 1886. Over the next eleven years, like many of the pioneers who migrated to Texas during the nineteenth century, the family moved ever westward. They stopped first in Kaufman, then moved to Coleman and Floydada, before finally settling in Matador.

The quiltmaker passed on her obvious love of quilting to her daughter, the grandmother of the quilt's present owner, Ruth Evelyn Keith Latimer, who remembers her grandmother continuing to quilt while chatting with visitors. "When people came to visit, they said Grandmother never missed a stitch," Mrs. Latimer recalled.

The quiltmaker lived from 1832 to 1909 and is buried in East Mound Cemetery in Matador, Texas, north of Lubbock, the family's final stop on its westward migration.

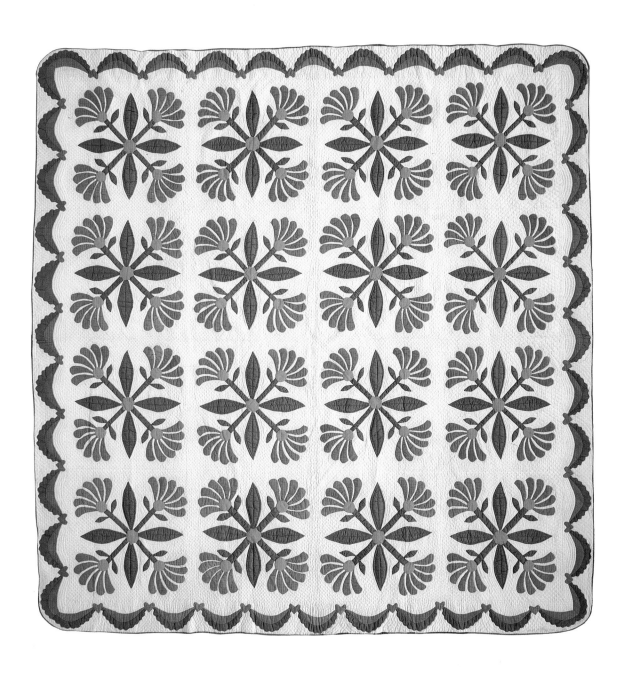

DOUBLE WEDDING RING QUILT

65" × 76"
Cotton

ca. 1890

Quiltmaker Lola Demetia Sweeten.
Made in Cleveland, Liberty County.
Owned by Edna Sweeten.

THIS graphic Double Wedding Ring has an impact in a photograph or when displayed as a wall hanging that would probably surprise the quiltmaker. The interlocking circles of the rings contain red and white with an indigo set and indigo accents. The background fabric has changed color, possibly because it was home-dyed green, which is fading unevenly to khaki, complicated by some fading of the indigo. It originally was an even more vivid quilt.

It is hand-pieced and hand-quilted in a double rainbow quilting pattern, with large stitches typical of a country quilt made rapidly for cover. Country women frequently had two classifications for their quilts: family quilts for everyday use and company quilts to be put on the guest bed only for visitors. This was obviously in the first category and shows evidence of quick and thrifty construction and extensive hard use. Its borders ripple and the quilt is uneven in width. The indigoes are pieced, probably because the quiltmaker ran out of her chosen fabric and had to make do with another. Hand-carded cotton was used for the batting, and cotton seeds can be felt and also seen if the quilt is held to the light.

The Double Wedding Ring is often thought of as a twentieth-century quilt pattern and we are accustomed to seeing it in its more usual form employing pastel hues and small floral percales beloved by brides-to-be quilting in the 1930s. Depression-era quilts also often use much smaller pieces in the rings. This quilt, however, illustrates that the bold piecing and striking solid color choices of a nineteenth-century quiltmaker can result in a very modern look. According to *The Romance of the Patchwork Quilt in America*, ". . . real quilt enthusiasts delight in this all-over pattern but it is hardly the design for the novice to undertake" (p. 101).

Quite likely, the quiltmaker, Lola Sweeten, was working in a hurry on this quilt to produce needed warm cover for her family, a husband and seven children. As the wife of a farmer, she worked by his side in the fields in addition to tending to household tasks and making all the clothing for her family. She is remembered as a quiet, reserved person who wore long, handmade dresses for all of her eighty-eight years, until her death on January 17, 1941.

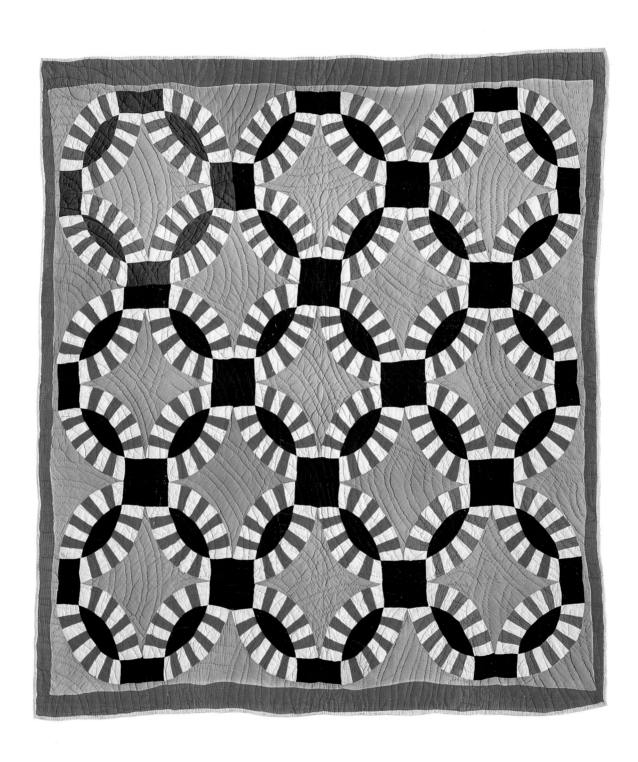

NEW YORK BEAUTY QUILT

68" × 70"
Cotton

ca. 1890

Quiltmaker Mary E. Chambers-Smith.
Made in Pursley Community, Navarro County.
Owned by Clarence A. Sprowl.

Mrs. Smith must have been a prolific quilter. This quilt is one of a pair of the same design; the other quilt is executed in red and white. In addition, when the family moved her possessions after her death, they recall "using old worn-out quilts for packing."

The quilter, grandmother of the present owner, was born in Navarro County, Texas, in 1858 and died in this area in 1938. She married twice, once in 1879 and again in 1892; both husbands were farmers in the Navarro County area. "She was an excellent seamstress but sewed only for the family and friends. She was a Christian wife and a good mother," according to family recollections.

Mary E. Chambers-Smith

A CLASSIC blue-and-white geometric quilt, this New York Beauty is also known by other descriptive names, such as Rocky Mountain Road and Crown of Thorns. The visual impact of this design depends entirely upon the manipulation of a simple triangle in varying sizes; the effect, however, is complex and exciting. This quilt carries the basic design two steps further by adding an inner jagged row to the large circular design and by repeating the curved element on a smaller scale in the center squares. This pattern was particularly time-consuming to make because of the multitude of blue and white triangles that had to be pieced together, approximately 2,700 in this quilt, all pieced by hand.

The quiltmaker chose to contrast the geometric precision of the pieced design with triple rainbow quilting so heavy that the quilting itself adds a third dimension. This juxtaposition of curves and geometric designs is a link to earlier quilts, which feature elaborately curved, appliquéd borders for pieced geometric quilts. The quilt binding has been carefully planned so that each corner is edged in blue; the binding was applied by machine.

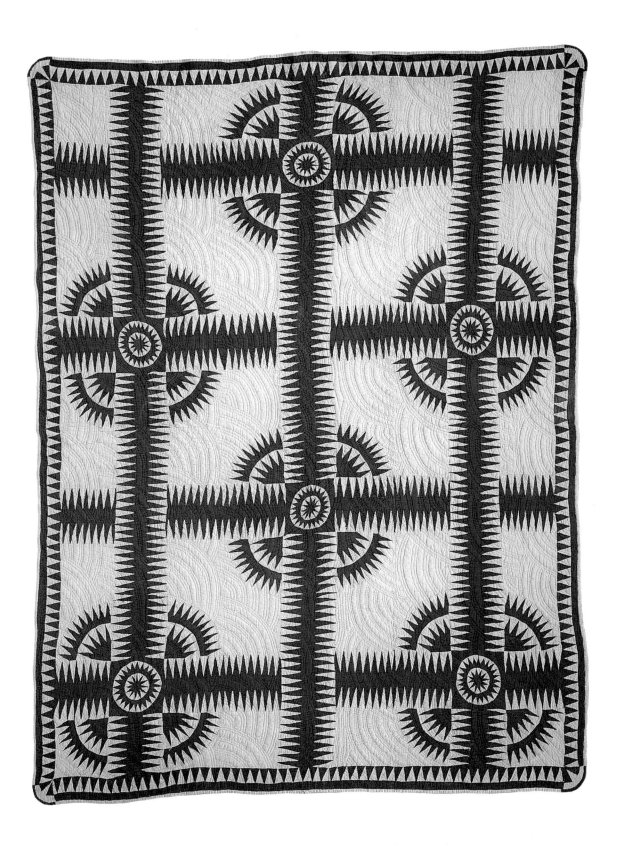

FAMILY TREE QUILT

82" × 63"
Cotton

1893 *(dated)*

Quiltmaker J. B. Roberson.
Made in Cleburne, Johnson County.
Owned by Christine, Bruce, Ruth, and Amanda Roberson.

THE MAN who made this quilt has left behind a unique statement about family unity and tradition in the form of this machine-quilted tribute to past generations. Family tree quilts are extremely rare; more commonly found are needlework samplers that trace family histories. It is also uncommon to find the quiltmaker's name as an integral part of the design of the quilt. Certainly the inscription leaves no chance to ascribe this quilt to "anonymous":

This quilt was quilted by J. B. Roberson at Cleburne, Texas December 20, 1893. Joshua Pitts was born 1799 and Nancy Pitts was born 1807 in S.C. J. B. and Mrs. Molly Roberson, Charlie and Mrs. Beulah Roberson. Rev. J. W. and Mrs. J. W. Rewbrough, Myrtle, Ollie Roberson and Edgar Rewbrough. Mr. and Mrs. J. P. Roberson, Hermon, Clyde, Wylie, Obie Roberson. Return good for evil—Cleburne, Texas, Johnson County. December the 20th 1893, this the 20th day of December. God Bless our Home. Mr. and Mrs. S. P. Witherspoon Tom Vance Brunette and Hial Witherspoon. T. W. Roberson and L. S. Roberson Edgar M. Roberson died June 26, 1887 Dick Roberson, John B. Roberson, Charlie Roberson, Buck Roberson, Mollie A. Roberson, Jesse P. Roberson, Nannie S. Roberson, Emma F. Roberson. This quilted by J. B. Roberson. J. B. Roberson J. W. Mills

The quiltmaker was a young man, married a little over a year. In a very short span of time, he lost his first-born daughter, who lived only three days, his mother, and his younger sister. Plainly, preserving the memory of his family was important to him. Because of the December twentieth date and the fact that he also included a line of information on members of his wife's family, the quilt was probably made as a Christmas present to his wife, as family tradition confirms. At the bottom of the quilt, he credits his brother-in-law, J. W. Mills, who held the bulk of the quilt for him while he guided it under the needle of the treadle sewing machine.

Because machine-quilted quilts lack handwork, they are often thought of as less valuable than hand-quilted works. However, that certainly cannot apply to a quilt that exhibits such mastery of technique. Mr. Roberson, remembered by a son as selling and demonstrating sewing machines later in life, perfected his use of this new tool early. He even accomplished readable script lettering, a very difficult task because to achieve the curves of script required pivoting the whole quilt around under the needle instead of simply moving a single needle. It is readily apparent that this piece is a fine example of American folk art. To stand before the quilt and read the Roberson history, and to sense the significance of the entwined lovebirds and "God Bless our Home" to a young man trying to establish a family in a frontier state, is to feel the strong emotional pull of the quilt even today. The admonition "Return good for evil" found in the quilt is especially apropos for a man who later became a successful horse trader near Stanton in Martin County.

In 1892, a separate quilting attachment for the sewing machine was invented by Henry Davis of Chicago, but this device was not commonly used. However, because there is so little evidence of the three layers shifting under the presser-foot of the machine, it is possible that Mr. Roberson used one in creating his quilt. It seems only logical that since he was selling and demonstrating sewing machines he would make it his business to practice with the very latest attachments.

Men quilted more often than we might believe. Two United States presidents, Calvin Coolidge and Dwight D. Eisenhower, took part in quilting. Coolidge pieced a Baby Block quilt when he was ten, and Eisenhower helped piece a Tumbling Block when he was a young boy. *The Romance of the Patchwork Quilt in America* cites Charles Pratt, who claimed to be champion quilter of the whole world and who created the Lamb of Peace quilt in 1911. This book also mentions Charles Esterly, a Pennsylvania farmer, who once made a quilt with more than nine thousand quarter-inch triangles, all hand-pieced. In our own family, Great-Uncle August Glaeser pieced a Feathered Star in the 1930s, learning at the same time as his young niece. Another Texas quilter, a Navy officer in World War II, remembers hiding his piecing under his bunk to avoid the teasing of his shipmates.

The early years of the Roberson family were full of sorrow—they lost four children between 1893 and 1896. However, Mr. Roberson and his wife, Molly Mills Roberson, went on to have six sons who grew up and married. According to his family, Roberson "was a rancher who bought, broke, sold, and shipped horses all over the country." J. L. Roberson was born in Texas in 1868 and died in Estacado, Texas, in 1925 at the age of fifty-seven.

J. B. Roberson

DIAMONDBACK RATTLESNAKE QUILT

70" × 73"
Cotton

ca.1895

Quiltmaker Jemima Elvira Johnson Bristol.
Made in McKinney, Collin County.
Owned by Marguerite Houston Brock.

Elvira Johnson Bristol with her husband, William H.

LIFE in early Texas was a constant battle with nature. The heat, blizzards, tornadoes, hurricanes, drought, flood, boll weevils, stampedes, epidemics, dust storms, mosquitoes, scorpions, and, perhaps, most frightening of all, the rattlesnake . . . the diamondback . . . the sidewinder.

The snake has had religious significance since Adam and Eve left the Garden of Eden and has fascinated Southern quiltmakers for that reason. Southwesterners also see the snake as a poisonous threat to home and family, as a personification of evil. "My grandmother, Hellen Drury West, lived in this part of harsh South Texas while most of it was brushland," recalls Riviera, Texas, quilter June West Martin. "The family milked cows for a living, and water was hauled from a well several miles away in the back of a wagon. My grandmother quilted and pieced quilts that she sold to help make a living to raise seven children. She received $1.50 to $2.50 per quilt. She died in 1943 as a result of a rattlesnake bite she received while rounding up the cows in the pasture. She killed the snake, made a tourniquet from a part of her apron, and then walked the mile back to the house." Women like this are the stuff of Texas legend.

The quiltmaker has clearly "geometricized" her coiled rattlesnake—note the complex patterning of the hand-pieced diamondback design and how intricate the piecing had to be to achieve the sinuous curve of the snake while working strictly within the diamond and triangle format. The quilting design itself resembles the distinctive, lateral looping bodily motion the sidewinder uses to move across the ground. It is uncannily accurate, almost as though the designer had stood and watched the snake's progress. The color combination and choice of prints perfectly match the protective coloration of the snake itself. The sere, drab, speckled browns were not the choice of a woman using whatever scraps were on hand, but instead were painstakingly selected to convey the image of the snake.

The Rattlesnake quilt bears resemblance to Mohawk Trail or Baby Bunting, but its closest kin is pictured on page 72 of John Rice Irwin's book about Tennessee quilters, *A People and Their Quilts*: the Georgia Rattlesnake quilt made from a borrowed pattern between 1926 and 1929 in a remote section of Union County, Tennessee. Irwin also discusses two other similar quilts called Quiled [Coiled] Rattlesnake—one found in Scott County, Virginia, and the other in Hancock County, Tennessee. This is significant to the Texas quilt because the Johnson family migrated from Virginia to North Carolina to Tennessee before moving to Texas, which raises the strong possibility that the four quilts all derive from one regional design.

Mrs. Bristol, the great-grandmother of the owner, was born in 1840, married in 1859, and died in 1908; she lived most of the time in McKinney, Collin County, after she moved to Texas in 1873 following her husband's service in the Civil War. She had nine children but lost five before they reached adulthood. Only one daughter survived, and the Rattlesnake quilt was left to her. She in turn passed it down to her daughter, who gave it to the great-granddaughter of the quiltmaker about twenty-five years ago because she also made quilts.

CRAZY QUILT

58" × 58"
Silk and ribbons

BRIGHT Mexican colors, which have been an integral part of San Antonio since its founding in 1718, must have influenced quiltmaker Annie McCauley, who was born there in 1873 and lived there until her death in 1934.

Crazy quilts were said to have been named for "crazed" china, whose glaze exhibited many tiny cracks, which the quilts imitated in their profusion of irregular patches. Many oldtime quiltmakers, however, have said they got their name because if you weren't crazy when you decided to start one, you surely were when you finished.

The rule for Crazy quilts, in most cases, was "the more the better." The more lavish the fabrics, the greater the number of pieces, the more intricate the embroidery, and the more elaborate the border and binding, the more admired the quilt. Many Crazy quilts were cluttered and virtually incoherent design statements—totally in keeping with the Victorian sensibility that rejected simplicity and cherished adornment. Sentimentality and anthropomorphism, which were also characteristic of the day, are perfectly expressed in this well-known period ode to the Crazy quilt by Flo E. Flintjer:

Oh, don't you remember the babes in the wood,
Who were lost and bewildered and crying for food,
And the robins who found them, thinking them dead,
Covered them over with leaves brilliant red
And russet and orange and silver and gilt?
Well! that was the very first crazy-patch quilt.

Such Crazy quilts ceased to be functional and were solely ornamental in nature. Most were nowhere near bed-sized, since they were not intended for cover. They were used as small "parlor throws" to show off their maker's stitches and to verify that she was, indeed, fashionable.

Always, though, there were quiltmakers who rejected, could not afford, or did not even know about this trend of the day. Many of them probably made Crazy-Patch quilts, all right, but they were utility quilts where one irregular patch of fabric was butted against another and stitched down as quickly as possible to produce a bedcover.

This Texas Crazy quilt strikes a middle ground. It is fancier and more elegant than a utility Crazy and at the same time more restrained and tasteful than the overblown elaboration of a typical parlor Crazy. It is organized rather than haphazard, and it exhibits selectivity in its color combinations and stitchery embellishment. There is an overall cohesiveness brought about by its block format, its employment of unifying black, apricot, and lavender throughout, and its use of only two delicate floral images—lilylike and rounded.

The quilt contains much moire and many silk ribbons and is pieced and embroidered to resemble Crazy quilts that contained commemorative ribbons. It has very fine decorative briar stitching around each fabric and around each of its blocks. The blocks are centered by a five-inch black square with a central motif of crossed lilies. All blocks except for the center one then have square or rectangular bands with small, spiky embroidered flowers, many with a spokelike center.

Many Crazy quilts were "tacked" from the backside with yarn or bits of ribbon to hold front and back together. Others, such as this, exhibit no evidence of tacking. Parlor Crazies were virtually never filled with batting or actually quilted, their sole purpose being decorative.

This quilt was made by Annie T. McCauley, the great-aunt of its present owner, for her sister's anniversary. The sister passed it down to her daughter, who gave it to her son, the Reverend Robert S. Loomis, and his wife. Its center block bears the inscription "1895 A . T."

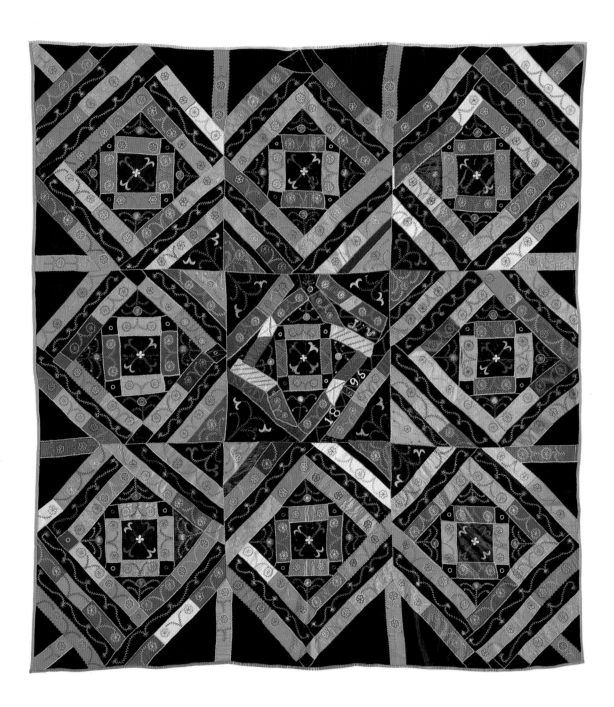

LOG CABIN QUILT

68¼" × 82"
Cotton

*ca.*1895–1900
Quiltmaker Rebecca Hooker Patterson.
Made in DeLeon, Comanche County.
Owned by Ruby Wood Cleveland.

CONSTRUCTED in the Barn Raising variation of the Log Cabin design, this quilt conveys contrasting values of both serenity and activity with its formal geometric design pieced in vibrant colors. The quilt was probably planned to fit a particular bed, which explains the off-center construction in an otherwise formal quilt. Hand-pieced in one-inch logs with three rows of hand quilting per log, this quilt reflects loving attention to detail. Most Log Cabins are either quilted "in the ditch," meaning in the seamline, or are quilted minimally, just enough to hold the back to the front. Since some are even tacked and not quilted, it is unusual to find the triple quilting that creates the dimensional effect found in this quilt.

The Log Cabin, considered by many to be the most American of the thousands of quilt patterns that exist, is one of the most abstract designs in quiltmaking and adds credence to the recurring theory that quiltmakers were among the first abstract artists in America. The Log Cabin derives its name from the construction of the basic block built of strips, or "logs," around a center square. Each block is divided diagonally by color or intensity, half light and half dark. The center square is usually in shades of red, yellow, orange, or rose, to indicate the hearth, or the heart, of the home.

It is the arrangement of the individual blocks, the way they are set together, that gives each Log Cabin its own particular design, such as Barn Raising, Streak of Lightning, Courthouse Steps, and Straight Furrows. Log Cabins are often dark and dramatic, pieced of somber colors, which makes this quilt more unusual in its use of livelier hues. It is also uncommon to find a turn-of-the-century Log Cabin that was not made of scraps but was made out of new fabric purchased in large

enough quantity to complete a quilt. The Log Cabin or Loghouse quilting, as it was called in England, was always considered an American invention, according to the *English Dictionary of Needlework*, published in the last quarter of the nineteenth century.

Mrs. Patterson, the grandmother of the present owner, was born in 1848, married in 1867, and the mother of six children, including twins. The family moved to Texas in 1896 from Pontotoc County, Mississippi, and she lived in Comanche County until her death in 1940. Mrs. Patterson gave the quilt to her granddaughter in 1925 for her graduation from Lamesa High School. The owner recalled that it was "selected from the many quilts my grandmother made over the years" and that "she did beautiful needlework of all kinds."

Rebecca Hooker Patterson with her three daughters

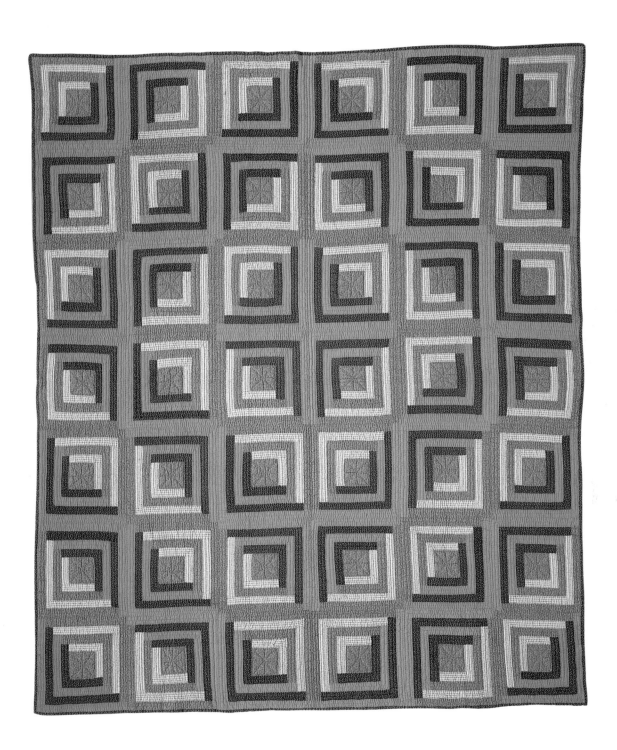

HARRISON ROSE QUILT

74" × 85"
Cotton

ca. 1895–1900
Quiltmaker Almeda Bell Dickerson.
Made in Brookeland, Sabine County.
Owned by Rebecca Doris Dickerson Radde.

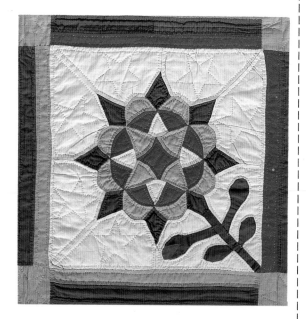

Almeda Bell Dickerson, *left*

LUSH, vivid colors and difficult curved-seam piecing combine in this appliqué quilt to create the striking effect of a flower garden in full bloom. The Harrison Rose is an appliqué pattern that requires the actual flowers to be pieced. Each blossom consists of thirty-three pieces before the stem and leaves are added; the roses alone account for more than five hundred pieces.

The vibrant flowers are contained within a tri-color gridwork with rose squares at each intersection. A double border is added at top and bottom only. The quiltmaker chose to set off the spiky flowers by quilting five-pointed Texas stars in both the white areas and the rose squares.

Adding a touch of whimsy, one rosebud is yellow and another is pink, the only departures from the otherwise carefully planned colors. Possibly this variation had a special significance to the quilter that is no longer apparent. The quilt top was pieced and appliquéd at one time and quilted and bound later, probably after 1900 because of the use of the unusual large floral printed backing fabric, which resembles cretonne.

Mrs. Dickerson, the mother of the present owner, lived in Texas all her life, from 1880 to 1965. She was born in Sabine County and died in Bosque County. According to her daughter, "She went to all the small schools available and wanted to go to Sam Houston Teachers Normal at Huntsville. However, family members objected. She took examinations and received a second-grade teacher's certificate; then she taught elementary school for one year before she married."

The quiltmaker was related to five of the families who were early settlers in the East Texas area now located within a radius of twenty-five miles of the present location of Sam Rayburn Dam. The first of the families, the Letneys and the Lowes, moved to Texas in 1829; the Magees and the Dickersons moved in 1840; and the Bells came in 1854. They all settled in San Augustine, Sabine, Jasper, Angelina, Newton, and Nacogdoches counties. Most of the families have remained in these areas. Almeda Bell Dickerson, the maker of this quilt, was born in 1880 in Sabine County, married in 1901, and moved to a ranch in Glasscock County in 1920. She and her husband remained on the ranch until 1948, when they moved to Bosque County to be with their daughter.

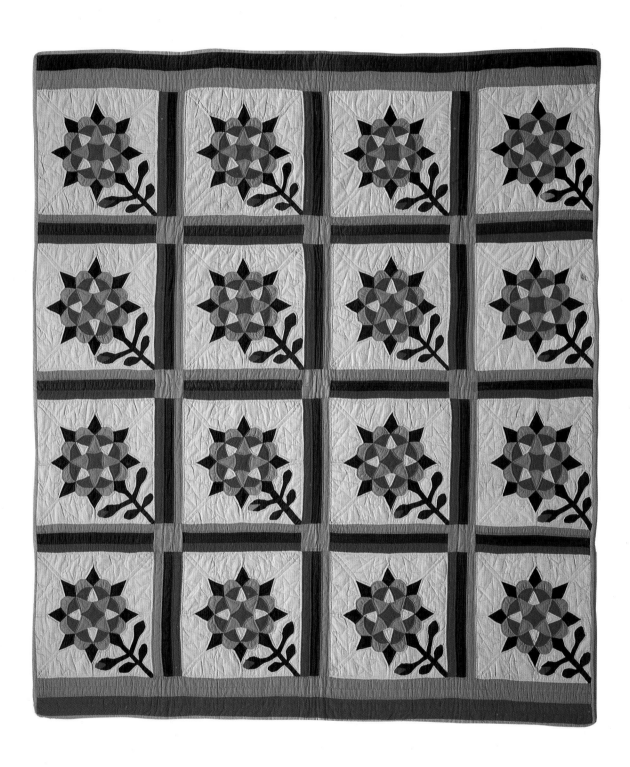

STARS AND STRIPES QUILT

87" × 91"
Cotton

ca. 1895–1910

Pieced by Laura Maria Ott Myers; quilted 1970 by
Inez Lee.
Pieced in Erath County.
Owned by Ilona Dee Tanner Smith.

AS AMERICAN as the Fourth of July, this bold
patriotic quilt positively reverberates with high
spirits. Full of movement and images, Stars and
Stripes seems too restrained by its binding, as
though it should break free to wave in a passing
breeze.

There are two categories of quilts, according to
authorities at the Shelburne Museum in Vermont: the "tame" ones with geometrically conceived pieced or imaginatively appliquéd tops
where each tiny fragment fits next to and matches
up with its neighbor, and the "wild" ones, where
the quilter has designed her quilt without regard
for the conventional rules of composition. Certainly this spirited example would belong to the
latter class. Barbara Brackman in *The Quilt Digest*
has called quilts such as this "quilts that break the
rules," and indeed this one does. Pieced stripes
don't match up, points of the stars are cut off, the
edge of the quilt ripples, and yet it is inspired.

The quilt breaks rules in another way, too.
Most quilts with multifabric pieced stars, which
required patience and precision to piece, showed
them off with negative white space of surrounding
counterpane blocks of quilting. In this case, the
maker used small red, white, and blue prints, of
which she obviously had a great deal, to strip-piece stripes, which she then cut into geometric
shapes to surround her stars. The conflict and
tension thus created between the stars and stripes
take this quilt out of the ordinary and produce a
whirling effect.

There actually is a great deal of order in what
seems to be chaos in this quilt. Separating the
center complete stars and the outer half-stars are
four squares of stripes that appear to be braided.
Within these squares, the stripes are carefully
matched to produce two blue swastikas, symbols
of good luck in ancient Egypt and of the sun in
Germany until their original meaning was corrupted in the twentieth century during World
War II. The spinning swastika can be found
painted on Pennsylvania-Dutch barns and was
referred to as "hexfeiss," or witches' feet, noted
Florence Peto in *Historic Quilts*, and it was used
as a quilting design.

The swastika also found its way into many
early American Indian designs, and, when this
quilt top was begun, Indian activity in Erath
County was still a distinct possibility. Tales of serious depredations by the Comanches and their
allies, the Kiowas, in Erath County between 1860

Laura Maria Ott Myers and her great-grandson,
Weldon Ivan Gates

and 1870 must have reached the ears of new arrivals, such as this quiltmaker shortly after she
settled there in 1880.

With its red, white, and blue theme and stars
and stripes, the pieced top could have been started
to commemorate some historically significant
date, perhaps the fiftieth anniversary of Texas
statehood in 1895. Family tradition has it that the
completed top was presented to Cecil Dale Tanner, the first grandson of the maker and the father
of the present owner. He was born May 4, 1910,
and this span of time would be consistent with the
variety in the quilt's fabrics.

The woman who pieced this quilt was born in
1853 in Mississippi, married in 1879 in Louisiana, and came to Texas in 1880 with her husband, father and mother, eight brothers and sisters, her mother's half-brother, and a young friend
and neighbor. She was pregnant with her first son
during the nine weeks of travel it took to reach
Erath County.

The present owner of the quilt, Ilona Dee Tanner Smith, daughter of the man whose birth it
celebrated, had the top quilted in 1970 to preserve it. Her husband's aunt, Inez Lee, quilted it
in a simple rainbow pattern and bound it by
bringing the back around to the front and stitching it down.

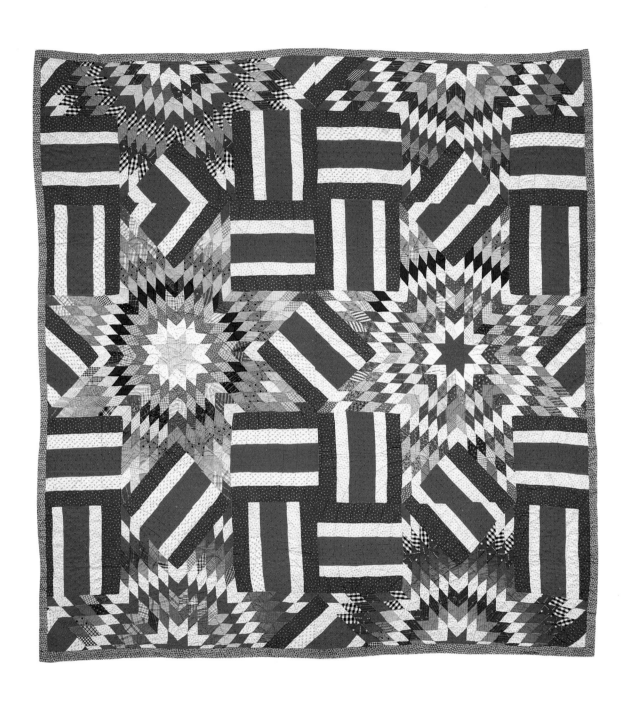

FEATHER EDGED STAR QUILT

67″ × 79″
Cotton

ca. 1900

Quiltmaker Lillie Ann McBee Daugherty.
Made in Gainesville, Cooke County.
Owned by Jessie Glynn Daugherty Burnett.

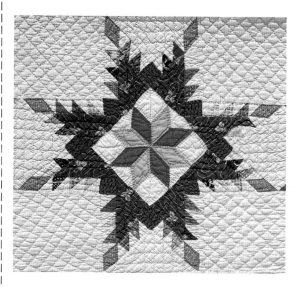

TURN-of-the-century and earlier fabrics make this lively, spirited Feather Edged Star scrap quilt a perfect textile commentary of its time.

There are several ways to date a quilt that has not been signed by its maker, and one is through the age of the textiles used in it. This can be a challenge, especially in quilts using many pieces of different fabrics—more than one hundred in some. Also, fabrics to be used in quilt blocks and tops were saved over many years, were exchanged with family and friends, and were handed down in scrap bags to daughters. Therefore, fabrics in a quilt can be considerably older than the quilt itself, or even its maker. It is not always accurate to date a quilt by the newest material used in it because quilts were repaired throughout their useful life, and new repairs on old quilts are common. Instead, a quilt should be dated by the age of its predominating fabrics.

Between 1875 and 1900, the period from which we can assume this quiltmaker gathered most of the fabrics used in her Feather Edged Star, there were several general trends in fabrics that help in dating. In her excellent section on dating textiles in *Quilts in America*, Patsy Orlofsky lists these as continued proliferation of roller-printed fabrics; less detailed, minute, and fussy prints in shirting and other cottons; slightly larger-scaled motifs; continued use of navy, blue, and white; continued use of conversation prints; continued use of commemorative fabrics throughout the fourth quarter of the century; and a single design that's available in a number of colors.

This quilt uses relatively large triangles of an indigo print containing a white trilobed flower and a yellow vine that was available during the Civil War era, 1865–1875. There is a strawberry print that was available and widely used for a span of years from 1875 to 1915. The small, deep red squares between the points of the feathered star are typical of a turn-of-the-century print, as is the black-and-white print used in a triangle "feathering" the top right blue point of the larger star. This quilt's textiles, therefore, are quite consistent with its age, which we know from family history.

Three things, though, set this particular Feather Edged Star apart. Its blocks have an unusual center composed of pieced gold and red eight-pointed stars; the manner in which the twelve feathered stars touch at the tips of their outer diamonds produces an optical illusion of oval white space between; and there are outer half-stars on two sides

of the quilt, as if it might have been made for a bed which would be in a corner against two walls.

Quiltmaker Lillie Ann McBee was born in Tennessee in 1877, came to Texas at age four, and grew up in Gainesville, Cooke County. She made this quilt in 1900, for her marriage to W. W. Daugherty, and six years later she moved with him to Middle Well Community in the southwestern part of sparsely settled Moore County. In 1914, they moved to Dumas, where her husband held county office for twenty-four years.

The quiltmaker passed her wedding quilt on to her daughter, Jessie Glynn Daugherty Burnett, who owns it now. Mrs. Burnett said her mother, who also did other fancy needlework, continued to piece quilts on through the years until her death in 1953.

Lillie Ann McBee
Daugherty

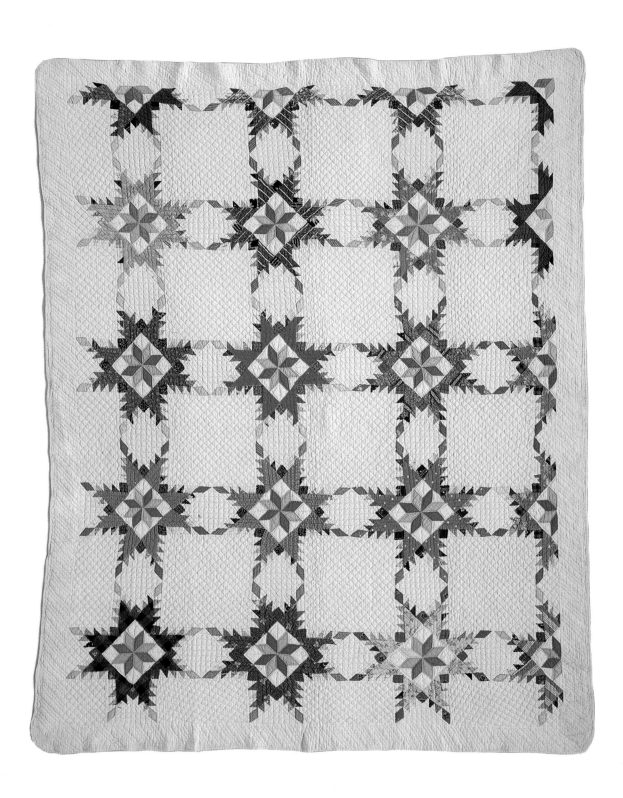

WHITE-WORK QUILT

72″ × 78″
Cotton

1901 (dated)

Quiltmaker N. Wagner.
Made in Calvert, Robertson County.
Owned by Sheralyn Hogan Humble.

WHITE-WORK quilts were often bride's quilts or marriage quilts, and this is no exception. Made as a wedding present by a maiden aunt for her favorite nephew's elopement, this is a beautiful example of twentieth-century white work which is centered on a medallion with flowers, grapes, and leaves. The grape, a symbol of fertility, was often associated with marriage.

The seams around each block are embellished with a delicate briar stitch executed in white, very similar to the Turkey red stitching often used for the same purpose in the Kate Greenaway embroidered quilts popular in the last quarter of the nineteenth century.

The individual blocks alternate between two designs: flowers and grapes. An outer border consists of stuffed grapes and grapevines, and a delicate sashing of small one-inch squares turned on the diagonal and individually stuffed separates the rows of blocks in an unusually handsome effect. The quilting on this piece is very fine and outlines the designs. Fill-in quilting is not used, however. Stuffing the design with extra cotton was most appropriate for work done in Calvert, a city that in 1871 "boasted the largest cotton gin in the world," according to the *Handbook of Texas*. The quilt is bound with twill tape.

Miss Wagner was born in Texas in 1865 and died in 1930, never having married and never leaving Texas. Her family moved to Texas in the early 1800s, settling first in areas along the Brazos River; later other members of the family settled in the Houston area. Because she had no children of her own, she was very close to her sister's children. Randolph Dixon, for whom the quilt was made, "was the first born and therefore was her 'favorite,'" according to the family. He eloped in 1901 with Emily Anderson to Atlanta, Georgia, but the couple returned to Texas that same year and lived in Galveston the rest of their lives. Mr. Dixon's father, Sam Houston Dixon, was a Texas legislator and historian. Family history states that Sam Houston Dixon's father, Shadrack Dixon, was Sam Houston's best friend during the Texas Revolution and that the family "was very instrumental in the settling of Texas and fighting for its independence."

TARGET QUILT

78″ × 79″
Cotton

ca. 1910

Quiltmaker Lorah Sasser Clark.
Made in Nancy Prairie or Whitesboro, Grayson County.
Owned by Dorris Peeler Saunders.

Lorah Sasser Clark with her husband,
James Milton, and their children

THE Target quilt is apparently a true regional quilt, originating almost exclusively in the Southern states or with Southern quiltmakers whose families migrated elsewhere. Other documented examples of Target quilts have been discovered in Kentucky, Mississippi, and Alabama. In this instance, the quiltmaker's family moved to Texas from Mumford, Alabama.

The Target quilt, or "Quill" quilt, so called because its component parts resemble porcupine quills, is hand-pieced of folded triangles like the ones most often found as Prairie Points, triangles used as edgings on quilts. These triangles of multicolored scraps are hand-sewn in concentric circles of overlapping rows completely covering squares of foundation fabric. When the squares were pieced together, the result was an exceptionally heavy quilt. The family estimates there are more than 42,000 tiny triangles in this stunning piece. The Target quilt's appeal is both tactile and visual. The feel of the piece is fascinating—the bits of folded triangles are stitched down only at their base, so the points of the half-inch pieces are loose and may be ruffled by passing a hand across them.

Target quilts do not meet the classic definition of a quilt because they do not contain quilting stitches holding three layers together. However, these creations are generally acknowledged as novelty quilts. They were inspired by the 1890–1910 fad for quilts containing thousands of tiny pieces. During that time and up until 1920, an unofficial competition existed within quiltmakers' minds to see who could create a quilt with the most pieces in it. As soon as word got out about a quilt containing 10,000 pieces, someone else would set out to make one with 50,000, then 75,000, and higher still. One quilt seen at the Austin Quilt Day, made in Alabama, contained over 100,000 pieces smaller than a grain of rice.

Visually, the Target quilt is dynamic. The black or dark bull's-eye centers provide focus and balance for the thousands of pieces of turn-of-the-century fabrics used, and the forty concentric rows per ring draw the eye inward into the heart of the quilt. A typical 1900s back of floral cretonne was used.

Lorah Sasser Clark, the grandmother of the present owner, was born in Whitesboro, Texas, in 1879 and died in Levelland, Texas, in 1954 at the age of seventy-five. She was married in 1898 and had five children. She started the Target quilt when she was sixteen and completed it over a fifteen-year period. Many of the fabrics used are from the fourth quarter of the nineteenth century, which indicates that she worked from a well-stocked scrap bag following her own precept: "Waste makes want."

Mrs. Clark was an interesting woman with great strength of will. As a young girl, she began working as a seamstress, sewing linings for the coffins her father built in Whitesboro. Later she served as a nurse and midwife for doctors in Saddler and Hopesville, Texas. According to the family, "She suffered a stroke about 1910, which kept her bedfast for several months and caused her loss of speech. Yet she made a complete recovery. Her philosophy of life is reflected in three mottos she often repeated: 'Where there's a will, there's a way . . . If at first you don't succeed, try, try again . . . and If a thing's worth doing, it's worth doing well.'" The coincidence of the quilt's estimated date and Mrs. Clark's stroke make it possible that she finished this work while recuperating.

Another textile piece that strongly resembles the Target quilt is the Pequito quilt found in New Mexico. This quilt is also constructed in large squares, pieced out of folded triangles, and produces the optical effect of spinning. Like the Target quilt, the triangles in the Pequito quilt are sewn down in a circular pattern that completely covers the foundation fabric.

POSTAGE STAMP QUILT

64″ × 74″
Cotton

ca. 1910

Quiltmaker Rosa Ana O'Riley Whitworth.
Made in Ellis County.
Owned by James M. McCrory.

TINY, multicolored pieces of cotton fabrics were manipulated by this skillful quiltmaker to produce a quilt that uncannily foreshadowed today's computer-generated paintings. To some, it may suggest a pointillist painting, where small dots of color blend when viewed at a distance. Whatever the visual connection, the quilt undoubtedly is very optical.

It's also a wonderful scrap quilt hand-pieced and quilted with almost eight thousand squares of fabric carefully arranged by color, except where the quiltmaker ran out of a piece. She obviously had more blue than anything else, not much red, and less yellow. Fabrics used include shirtings, checks, and chambrays.

This Postage Stamp quilt is a variation of one in which the pieces were the size of actual one-inch-square postage stamps. In this instance, however, the pieces are even smaller—more like one-half–inch–square sugar cubes. Quilts in which such squares of fabric are arranged in ever-enlarging series of squares are also called Trip around the World.

Between about 1890 and 1910, the challenge of trying to use as many small scraps of fabric as possible in a quilt was in vogue, with friendly rivalry under way in some communities. Quilt patterns lending themselves to such efforts included Postage Stamp, Trip around the World, Target, and String Pieced.

Quiltmaker Rosa Whitworth, born May 15, 1875, was a stalwart woman with only a grammar school education who moved to Texas from Kentucky with her five small children after her husband was killed in a logging accident. She settled on a farm near Waxahachie in Ellis County, where this quilt was made. She never remarried but reared a close-knit family and in later years lived with various children, helping with her grandchildren. She died in Harlingen at age ninety-five.

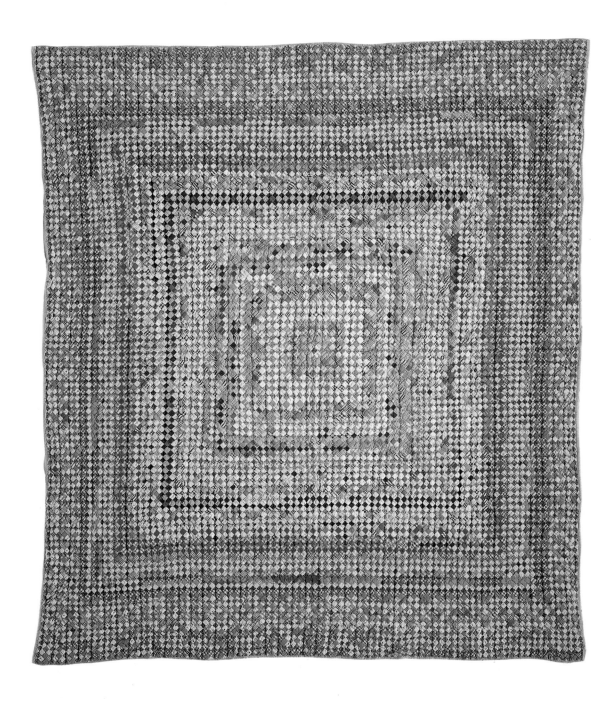

129

CRAZY QUILT

82½″ × 70½″
Wool

1911 *(dated)*

Quiltmaker Julia Savannah Beaty Florence.
Made in Mesquite, Dallas County.
Owned by Zenaide Florence McDaniels.

THE only thing predictable about this quilt is the uniformity of its pieces—men's suiting samples. The rest of the quilt is a highly imaginative rendering of daily life on a Texas farm just after the turn of the century. Full of eccentricities and family humor, the embroidered quilt tells the story of the Florence family every bit as much as a diary or a sampler would.

The quilt was clearly a special project undertaken out of love of family. Had the quiltmaker been making a bed cover for the sake of needed warmth, she would not have taken the time to hand-embroider a myriad of images all over the surface of the top. The rectangles of wool were quickly pieced together first, but the embroidery—its conception and its execution—took far more time. Expertly drawn with needle and thread by a woman who could neither read nor write, the images on this quilt were her way of recording family history; she used symbols instead of words, but the tale they tell "reads" as well as any autobiography.

Upon close examination, it is possible to find these images and their stories: The china lamp her husband gave her that was cherished but never lit because she was so afraid of fire on the farm . . . her youngest son's pet javelina hog, "Havie," that terrorized the farm . . . a memorial block for her baby daughter Martha, dead of the "summer complaint" before she was a year old and whose death caused Julia's hair to turn snow white at the age of twenty-two (see M.C.F. initials) . . . the Percheron horses and Hampshire sheep raised by her son on the family ranch . . . the time the pet javelina rose up on a fence to munch on the tasty young corn . . . the two horses "borrowed" one night by the famous outlaws, the Younger brothers, to replace their worn-out mounts . . . the three blocks her young grandchildren embroidered with their names or initials when they were visiting one summer ("Julia," her namesake, three; "IMF," Isabell, six; "DWF," David Walker, eight) . . . a patch of flowers carefully watered daily when she threw out the dishwater . . . an old-fashioned "morning glory" gramophone . . . a salamander . . . the old Indian who "hung around the ranch" with his tomahawk . . . a large placid cow with hearts entwined beneath its feet . . . a United States shield with flags behind it . . . five-pointed Texas Lone Stars of every variety, even a Texas flag.

The most delightful block on the quilt is small, located two rows to the left of "Havie" and seven blocks up toward the top of the quilt. It contains a precisely embroidered centipede. No one could improve on the words of the quilt's owner as she explained the appearance of the centipede on her grandmother's quilt: "When my father, John Hicks Florence, was about a year and a half old, Grandma Julie had to take him with her when she worked in her garden. One day he screamed, and when she reached him, she found that he had picked up a centipede and put it in his mouth. This caused him to have what is called a 'Geographical Tongue.' Although I was the baby and the eighth child to be born in my family, I inherited my father's 'Geographical Tongue.'" Some people might call this a perfect example of a tall Texas tale, but Mrs. McDaniels calls it family history.

Julia Savannah Beaty was born in 1850 in Arkansas and orphaned at the age of four. She was reared by a family in Grand Saline in Van Zandt County, Texas, where she met and married David Walker Florence in 1866. The Florence family established their homestead in Mesquite in 1871, two years before the town was even platted; the Florence family ranch is recorded as a Texas historical landmark. They had three children over the next eighteen years. Julia Beaty Florence died in 1914.

The oldest son, Dr. John Florence, was state health officer for Texas in 1922 and helped to found the Baylor School of Medicine. He was the father of the quilt's owner, Zenaide Florence McDaniels, who states: "I was so young when my grandmother died that I did not feel a closeness to her. But since her quilt was chosen for this book, I have made a minute study of each square in the quilt and now feel a personal, loving relationship with her. Now I know where I inherited my love of animals, wildlife, and all aspects of nature."

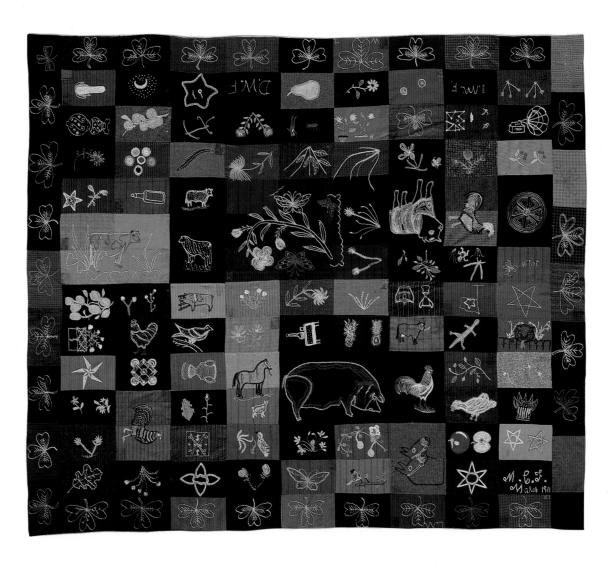

RED CROSS QUILT

85″ × 78″
Cotton

ca. 1918

Quiltmaker Anna Clare Tate Stanfield.
Made in Wichita Falls, Wichita County.
Owned by J. Tate Stanfield.

WITH America's entry into World War I in 1917, the aid and comfort provided our "doughboys" by the Red Cross captured the American imagination. Texas joined the rest of the nation in encouraging its citizens to make the sacrifices necessary to support the war effort. People cooperated in a food conservation program known as "Hooverizing" with wheatless Mondays and meatless Tuesdays; and everywhere, Texans were exhorted to "Give Till It Hurts" and "Do Your Bit."

To raise money for the Red Cross during what was innocently called "the last great war," signature quilts were created. These were a continuation of the American tradition of signed friendship quilts and signed commemorative quilts with a new twist: people were charged a small sum, usually a dime, to sign patches for the quilt. Businesses were asked to underwrite whole blocks with the names of their employees.

The quiltmaker started this quilt in January 1917 as her personal contribution to the Red Cross; she finished it in 1918. Some of the names on the quilt are those of young men who were learning to fly at Call Field, located in Wichita Falls during the infant days of army aviation. Mrs. Stanfield accepted donations to add the names and then donated the quilt to the Red Cross to be sold at auction. From the name donations and the auction, the quilt raised more than $300, a sizable sum for that time.

High bidder on the quilt was a Dr. Parnell, who then returned it to Mrs. Stanfield in appreciation for all the work she had put into it. She began to sew for the Parnell family and did such excellent work making the doctor's worn shirts look like new that she eventually began a tailoring business. She did all her work on a Singer Treadle Machine, and when it was later converted with an electric motor, she claimed that the motor "slowed her down."

With a needle and that sewing machine, she saw four children through high school and one through college. Her youngest son, J. Tate, now the owner of the quilt because his mother was pregnant with him when she made it, remembers being one of the best dressed boys in school in clothes his mother sewed. He wore his first store-bought shirt, tie, and boxer trunks on the day he graduated from high school.

Mrs. Stanfield was so proud of the quilt that she wrote on one of the Texas stars:

*This quilt
was designed,
made and given to
The Red Cross by
Mrs. G. W. Stanfield
Route 5, Wichita Falls, Texas
nee Clara Tate
Sipe Springs
Texas*

The signature wheels were created using reverse appliqué, with each of the more than 500 signatures on separate blocks of muslin carefully arranged in place before the red fabric was trimmed around each name and appliquéd. The entire wheel was then appliquéd to a block. The five-pointed stars, typical of Texas quilts, are pieced by hand and appliquéd down over the seam juncture where the individual blocks were joined. The appliqué was done with a running stitch. Additional names were also written in ink around each wheel; sometimes these were company names, and the names in that particular wheel refer to employees of the company.

Because of the positioning of the star in which Mrs. Stanfield wrote her inscription about the quilt, it is probable that she intended this portion with its half-wheels to show at the foot of the bed.

Anna Clare Tate was born in Sipe Springs, Comanche County, Texas, March 1, 1878. She attended Howard Payne College between 1898 and 1899, when the school term was only six months long—December through February and June through August—to free the students for spring and fall work on the farms. After her marriage in 1902 to George Washington Stanfield, the young couple had a general store in Gorman, Texas, and would make overnight trips in two big peddler's wagons out into the countryside to trade staples, hardware, and notions for eggs, chickens, butter, and other items. The Stanfields had four children between 1903 and 1917. Mrs. Stanfield died in Grand Prairie, Dallas County, in April 1961 at the age of eighty-three.

Anna Clare Tate Stanfield

133

PINWHEEL STAR QUILT

63″ × 76″
Cotton

ca. **1925** *(original design)*
Quiltmaker Paralee Hambleton Smith.
Made in Brazos, Palo Pinto County.
Owned by Myrtis Boling Womack.

KALEIDOSCOPIC effects make this original design Pinwheel Star outstanding. The solid and printed rays of the center red stars, bisected by white and overwhelming at close range, are set into motion by the surrounding negative space of the larger white eccentric Texas stars. They seem to be whirling straight off the quilt when viewed at a distance.

The only things restraining them are the strong hexagonal bands of reverberating red. At the ends of each ray are white hexagonal stars that form a trio in the set and look like small constellations. The quiltmaker used two kinds of white fabric in her quilt, which gives it subtle shadings, but the important thing is how she manipulated that white space as a major design element in her work.

This hand-pieced and hand-quilted quilt is more noteworthy for its unusual, exuberant design than for its emphasis on technique. It is simply quilted in an allover rainbow design and simply bound with printed fabric repeated from one of the star rays.

The quiltmaker was born in Missouri in 1872. Her father was a saloon owner who, with his family, headed west in a covered wagon. They stopped first in Palo Pinto County, Texas, then moved to Weatherford, "still trying to find the perfect place," according to a relative. The eldest daughter, Paralee, left school in the fifth grade to help care for her family and their home. She married at twenty-two and moved with her husband to Indian Territory in Oklahoma. "Life was so hard in Oklahoma they moved back to Texas," said the same relative; eventually they settled in Weatherford.

The quiltmaker had eight children, one of whom died and another of whom had polio. The family moved to a farm near Brazos, where Paralee Hambleton Smith died in 1949 at age seventy-two, after "she picked her prettiest quilt top and quilted it" for her last grandchild. After Mrs. Smith died, her husband passed on this bold, graphic quilt, as optical in its effect as any contemporary painting, to its present owner to keep for her daughter, Lawana.

Paralee Hambleton Smith with her husband, Elijah Bush, on their fiftieth wedding anniversary, May 1, 1944

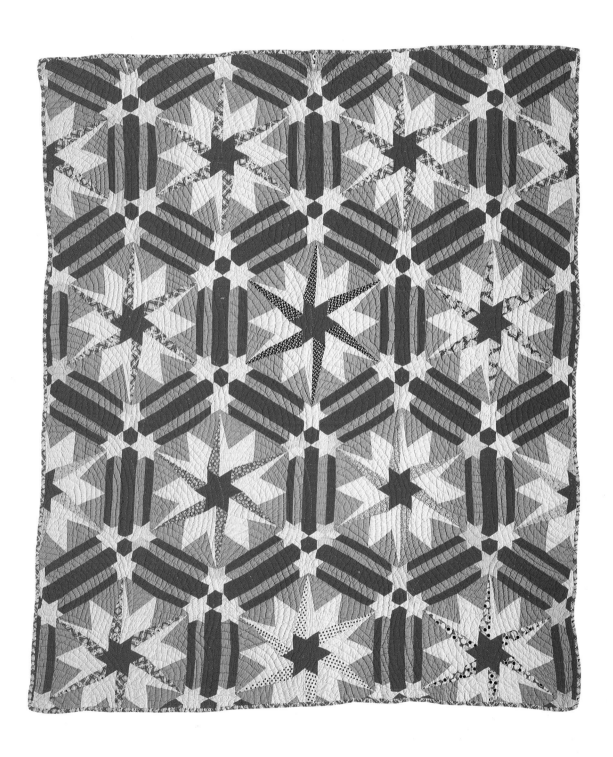

CUT-PAPER APPLIQUÉ QUILT

72″ × 81″
Cotton

ca. 1925

Quiltmaker Mabel McBurnett Watt.
Appliquéd in Roscoe, Nolan County.
Owned by Lady Frank Watt Brown and
Mary Brown Cox.

PINK and pretty is the best description for this lacy-looking hand-appliquéd quilt from the twenties, which resembles a snowflake crystal.

Quiltmakers drew appliqué patterns freehand or copied designs from anything that could be traced—purchased patterns, leaves, tile floors, and other available items. Then they made reusable templates from paper, cardboard, wood, or metal and traced the template pattern onto the fabric. The design was cut out, its hems pressed and edges basted down, and it was appliquéd onto the background fabric. Finally, the basting threads were removed.

Cut-paper appliqué, which produced an abstract, free-form design, was begun by folding a large square of paper into quarters or eighths. The design for the entire wide border of a quilt could then be cut out all at the same time, leaving a large center section for a cut-paper medallion. This method of producing ornate, original appliqué designs is most often found in quilts made in Hawaii or Pennsylvania, according to *Quilts in America*, although "as early as the Revolutionary days, the art of paprotamia—the cutting of paper to create ornamental designs—was popular in America . . . Quilters copied delicate cut-outs of tulips and roses for border patterns and in some instances, . . . the symmetrical patterns of cut-out paper were copied to create lovely abstract patterns" (pp. 251–253).

In Pennsylvania, the strong Pennsylvania-Dutch folk art tradition of "Scherenschnitte," or cut-paper work, accounts for the appearance there of cut-paper appliqué quilts. In Hawaii, however, the cut-paper technique evolved because the missionary wives who taught sewing and quilting to Hawaiian women found that all clothing in the islands was cut in full widths with no scraps left over for a scrapbag and the resulting pieced quilts.

In this graceful Texas cut-paper appliqué quilt, a bright solid pink fabric typical of the 1920s was used on a white ground to create a striking abstract central medallion quilt. It's possible but not likely that a purchased pattern, which would have been available at that time, was used to make the quilt. The quilt is finished with an alternating pink-and-white sawtooth, or prairie point, edge.

The quiltmaker and her farmer husband had four children and were a poor family, according to her granddaughter, Mary Brown Cox, who with her mother, Lady Frank Watt Brown, owns the quilt. Mrs. Cox also remembers that her grandmother was an excellent horsewoman as well as quilter.

Mabel McBurnett Watt, *left*

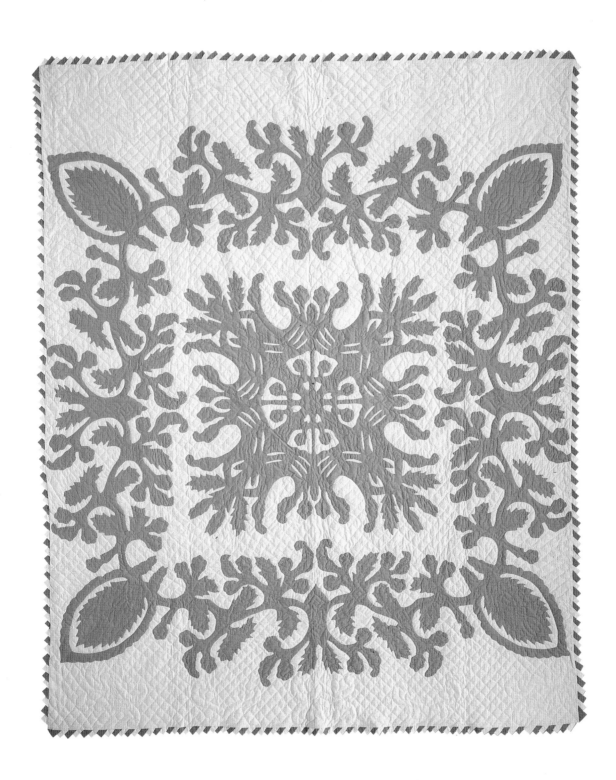

STRING SCRAP QUILT

69″ × 82″
Cotton

ca. 1925

Quiltmaker Gazzie Hill.
Made in Smithville, Bastrop County.
Owned by Mrs. George Powell and Travis Kirchner.

THE child of a slave, Gazzie Hill was born, lived, and died without ever leaving the Smithville-LaGrange area of Central Texas. Yet despite her limited exposure to sophisticated art, she has created a highly imaginative example of primitive design out of the poorest of scraps available to her in a small town in rural Texas. Her sense of design shortcuts the traditional values of Anglo-American quilters and draws directly on the rich African heritage of vivid imagery and strip-piecing.

The design element of strip-piecing is now thought of as directly linking black American string quilts and West African art as represented by woven textiles. Another link can be traced through the slave superstition that evil spirits follow straight lines. As a result of that belief, many examples of slave-made crafts tend to have crooked, wavy lines to deceive the evil spirits. What the quiltmaking world judged to be crude workmanship was often, in reality, a deliberate response to the history and traditions of another culture.

It is also probable that this piece of folk art reflects the "deliberate error" tradition in quiltmaking. This refers to the existence of a universal folk belief that the gods can be appeased by the admission of imperfection. This common thread of reasoning links the cultures of the ancient Persians and their rugs, the American Indian tribes and their pottery, the Africans and their crafts, and the American quiltmakers, among others.

The free-form images in this quilt convey impressions of innocence and thrift, combined with an idiosyncratic disregard for formality—and a secret to be revealed to the observer willing to spend time with this quilt. Many of the individual six-inch blocks have the feel of a Log Cabin design, yet very few of them are actually pieced as such. Certain red and white blocks appear to have been cut out of a larger completed block (perhaps 12″) and reused as asymmetrical accents.

Black-made quilts in Texas have not yet received much formal study; however, they obviously reflect different design sensibilities and a need for economy. When the Carver Museum in Austin held a special exhibit of black-made quilts in 1984, we met Mrs. Ada Simonds, known as the unofficial historian for that city's black community. Mrs. Simonds told us about "skirttail" quilts frequently made by blacks in Texas: pieced quilts using the only unworn portion of an every-day housedress—the skirttail. As she explained, "Suppose you're standing at the sink and washing the dishes when the doorbell rings. The first thing you do is wipe your hands on whatever's closest . . . and your skirttail's never closest. So it stays nice and fresh while the rest of the dress wears out." Mrs. Simonds also knew the origins of the orange-red ties so often seen on utility tacked comforters with flannel backs. As she explained, "Those red cords are what fastened the feed sacks. The man at the feed store would save those nice red strings for us to pick up. They made great ties for quilts because they were very strong."

Gazzie Hill was the family cook for the Dr. J. H. E. Powell family in Smithville for almost seventy years. She was known to the family and the community as Aunt Gazzie, and when she died there in 1976 at the age of ninety-eight, the *Bastrop County Times* reported that "her passing was mourned by all races." Never married, she was born in LaGrange, Texas, in 1877 and moved to Smithville in 1908 to go to work for the Powell family.

Although she had no education, the quiltmaker could print letters and numbers and served as treasurer for her church. As Mrs. Powell recalls, "Without an education, Gazzie was always saying the wrong words. One time I got dressed for a party and paraded in her kitchen and said, 'Aunt Gazzie, don't I look like Mrs. Astor?' She took a quick look and said, 'Lord Jesus, you look like dis-aster!' Another time I felt ill and complained that I was sick and sore all over. Aunt Gazzie came close and said, 'Honey, if you don't quit that producin', you're goin' to kill yourself.' (She meant my reducing!)"

According to the Powell family, Gazzie didn't enjoy television, and the radio bothered her. As they recall, she liked to rock in her chair, sing, and piece her beautiful quilts. Mrs. Powell also remembers that "Gazzie had a very strong will and would always say exactly what she thought. She carried her money in a bag tied to her teddies and at night she carried her favorite big stick for protection. She was devoted to the Powell family."

The secret to this quilt? A crudely pieced scrap alphabet. To translate it from what almost looks like pictographs, use your imagination, look at the quilt from all four directions, and don't expect the letters to appear in any logical sequence. They're hard to find, but they're there!

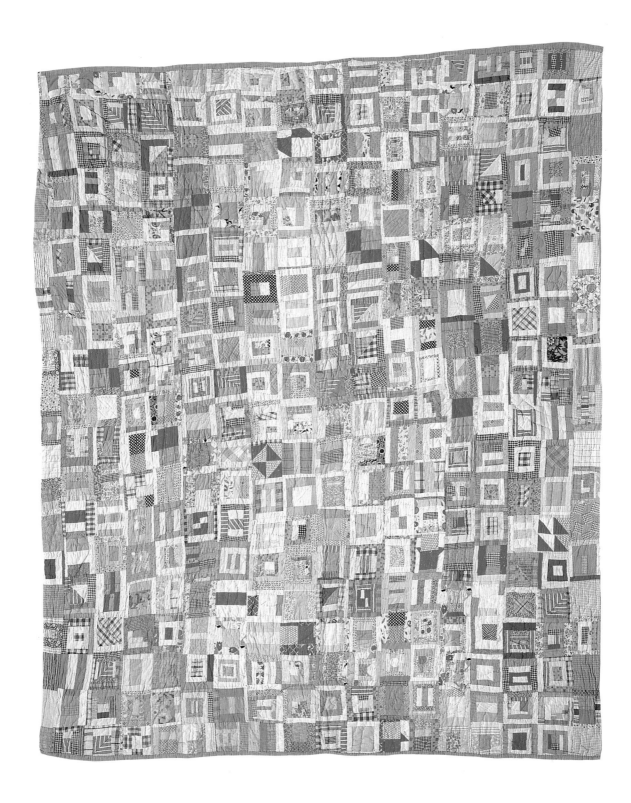

CHERRY QUILT

68″ × 82″
Cotton

ca. 1929

Quiltmaker Levina Thomas Stone.
Made in Five Points Community south of Lamesa,
Dawson County.
Owned by Inez Loyless Cox.

THE visual complexity of this quilt is so striking that it almost overshadows the meticulous workmanship required to produce twelve hundred stuffed cherries. Each cherry is a perfect circle, which is one of the most exacting tasks for any quilter. The unusual combination of the graphic geometric diamond sashing with the curves of the appliqué design adds excitement to the impact of this quilt and creates an optical illusion of stars at each intersection of the sashing. Completely hand-appliquéd and hand-pieced, the quilt is also hand-quilted on a coarsely woven muslin background.

Fruit and floral designs were especially popular during the 1920s and 1930s, perhaps because this was the one area where the quiltmaker was allowed to indulge her love of beauty and bounty during a time when the utmost thrift was required in all other ways. This particular design has only one difference from the "Cherry" pattern shown in quilt books of that period—it has one pair of leaves rather than two.

By simply reversing the direction of the clusters of cherries so that the triangles point inward, one creates a variation of one of the early quilt patterns, Foundation Rose and Pine Tree. In this pattern, the circles form the shape of the Pine Tree.

Mrs. Stone, grandmother of the present owner of the quilt, was widowed in 1922 and went to live with her eldest son and his family in Dawson County, a major cotton-growing area of the state. She made the Cherry quilt while living in Dawson County and, according to her granddaughter, "picked cotton during the Depression to earn money for her family's needs."

Levina Thomas Stone with her husband and their children

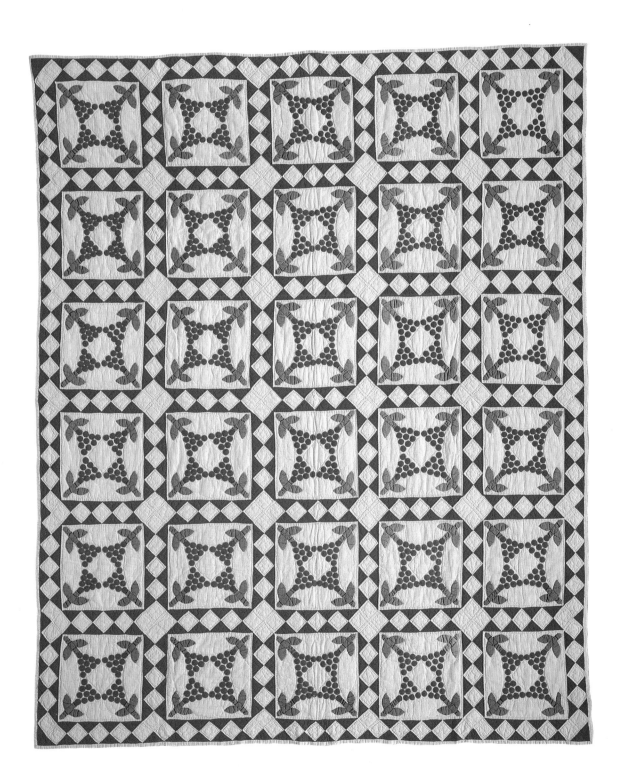

EXPANDED STAR QUILT

92″ × 96″
Cotton

ca. 1930 *(original design)*

Quiltmaker Julia Ann Mills Trueblood.
Made in Missouri and brought to Lubbock,
Lubbock County, in 1932.
Owned by Leota Trueblood Hopp.

DRAWING their inspiration from the heavens, quiltmakers through the centuries have turned stars into beautiful quilt designs. Two of the best known and best loved are Star of Bethlehem and Broken Star.

This unique Expanded Star is essentially two halved eight-pointed Stars of Bethlehem that have been joined to form a dramatic inner border surrounding, not a smaller Star of Bethlehem, as is customary, but a "window" of negative white space. This "window" of white muslin amounts to a very large counterpane medallion in which the quiltmaker could exhibit her considerable quilting skills.

An original design, this quilt most resembles a Broken Star. The Broken Star developed from the Star of Bethlehem, which had a large central eight-pointed star pieced of many diamonds, and is basically a smaller Star of Bethlehem surrounded by another "exploded" one, which forms an inner border of pieced diamond "rays."

Stars such as these, formed of many small diamonds, look difficult to hand-piece—and they are. Precise cutting and piecing are extremely important because any error is multiplied as the pieces are joined progressively, with the result that the points won't match and the quilt will bunch up or its edges will ripple when quilted.

This quilt is distinguished by very fine quilting, including feathered hearts in the corners of the inner border and single feathers in the central medallion. Quilting used to fill in the white muslin background is an original design. The inner border is a pieced gold Streak of Lightning, which is double outline quilted and banded by two strips of a soft green. That green combined with an orchid color and dark, almost black, navy diamonds, which themselves form an innermost border, is a typical palette for 1930s quilts.

One mark of a master quilter is how she plans and executes the turning of the outer corners of her quilt. In this case, the corners of the Streak of Lightning border are well conceived, well pieced, and beautifully quilted. The quilt is finished with a wavy, rather than a tightly scalloped, edge and bound with a narrow orchid binding. The curved corners of the quilt anticipate the look of contemporary bedspreads.

Julia Ann Mills Trueblood

There is an unsettled look to this quilt, which surprises the viewer who is expecting the customary Broken Star. It's as if the quiltmaker were striving to make the viewer reevaluate a familiar pattern that warranted closer attention. The present owner, daughter of the quiltmaker, confirms this. She said her mother felt "a strong challenge to make an original quilt both in design and quilting."

Julia Ann Mills Trueblood was born in Iowa in 1872, moved to Missouri in 1918, and then came to Texas in 1948, where she settled in Lubbock and lived until her death in 1958. Her quilt was a gift to her daughter, who came to Texas as a bride in 1932, which explains the hearts used in the quilting.

In recalling her mother, Leota Trueblood Hopp mentioned her beautiful large garden and said, "A fond memory I have is about the times she read poems and stories and sang special songs to us children as we sat close around her."

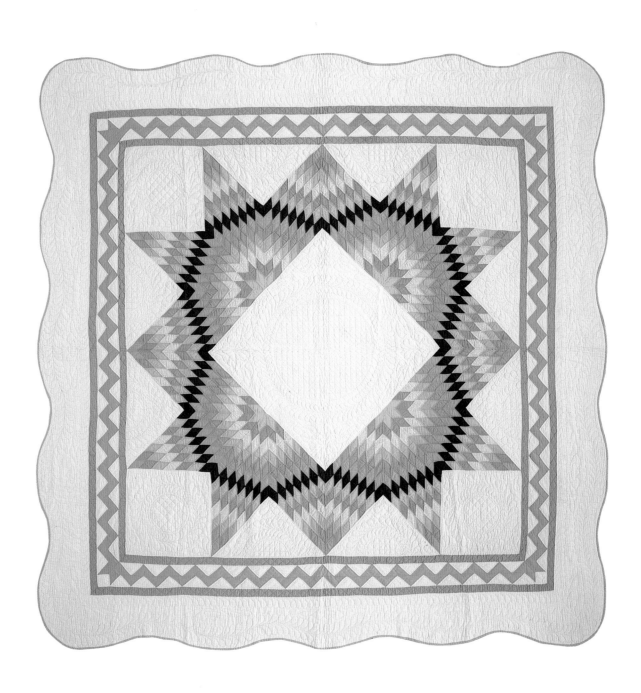

FOUR SEASONS QUILT

84″ × 85″
Cotton

ca. 1932

Quiltmaker Melinda Florence Rush Hall.
Made in Bovina, Parmer County.
Owned by June Looney McMeans.

CHANGING seasons are reflected in this unusual 1930s hand-appliquéd folk art quilt showing a West Texas family farmhouse at different times of the year.

To a farm family in the Panhandle county of Parmer, the passing seasons would have had major significance, since seasonal changes of weather affect the crops, and thus the family's fortunes. This would have been especially true in Bovina, a farm trade center on the border with New Mexico located in one of Texas' leading areas for total farm income and cattle production.

Four central blocks with four views of the farmhouse are surrounded by twelve blocks of sprightly and stylized multicolored flowers with the long, spindly stems seen on many Texas quilts, a feature that Jonathan Holstein remarks on in his Foreword. Four half-blocks of these flowers are arranged across the bottom of the quilt.

During the Depression and Dust Bowl years that devastated the Panhandle, years in which this quilt was made, farm prices declined 65.5 percent and cattle prices were off 58.9 percent from 1929 to 1933. The order of the passing seasons and the reappearance of seasonal flowers must have seemed reassuring signs to the quiltmaker that life, indeed, does go on.

The quilt, with its six pieced feedsacks for a backing, indicates that its maker, like all quiltmakers of her day, recognized the importance of "making do." In *The American Frugal Housewife*, published in 1820, Lydia Child seems to speak for all quilters when she says that "the true economy of housekeeping is simply the art of gathering up all the fragments so that nothing be lost. I mean the fragments of *time*, as well as *materials*. Nothing should be thrown away so long as it is possible to make any use of it . . ."

Melinda Florence Rush Hall, maker of the Four Seasons, "came from good stock" as Bovina cattle breeders might say, for she was a direct descendant of Dr. Benjamin Rush, signer of the Declaration of Independence and surgeon general to

Melinda Florence Rush Hall

President George Washington. Born in 1860, she moved to Texas in 1875 and eventually settled in Bovina. She was an individualist who stubbornly overcame odds. As a young woman, she was in poor health and her family doctor told her she would never live to forty although she proved him wrong by reaching ninety-seven years. Along the way, she lost all four of her children before their first birthday, and she divorced her husband in 1915, an almost unheard-of action for a woman in those days.

With no children to leave the quilt to, "Aunt Flo" gave her Four Seasons to a niece, who passed it on to her daughter, its present owner.

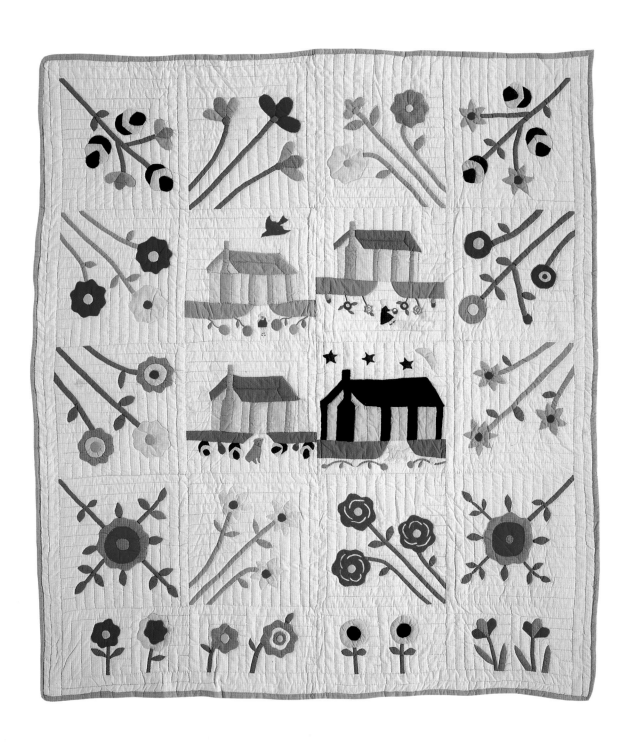

NEW YORK BEAUTY QUILT

84″ × 92″
Cotton

ca. 1933

Quiltmaker Hedwig Fertsch Buske.
Made in Shiner, Lavaca County.
Owned by Roxie Buske Canon.

EVEN though enamored of their Lone Star State, Texas quiltmakers have always been partial to this beautiful old pieced-quilt pattern most frequently called New York Beauty, which dates from 1776.

The pattern goes by different names, too, names of other faraway places, such as Bristol Beauty or Tennessee Beauty, or names with religious connotations, such as Crown of Thorns or Crossroads to Jerusalem. Occasionally, it is known as Rocky Mountain Road.

This particular New York Beauty consists of six complete blocks with four Fans in the corners, ten half-blocks with two Fans, and four quarter-blocks with one Fan; five alternating brown and white borders on the sides, three on the bottom, and one on the top; and corners at the bottom set off by rectangular Fifteen Patch blocks. The quilt is finished with a simple binding.

It's helpful to realize that in this version each quarter-block is basically a brown-and-gold Fan variation with gold rays. The set of this exceptional hand-pieced quilt has a look of green, white, and brown railroad tracks. The juncture of the set consists of a spiky, needle-pointed gold star pieced into a larger brown star, which in turn is pieced into a green square. The gold center of the first star is appliquéd.

The quiltmaker, Hedwig Fertsch Buske, was the youngest girl of eleven children, four of whom died in childhood. Her father died at thirty-three, leaving his wife to raise the nine remaining children on a small farm in the Kinkler Community in Lavaca County. All of them had farm and house chores but were also sent to a two-teacher country school, according to the present owner of the quilt, Roxie Buske Canon, "to learn the three R's. The five boys, being ambitious, managed without money to get out on their own. [One became a postmaster, another a prominent attorney, one the president of a community college, one a school principal and author of a mathematics textbook, another a county attorney and later judge.] These advantages were not available to the four girls. All that was really available was to get married."

In 1905, Hedwig Fertsch married Emil Buske, who was ten years her senior. Together they be-

came co-owners of a family cotton gin in Witting, Texas. They soon sold that and bought another in Shiner, which they operated with their son until 1971, when all cotton operations in Lavaca County ceased. Theirs was the last gin in the county to close.

New York Beauty quilts, being a true labor of love to piece, usually were made for special people or special events. In this case, it was for both, since the maker pieced and quilted it for the marriage of her only daughter. Roxie Buske Canon, who was given this New York Beauty when she married and moved to New York, said of her mother in 1985: "It is only now that she is gone that I can appreciate her creativity. She had very little formal education but was willing to try anything."

Mrs. Buske knitted, crocheted, and sewed, as well as quilted, cooked three meals a day for family and hired hands, and yet was active in church and the Parent-Teacher Association. Apparently, she was tireless with her needlework, for her daughter, while living in New York, enrolled her visiting mother in an art class "to keep her from putting crocheted edgings on all my linens." Mrs. Buske died in 1978 at ninety-two.

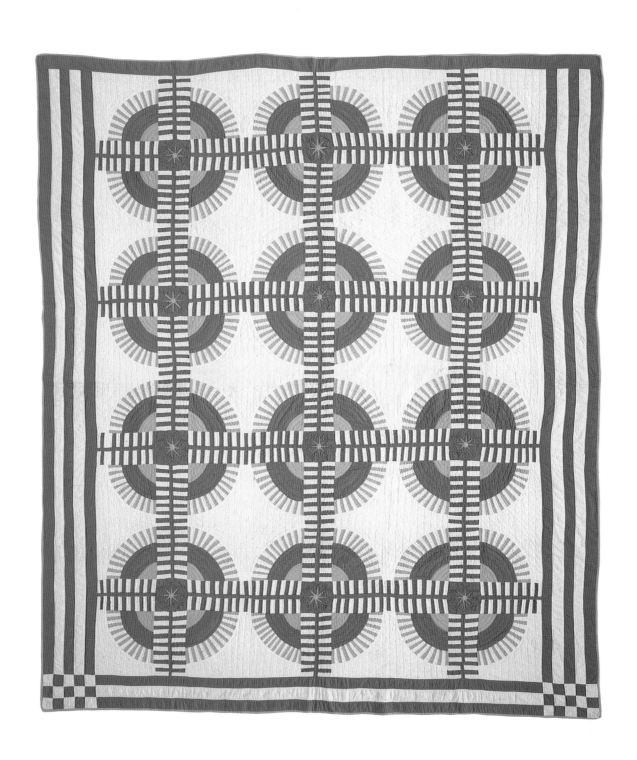

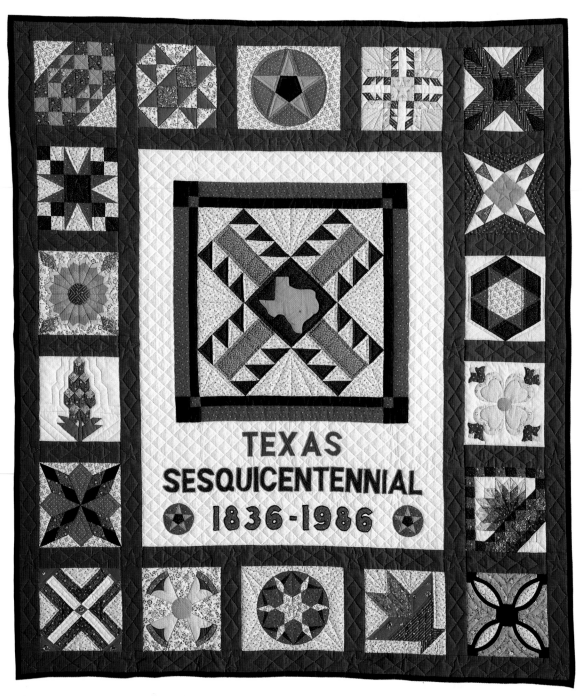

Crossroads to Texas quilt, made as the official symbol of the
Texas Sesquicentennial Quilt Association by board member
Kathleen McCrady of Austin.

THE SEARCH FOR TEXAS QUILTS

"Many hands make light work." —*Old Proverb*

THIS BOOK is an integral part of an overall program begun by the nonprofit Texas Sesquicentennial Quilt Association in 1980. The underlying purpose of TSQA, its statewide program, and its projects was to see that the artistic and cultural contributions of Texas women, through the predominantly female art of quiltmaking, were not forgotten during the state's Sesquicentennial, its 150th birthday as a Republic.

When Suzanne Yabsley and we founded TSQA in 1980, a two-pronged approach to the objective was adopted. There were to be aspects of the program to appeal to lovers of antique quilts and of contemporary ones, to people who were already knowledgeable about quilts as art and as cultural records, and to those whose primary appreciation of quilts was as bedcovers. In this way, it was hoped that a maximum number of Texans would be exposed to quilts during the Sesquicentennial.

When TSQA was formed and plans were begun for the Texas Sesquicentennial, another statewide quilt project was being formulated in Kentucky. Texas, with its 254 counties, covers 267,339 square miles. Because of the logistics involved in covering such a huge territory, TSQA founders allotted three years of planning and laying of groundwork for the Texas Quilt Search. During that time, the Kentucky Quilt Project took place, and its organizers, in the spirit of sharing that characterizes quiltmakers and quilt lovers, generously offered to their counterparts in Texas what they had learned about statewide quilt documentation.

The resulting Texas Quilt Search Days began on February 6, 1983, and continued through March 30, 1985. The search covered twenty-seven Texas cities and towns in every part of the state. This endeavor was truly a populist activity, as the aim was to discover the unknown Texas quilt treasures still in private hands, not to document quilts already known to be in Texas museums.

Two TSQA Board members conducted the Quilt Search Days; Karey Bresenhan served as quilt historian responsible for identifying, dating, and discussing each quilt, and Nancy Puentes served as quilt documentor, recording in slides and photographs the quilts that were discovered.

Local nonprofit co-sponsors were obtained for each Quilt Search Day—in many cases a local quilt guild, in others a local museum, art group, or historical association. Local volunteers were an important part of these activities, for each Quilt Search Day required many hours of advance work.

Each quilt that was brought to a Quilt Search Day was documented and a $100 prize was awarded each day to the oldest, most beautiful, and best preserved quilt, with preference given to quilts made in or brought to Texas prior to the State Centennial in 1936. All Quilt Search Day activities were free, and education about quilts and quilting was an important part of each day. Recommendations were given for better quilt care, storage, and display, since the aim of TSQA was not only to heighten the awareness of quilts as art and to recognize the achievements of quiltmakers, but also to ensure that the quilt heritage of the state was preserved.

At the end of the two-year Quilt Search period, 3,500 quilts had been documented. Information gathered about these quilts and other material became the basis for the establishment of the nonprofit Texas Quilt Archives, a resource center for persons wishing to learn more about Texas quilts.

Those 3,500 quilts were narrowed to 350 semifinalists by a TSQA selection committee. A panel of three distinguished authorities was then invited to curate the final exhibit. Jonathan Holstein, noted art historian and author of *The Pieced Quilt: An American Design Tradition*; Julie Silber, corporate curator for the famed Esprit Quilt Collection and author of *American Quilts: A Handmade Legacy*; and Cecilia Steinfeldt, senior curator for the San Antonio Museum Association and author of *Texas Folk Art: 150 Years of the Southwestern Design Tradition*, were flown to Houston for an intensive three-day weekend of selection in spring 1985. Their final choices resulted in the selection of sixty-two quilts for exhibit in the State Capitol during Texas Quilt Appreciation Week. Of those, they selected thirty-nine of the finest to offer Texas museums as a touring exhibition during 1986 and 1987.

149

As part of the preparation for Texas Quilt Appreciation Week and the ensuing tour of the antique quilts through Texas museums, TSQA in July 1985 co-sponsored with Taylor Bedding Manufacturing Company, Inc., a historic Quilt Conservation Seminar. This four-day seminar was the first in the nation to bring together professional textile conservators, museum textile curators and staff, and quilt artists to establish a dialogue about the need for the preservation of quilt and textile art. A particular emphasis was on protecting quilt art currently in Texas museums. In addition, there was a two-day intensive hands-on laboratory attended by expert quilters who were instructed in museum mounting methods for quilts. Those quilters then stabilized, backed, and prepared for exhibit the quilts chosen by the curators for "Lone Stars: A Legacy of Texas Quilts, 1836–1936." Several supplemental laboratory sessions were also held in August 1985.

A distinguished faculty of experts in the field of quilt conservation was assembled for the seminar, including Patsy Orlofsky, founder and executive director of the renowned Textile Conservation Workshop in South Salem, New York; Sara Wolf, senior conservator and head of the Materials Conservation Laboratory at the Texas Memorial Museum, the University of Texas at Austin; Nancy Terry, consulting textile conservator, who has done work for the Museum of Fine Arts and the Bayou Bend Collection in Houston and for the San Jacinto Museum and the Pioneer Arts Foundation; and Nancy Wyatt, consulting textile conservator, who has worked with the Los Angeles County Museum of Art, the Institute of Fine Arts and the Cooper-Hewitt Museum in New York City, the Delaware State Museum in Dover, and the Valentine Museum in Richmond, Virginia.

Also participating at the seminar were museum curators Jo Anne Arasim, textile curator for the Panhandle-Plains Historical Museum, Canyon, Texas; Dr. Cynthia Brandimarte, curator of textiles and photography, Harris County Heritage Society; and Cecilia Steinfeldt, senior curator, San Antonio Museum Association. Also on the program was Dr. Jack Gill, chairman of the Fashion and Textile Department at Texas Woman's University, Denton. The laboratory was conducted under the direction of Sara Wolf, who was assisted by TSQA Board member Kathleen McCrady.

The Great Texas Quilt RoundUp was co-sponsored by TSQA, the Rouse Company through its Arts in the Marketplace Division, and the Simon Group. It was a year-long contest for contemporary Texas quilters to produce quilts on Texas themes. Several categories, such as Texas myths and heroes, industry, history, and nature, were available. Winners, receiving a total of $5,100 in prizes, were selected in early 1986 by Bonnie Leman, editor and publisher of *Quilter's Newsletter Magazine*. They were initially exhibited at Highland Mall Shopping Center in Austin during Texas Quilt Appreciation Week and will tour Rouse Company and Simon Group malls during 1986 and 1987.

A celebration of Texas quilts and quiltmakers took place in April 1986 in Austin, when Texas Quilt Appreciation Week was held. Two key events were the centerpieces for San Jacinto Weekend, April 19–21: the opening of "Lone Stars: A Legacy of Texas Quilts, 1836–1936" in the Rotunda of the State Capitol and the opening of the Great Texas Quilt RoundUp at Highland Mall. Additional related quilt exhibitions were held in Austin and Taylor, and lectures, a film, and a play were scheduled around the theme of Texas quilts. Receiving special recognition were the owners of "Lone Stars" exhibit quilts, who were the honored guests at all events, as were the winners of the Great Texas Quilt RoundUp.

CREDITS

WITHOUT the enthusiastic involvement of individuals all across the state and the nation, this Texas-sized endeavor would necessarily have been narrower in breadth and shallower in depth. TSQA thanks each of the individuals listed for their contributions.

Quilt Search Days

During the two-year period from February 6, 1983, to March 30, 1985, twenty-seven Quilt Search Days were held across Texas. Karey Bresenhan, Houston, served as quilt historian, and Nancy Puentes, Austin, as quilt documentor. For twenty Quilt Search Days, Mary Reddick, Houston, directed operations as general coordinator. It would have been impossible to hold Quilt Search Days without the many local volunteers who assisted. Because there were so many, it is impossible to list them individually, but TSQA extends a very special "thanks" for their efforts. Local Quilt Search Day co-sponsors and coordinators are listed below:

1. Victoria, February 6, 1983
 Local co-sponsor: Victoria Regional Museum Association
 Local coordinator: Judy Murrah
2. Austin, May 5, 1984
 Local co-sponsor: Austin Area Quilt Guild
 Local coordinator: Carol Robbins
3. Wichita Falls, August 4, 1984
 Local co-sponsors: Wichita Falls Museum & Art Center and Wichita Falls Embroiderers Guild
 Local coordinator: Jean Joubert
4. Houston (1), August 24–25, 1984
 Local co-sponsor: Quilt Guild of Greater Houston
 Local coordinators: Elaine Goldfoot and Catherine Purifoy
5. San Antonio, September 29, 1984
 Local co-sponsor: Greater San Antonio Quilt Guild
 Local coordinators: Linda Robinson and Judy Moore
6. Houston (2), November 2, 1984
 Local co-sponsor: Quilt Festival
 Local coordinator: Lynn Young
7. Fort Worth, November 10, 1984
 Local co-sponsor: Trinity Valley Quilt Guild
 Local coordinator: Janet Mullins
8. Tyler, December 1, 1984
 Local co-sponsors: Tyler Museum of Art and Quilters' Guild of East Texas
 Local coordinator: Anne Tuley

9. McAllen, January 12, 1985
 Local co-sponsors: McAllen International Museum and Rio Grande Valley Quilt Guild
 Local coordinator: Virginia Hartnell
10. El Paso, January 26, 1985
 Local co-sponsors: El Paso Museum of History and El Paso Quilters' Association
 Local coordinators: Barbara Ardus and Nannette Strain
11. Abilene, February 23, 1985 (TSQA supported)
 Local co-sponsor: Abilene Quilters' Guild
 Local coordinator: Sue Thomas
12. Galveston, February 8, 1985
 Local co-sponsor: Galveston Arts Council
 Local coordinator: Karen Schweitzer
13. Houston (3), February 9, 1985
 Local co-sponsor: Quilt Guild of Greater Houston
 Local coordinator: Adele Mozek
14. Huntsville, February 9, 1985
 Local co-sponsor: Tall Pines Quilters' Guild
 Local coordinator: Iona Andrea
15. Lubbock, February 16, 1985
 Local co-sponsor: South Plains Quilt Guild
 Local coordinators: Sharon Newman and Edna Thompson
16. Midland, February 23, 1985
 Local co-sponsors: Museum of the Southwest and Midland Quilters' Guild
 Local coordinator: Karen Collins
17. LaPryor, February 9, 1985 (TSQA supported)
 Local co-sponsor: Texas Sesquicentennial Quilt Association
 Local coordinator: Hazel Friedrich
18. Waco, March 1, 1985
 Local co-sponsors: Baylor University Home Economics Department, Waco Historical Foundation, and Brazos Star Quilt Guild
 Local coordinators: Lee Fadal and Jan Milespre
19. New Braunfels, March 2, 1985
 Local co-sponsor: New Braunfels Quilt Guild
 Local coordinator: Pat Dial
20. Dallas, March 8, 1985
 Local co-sponsor: Quilters' Guild of Dallas
 Local coordinator: Margaret Kalmus
21. Del Rio, March 19–20, 1985 (TSQA supported)
 Local co-sponsors: Rio Grande Valley Quilt Guild and Piecemakers Quilters
 Local coordinator: Lottie Salinas
22. Lufkin, March 9, 1985
 Local co-sponsor: Lufkin Historical & Creative Arts Center
 Local coordinator: Joan Finley
23. Corpus Christi, March 14, 1985
 Local co-sponsor: Art Museum of South Texas
 Local coordinator: Joan Gillespie
24. San Angelo, March 15, 1985
 Local co-sponsors: Fort Concho Museum and Concho Valley Quilt Guild
 Local coordinators: Cora Pugmire and Donna Landers

25. Amarillo/Canyon, March 16, 1985
 Local co-sponsors: Panhandle-Plains Historical Museum, High Plains Quilters' Guild, and Jan's Quilt Shop
 Local coordinators: Jo Anne Arasim and Jan Miller
26. Nacogdoches, March 18, 1985
 Local co-sponsor: Stone Fort Museum
 Local coordinator: Carolyn Spears
27. Grand Prairie, March 30, 1985
 Local co-sponsor: Grand Prairie Public Library
 Local coordinator: Joan Dobbins

Quilt Conservation Seminar

Coordinator: Nancy Puentes, Austin

Conservators: Patsy Orlofsky, South Salem, New York; Sara Wolf, Austin; Nancy Terry, Houston; Nancy Wyatt, Paris, Texas

Textile curators and participants: Jo Anne Arasim, Canyon, Texas; Dr. Cynthia Brandimarte, Houston; Dr. Jack Gill, Denton; Cecilia Steinfeldt, San Antonio

Laboratory director: Sara Wolf, Austin, assisted by Kathleen McCrady, Austin

Texas participants:
AMARILLO: Jan Miller
ARLINGTON: Jane Baird
ATHENS: Bettye Goforth, Annie L. Rosser
AUSTIN: Flo Cochran, Oma Harlan, Ann H. Harrington, Lisa Harms Holmes, Pat Hunt, Florene Imken, Beth Kennedy, Anne Long, Jack McCrady, Kathleen McCrady, Pat McLerran, Phyllis Merchant, Meredith Montague, Barbara Murchison, Debbie Nicklaus, Ruel Phillips, Nancy Puentes, Johnie Roberson, Carol Robbins, Jean Roberie, Erika Rogala, Mary Steele, Sara Wolf, Suzanne Yabsley
AZLE: Linda Schnacke
BOERNE: Willoa A. Shults
BROWNSVILLE: Margaret Douglass
BRYAN: Ruth Moore
CANYON: JoAnne Arasim
CARROLLTON: Laura Hobby
COLLEGE STATION: Norma Metzer
CORPUS CHRISTI: Joan Gillespie
EDINBURG: Mary Louise Shelby
FRIENDSWOOD: Mary Murray
HARLINGEN: Marjorie K. Steward
HOUSTON: Lucille Anderson, Ria Aufdermarsh, Karey Bresenhan, Betty Carbery, Nanette Crawford, Gwen Crockett, Ann Discenza, Katherine Fay, Nancy Glenn, Elaine Goldfoot, Carolyn Groschke, Beverly Hallen, Bobbie Heider, Marie Malone, Eloise Manis, Adele C. Mozek, Jacklyn New, Helen O'Bryant, Susan Odom, Tommie Orwig, Jewel Patterson, Jini Rasmussen, Mary Reddick, Lorraine Reed, Diane Schultz, Susan Schwartz, Peggy Sichenze, Janet Steadman, Nancy Lane Terry, Mary Thro, Lois White, Lynn Young

HUNTSVILLE: Iona Andrea, Susan Jones
JONESTOWN: Joy McCrady
KINGWOOD: Carol Turpin
LUBBOCK: Anne Brann, Kay Fleming, Sharon Newman
MERCEDES: Virginia Hartnell
MIDLAND: Karen Collins, Rosemary Rose
RICHARDSON: Jackie Asbill
ROUND ROCK: JeNeal Carter
SAN ANTONIO: Charlotte Flesher, Jack Flesher, Shirley P. Levine, M.D., Cecilia Steinfeldt, Juanita Watson
SUGARLAND: Dolores Moore
TAYLOR: Dave Forwood, Ed Kruse, Virginia Kruse
WEATHERFORD: Betty Nuss
WICHITA FALLS: Laurel Barber, Judy Puder

Out-of-state participants:
BARTLESVILLE, OKLAHOMA: Ruth Montgomery
CARLINVILLE, ILLINOIS: Rita Barber
DES MOINES, IOWA: Donna Miles
EVANSTON, ILLINOIS: Ann Wasserman
LAKE CHARLES, LOUISIANA: Evelyn Bassham
LITTLETON, COLORADO: Julia Butler
MINDEN, LOUISIANA: Phyllis S. Frye
STILLWATER, OKLAHOMA: Sue Rose

Sponsors

Texas Sesquicentennial Quilt Association wishes to thank these corporate sponsors who had generously supported our program at the time this book was printed:

Arts in the Marketplace/The Rouse Company
Continental Airlines
Freeman Decorating
Glick Textiles, Inc.
Great Expectations Quilts
Printing Unlimited
Shamrock Hilton Hotel
The Simon Group
Taylor Bedding Manufacturing Company, Inc.
Texas Timesharing

Many, many individuals have contributed both funds and time to TSQA and its projects. While we are too limited by space to thank each of them, some must be recognized because of the extent of their commitment: Bonnie Leman, Michael Kile, members of the Kentucky Quilt Project, Sharon Risedorph, Lynn Kellner, Lynn Young, Bettina Winn, Athalie Young, Doris Kosub, and Cathy Cooney.

DEFINITION OF TERMS

APPLIQUÉ: Derived from French verb "appliquer," meaning to apply or lay one thing on another; cut-out shapes of fabric are "applied" to a larger background fabric and held down with a blind stitch, whip stitch, buttonhole stitch, or embroidery.

BATTING: The filling of a quilt, usually cotton or wool; also called wadding or inner lining; the middle layer of the quilt "sandwich."

BINDING: Finishing the raw edges of an otherwise completed quilt, or the finished edge itself.

BRODERIE PERSE: French term meaning Persian embroidery; nineteenth-century appliqué method in which design elements, such as trees or flowers, are cut from printed fabrics and sewn to a background fabric using blind stitch, whip stitch, or decorative stitches.

CARDING COTTON: Method of working raw cotton by hand into quilt batting by placing the cotton between a pair of boards with metal "teeth" and combing the cotton through the "teeth" to produce a flat batt of uniform thickness.

CORNERS, TO TURN: Planning the borders and quilting designs to curve around the corners without having a broken line; stems from old superstition that a broken line in the border foretells a broken life.

COUNTERPANE: Derived from French "contre-point," meaning backstitch or quilting stitch; refers to plain blocks that alternate with pieced or appliquéd blocks in a quilt and are often quilted with a fancy design; sometimes refers to a spread used on top of a bed.

FABRICS:

Calico: Cotton cloth with small, stylized patterns printed in one or more colors.

Chintz: Glazed cotton cloth; in the eighteenth century, always printed; first manufactured in India but then imitated elsewhere; printed designs usually have at least five colors and are frequently large-scale floral patterns; solid color chintz available today.

Cretonne: Sturdy, textured cotton material in printed designs, often large florals, used especially for draperies, slipcovers, and the backing for utility quilts.

Muslin: A fine cotton cloth with a downy nap on its surface; today considered a basic of quilting; also called unbleached domestic in common usage.

GINNING COTTON: Mechanical process to remove seeds from cotton; Eli Whitney invented the cotton gin in 1793; in Texas many small farms had their own cotton gins or belonged to a cotton gin co-op.

HOMESPUN: Cloth manufactured by an individual on a loom at home; can range from coarsely woven to finely woven but contains slubs and is more textured than factory-made cloth.

LAYING ON: Drawing a quilting design on fabric with the point of a needle so that the impression of the design remains long enough to quilt but leaves no lasting mark on the quilt.

PIECING: To sew small patches of fabric together with narrow seams to form a quilt block, top, or backing.

QUILT: A fabric "sandwich" consisting of three layers—top, batting or filling, and back; derived from French "cuilte," which was derived from Latin "culcita," a stuffed mattress or cushion.

QUILTING: Simple running stitches, preferably small and even, holding all three layers of a quilt together; stitches often follow fancy designs.

QUILT TOP: The top side of the fabric "sandwich" that shows on the bed; usually used to refer to the completed pieced or appliqué design before it is quilted.

REVERSE APPLIQUÉ: Method of appliqué whereby part of background fabric is removed in a desired shape and another fabric added from underneath to fill the area; known also as inlaid appliqué.

SASHING: Strips that are used to separate blocks in a quilt; also called stripping.

SET: To sew the finished blocks together to form the top; refers also to the arrangement of the blocks.

STUFFED WORK: Produced when a quilter stitches the design outlines in a fine running stitch and then from the back carefully eases cotton or wool through small holes to pad the outlined areas.

TRAPUNTO: A term applied in the nineteenth century to American and English stuffed and corded work.

TURKEY RED: Produced by natural dye from the madder plant; originated in India and from there was carried to Turkey, where it got its name; a soft, colorfast red that predates the more vivid manufactured aniline dyes, which were developed in 1856.

SELECTED READING LIST

FROM the many good books on quilts and quilting we have selected a few for individuals who want to learn more. If we had to choose a single reference book, however, there is no question that it would be *Quilts in America* by Patsy and Myron Orlofsky. This book is truly encyclopedic in the depth and breadth of its coverage of American quilts. It is, unfortunately, out of print, but it can be found in libraries and, sometimes, through out-of-print and rare book dealers. It is well worth seeking.

History of Quilts and Quilting

Colby, Averil. *Patchwork*. New York: Charles Scribner's Sons, 1958.

———. *Quilting*. New York: Charles Scribner's Sons, 1971.

Cooper, Patricia, and Norma Bradley Buferd. *The Quilters, Women and Domestic Art*. Garden City, N.Y.: Doubleday and Co., 1977.

Finley, Ruth. *Old Patchwork Quilts and the Women Who Made Them*. Philadelphia: Lippincott, 1929.

Frye, L. Thomas, ed. *American Quilts: A Handmade Legacy*. Oakland, Calif.: Oakland Museum, 1984.

Hall, Carrie A., and Rose G. Kretsinger. *The Romance of the Patchwork Quilt in America*. New York: Bonanza Books, 1935.

Holstein, Jonathan. *The Pieced Quilt: An American Design Tradition*. New York: Galahad Books, 1973.

———, and John Finley. *Kentucky Quilts, 1800–1900*. Louisville: Kentucky Quilt Project, 1982.

Ickis, Marguerite. *The Standard Book of Quilt Making and Collecting*. New York: Dover Publications, 1949.

Irwin, John Rice. *A People and Their Quilts*. Exton, Penn.: Schiffler Publishing, 1983.

Orlofsky, Patsy and Myron. *Quilts in America*. New York: McGraw-Hill Book Co., 1974.

Peto, Florence. *American Quilts and Coverlets*. New York: Chanticleer Press, 1949.

———. *Historic Quilts*. New York: American Historical Co., 1939.

Safford, Carleton L., and Robert Bishop. *America's Quilts and Coverlets*. New York: E. P. Dutton, 1980.

Swan, Susan Burrows. *Plain & Fancy: American Women and Their Needlework, 1700–1850*. New York: Holt, Rinehart, 1977.

Quilts As Art

Bishop, Robert. *New Discoveries in American Quilts*. New York: E. P. Dutton & Co., 1975.

Holstein, Jonathan. *The Pieced Quilt: An American Design Tradition*. *See* History.

Mainardi, Patricia. *Quilts, the Great American Art*. San Pedro, Calif.: Miles & Weir, 1978.

Nelson, Cyril I., and Carter Houck. *The Quilt Engagement Calendar Treasury*. New York: E. P. Dutton, 1982.

Robinson, Charlotte, ed. *The Artist & the Quilt*. New York: Alfred A. Knopf, 1983.

Safford, Carleton L., and Robert Bishop. *America's Quilts and Coverlets*. *See* History.

Textiles and Dyes in Quilts

Adrosko, Rita J. *Natural Dyes & Home Dyeing*. New York: Dover Publications, 1971.

Beer, Alice Baldwin. *Trade Goods*. Washington, D.C.: Smithsonian Institution Press, 1970.

Montgomery, Florence M. *Printed Textiles*. New York: Viking Press, 1970.

Orlofsky, Patsy and Myron. *Quilts in America*. *See* History.

Pettit, Florence H. *America's Printed & Painted Fabrics*. New York: Hastings House, 1970.

Quilt Pattern Identification

Bishop, Robert. *The Knopf Collectors' Guides to American Antiques: Quilts*. New York: Alfred A. Knopf, 1982.

Haders, Phyllis. *The Warner's Collector's Guide to American Quilts*. New York: Warner Books, 1981.

Hall, Carrie A., and Rose G. Kretsinger. *The Romance of the Patchwork Quilt in America*. *See* History.

Rehmel, Judy. *Key to 1,000 Quilt Patterns*. Richmond, Ind.: Judy Rehmel, 1978.

———. *Key to a Second 1,000 Quilt Patterns*. Richmond, Ind.: Judy Rehmel, 1979.

———. *Key to a Third 1,000 Quilt Patterns*. Richmond, Ind.: Judy Rehmel, 1980.

———. *Key to a Fourth 1,000 Quilt Patterns*. Richmond, Ind.: Judy Rehmel, 1983.

———. *Key to 1,000 Appliqué Quilt Patterns*. Richmond, Ind.: Judy Rehmel, 1984.

How to Quilt and Quilt Patterns

Beyer, Jinny. *The Art and Technique of Creating Medallion Quilts*. McLean, Va.: EPM Publications, 1982.
———. *Patchwork Patterns*. McLean, Va.: EPM Publications, 1979.
———. *Quilter's Album of Blocks and Borders*. McLean Va.: EPM Publications, 1980.
Gutcheon, Beth and Jeffrey. *The Quilt Design Workbook*. New York: Rawson Associates Publishers, 1976.
Hassel, Carla. *You Can Be a Super Quilter*. Des Moines, Iowa: Wallace-Homestead Book Co., 1980.
———. *Super Quilter II*. Des Moines, Iowa: Wallace-Homestead Book Co., 1982.
Houck, Carter. *American Quilts and How to Make Them*. New York: Charles Scribner's Sons, 1975.
Ickis, Marguerite. *The Standard Book of Quilt Making and Collecting*. See History.
Leman, Bonnie. *How to Make a Quilt*. Rev. ed. Wheatridge, Colo.: Leman Publications, Inc., 1979.
———. *Quick and Easy Quilting*. Great Neck, N.Y.: Hearthside Press, 1972.
———, and Judy Martin. *Taking the Math Out of Quilting*. Wheatridge, Colo.: Moon over the Mountain Publishing, 1981.
McKim, Ruby. *One Hundred and One Patchwork Patterns*. New York: Dover Publications, 1962.
Orbello, Beverly Ann. *A Texas Quilting Primer*. San Antonio: Corona Publishing Co., 1980.
Puckett, Marjorie. *Patchwork Possibilities*. Orange, Calif.: Orange Patchwork Publishers, 1981.
Simpson, Grace. *Quilts Beautiful: Their Stories and How to Make Them*. Winston-Salem, N.C.: Hunter Publishing Co., 1981.

Texas Quilts and Needlework

Exley, Jo Ella Powell, ed. *Texas Tears and Texas Sunshine: Voices of Frontier Women*. College Station: Texas A&M University Press, 1985.
Orbello, Beverly Ann. *A Texas Quilting Primer*. See How to Quilt and Quilt Patterns.
Steinfeldt, Cecilia. *Texas Folk Art: 150 Years of the Southwestern Tradition*. Austin: Texas Monthly Press, 1981.
Yabsley, Suzanne. *Texas Quilts, Texas Women*. College Station: Texas A&M University Press, 1984.

Quilt Magazines

The following magazines are published periodically and cover a wide range of information regarding antique quilts and contemporary quiltmaking. They are available by subscription or through local quilt specialty shops. Some are available on the newsstand.

Country Quilts
Ladies Circle Patchwork Quilts
Quilters Newsletter Magazine
Quilt Magazine
Quiltmaker
Quilt World

Women and the Frontier

Barr, Amelia E. *All the Days of My Life*. New York: D. Appleton and Co., 1913, 1923; reprint New York: Arno Press, 1980.
Bunton, Mary Taylor. *A Bride on the Old Chisholm Trail in 1886*. San Antonio: Naylor Co., 1939.
Carrington, Evelyn M., ed. *Women in Early Texas*. Austin: Jenkins Publishing Co., 1975.
Clack, Tommie, and Mollie Clack. *Pioneer Days . . . Two Views*. Abilene, Tex.: Reporter Publishing Co., 1979.
Cleveland, Morely. *No Life for a Lady*. Santa Fe, N.M.: W. Gannon, 1976.
Connor, Seymour V., ed. *The West Is for Us: Reminiscences of Mary A. Blankenship*. Lubbock: West Texas Museum Association, 1958.
Crawford, Ann, and Crystal Ragsdale. *Women in Texas*. Burnet, Tex.: Eakin Press, 1982.
Exley, Jo Ella Powell, ed. *Texas Tears and Texas Sunshine*. See Texas Quilts and Needlework.
Fehrenbach, T. R. *Lone Star: A History of Texas and the Texans*. New York: Macmillan Publishing Co., 1968.
Fischer, Christiane. *Let Them Speak for Themselves: Women in the American West*. New York: E. P. Dutton, 1978.
Holley, Mary Austin. *Mary Austin Holley: The Texas Diary, 1835–1838*. Ed. J. P. Bryan. Austin: University of Texas Press, 1965.
Jeffrey, Julie. *Frontier Women*. New York: Hill and Wang, 1979.
Jones, Katharine M., ed. *Heroines of Dixie: Winter of Desperation*. St. Simons Island, Ga.: Mockingbird Books, 1975.
King, C. Richard, ed. *Victorian Lady on the Texas Frontier: The Journal of Ann Ramey Coleman*. Norman: University of Oklahoma Press, 1971.

155

Luchetti, Cathy. *Women of the West.* St. George, Utah: Antelope Island Press, 1982.

Pickrell, Annie. *Pioneer Women in Texas.* Austin: E. L. Steck Co., 1929.

Plummer, Rachel. *Rachel Plummer's Narrative of Twenty-One Months Servitude as a Prisoner among the Comanche Indians Written by Herself.* Austin: Jenkins Publishing Co., 1977 [reprint].

Rabb, Mary Crownover. *Travels and Adventures in Texas in the 1820's.* Waco: W. M. Morrison, 1962.

Rawick, George P., ed. *The American Slave: A Composite Autobiography.* 19 vols. Westport, Conn.: Greenwood Press, 1976 [reprint].

Roberts, Mrs. D. W. *A Woman's Reminiscences of Six Years in Camp with the Texas Rangers.* Austin: Von Boeckmann-Jones Co., 1928.

Smithwick, Noah. *The Evolution of a State or Recollections of Old Texas Days.* Austin: University of Texas Press, 1983 [reprint].

Snyder, Grace, and Nellie Snyder Yost. *No Time on My Hands.* Caldwell, Idaho: Caxton Printers, 1963.

Stratton, Joanna. *Pioneer Women.* New York: Simon & Schuster, 1981.

Tyler, Ronnie, and Lawrence Murphy. *The Slave Narratives of Texas.* Austin: Encino Press, 1974.

Wilson, Nancy. *Westward the Women.* New York: Alfred A. Knopf, 1944.

Woods, Gary D. *The Hicks-Adams-Bass-Floyd-Patillo and Collateral Lines, Together with Family Letters, 1840–1868.* Salado, Tex.: Anson Jones Press, 1963.